HYBRID DRAWING TECHNIQUES

Hybrid Drawing Techniques: Design Process and Presentation reaffirms the value of traditional hand drawing in the design process by demonstrating how to integrate it with digital techniques, enhancing and streamlining the investigative process while at the same time yielding superior presentation images. This book is a foundations guide to both approaches: sketching, hardline drawing, perspective drawing, digital applications, and Adobe Photoshop; providing step-by-step demonstrations and examples from a variety of professional and student work for using and combining traditional and digital tools. Also included are sections addressing strategies for using color, composition, and light to further enhance one's drawings. The eResource offers copyright-free images for download, including tonal patterns, watercolor fields, people, trees, and skies. It can be found at www.routledge.com/9780415702263.

Gilbert Gorski is a licensed architect and an Associate Professor at the University of Notre Dame, where he holds the James A. and Louise F. Nolen Chair in Architecture. He is a recipient of a National Award for Collaborative Achievement by the American Institute of Architects and has twice been awarded the Hugh Ferriss Memorial Prize by the American Society of Architectural Illustrators. He has also taught studios at the Illinois Institute of Technology and at the School of the Art Institute of Chicago.

'Gorski conducts a masterclass in situating digital and analog methods of drawing in this richly illustrated paean to the art of representation in contemporary times. From the scratch of a pen to the click of a mouse, this book teaches not only proven technique but strategic thinking about the new ways of rendering the image. This is a must-have manual for all those wrestling with the transformative role of hand-drawing in a digital age.' – **Gil Snyder, Professor, Department of Architecture, University of Wisconsin-Milwaukee, USA**

'Gorski's pioneering work in combining traditional and digital media, elucidated in this timely and important book, places him at the forefront of contemporary visualization.' – **Paul Stevenson Oles, FAIA, Principal, Interface Architects, New Mexico, USA**

'One of the finest architectural illustrators practicing today, Gorski commands an exceptional talent for creating beautiful, powerful, and enlightening images. And he is a pathfinder. In your hands, you hold a brilliantly drawn map, a dedicated course, designed to empower digital innovation to evoke the sublime—building on the best of the old masters.' – **Henry E. Sorenson, Jr., Professor, School of Architecture, Montana State University, USA**

'With the keen sense of the artistic genius, Gorski uninhibitedly and passionately mates hand-drawn architectural drawing with the boundless possibilities of computer generated methods, resourcefully proving what interdisciplinary stands for. With this simple, yet fundamental, credo this volume is a standard reference for all students of architectural representation.' – **Sergei Tchoban, Architekt BDA, Germany**

'Gorski presents an invaluable treatise acknowledging that great architecture is inextricable from a mastery of *techné* invoked in *multiple* delineation processes of great design. That is to say, because what we draw is in fact what we build, how we draw becomes a critical modality of aesthetic intelligence implicit to the way by which great design is crafted, evaluated and made. I believe masterful drawing is our most useful tool in *building well* once again.' – **Duncan McRoberts, Principal, Duncan McRoberts Associates, USA**

HYBRID DRAWING TECHNIQUES

Design Process and Presentation

Gilbert Gorski

Routledge
Taylor & Francis Group

NEW YORK AND LONDON

First published 2015
by Routledge
711 Third Avenue, New York, NY 10017

and by Routledge
2 Park Square, Milton Park, Abingdon, Oxon OX14 4RN

Routledge is an imprint of the Taylor & Francis Group, an informa business

Library of Congress Cataloging in Publication Data
Gorski, Gilbert.
Hybrid drawing techniques : design process and presentation / Gilbert Gorski.
pages cm
Includes bibliographical references and index.
1. Architectural drawing--Technique. 2. Architectural drawing--Data processing.
I. Title.
NA2708.G67 2015
720.28'4--dc23
2014013343

ISBN: 978-0-415-70225-6 (hbk)
ISBN: 978-0-415-70226-3 (pbk)
ISBN: 978-1-315-75394-2 (ebk)

Acquisition Editor: Wendy Fuller
Editorial Assistant: Grace Harrison
Production Editor: Alanna Donaldson

Typeset in Univers
by Fakenham Prepress Solutions, Fakenham, Norfolk NR21 8NN
Printed by Bell and Bain Ltd, Glasgow

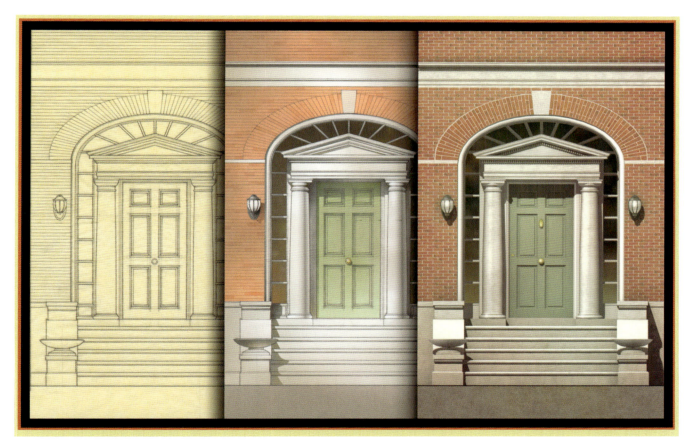

Doorway Study: traditional drawing on sketch paper, traditional drawing with digital color, 3D digital model.

Contents

Contents

Preface: Architecture in the Age of Digitalism

A short time ago, computers did not exist for most people. Now, most people cannot exist without computers. We occupy a pivotal moment in history when digital tools challenge long-held conventions for how we learn, create, and communicate.

Perhaps the best process for creating architecture still remains the one practiced by medieval and traditional builders: wait for the sun to come up, go to the site, and build! Relying on their imaginations informed by practical knowledge accumulated over many generations, these master builders created works of aesthetic integrity that continue to be admired today. Building in this manner is no longer possible; a more complicated modern world requires specialists. Architects and designers do not build; they rely on others to implement their ideas and make them real. This process invites a disconnect between concept and reality, particularly since the tools architects use to predict reality are in some ways all imperfect. Each different tool has strengths and limitations that affect the design process in unique and significant ways.

Traditional orthographic and perspective drawing has intimately influenced the process of creating architecture for over half of the last millennium. In an astonishingly short time, however, digital tools have displaced traditional ones. While computers offer design possibilities not attainable with traditional tools, I believe the primary reason for their overwhelming embrace is that they synchronize with modern society's trajectory toward ever increasing efficiency. Those who are not using computers fall behind in a competitive marketplace. Yet, some endeavors – art for instance – involve intangibles not so easily measured by time or money.

Recent advances in cognitive theory and neuroscience question Rene Descartes' long-accepted theory that self-awareness is a state of being separate from the body. As Maurice Merleau-Ponty suggests in *Phenomenology of Perception*,[1] consciousness occurs through "embodied" experiences that equally involve the body, mind, and senses together. If the art we create facilitates our quest to find meaning in life, then processes for creating art should also involve embodied methods of inquiry: "the hand speaks to the brain as surely as the brain speaks to the hand. Self-generated movement is the foundation of thought and willed action."[2]

Preface

Presently, there are a dwindling number of practitioners who, in their early careers, exclusively used traditional techniques and then, in their later careers, employed digital tools. Their unique perspective of comparing both approaches will soon be lost.

In *Hybrid Drawing Techniques* I advocate mastering both traditional and digital skills. This asks much from a designer, particularly someone just beginning their career. The examples included in this book are possibly the best arguments to be made for considering hybrid techniques. They demonstrate methods for combining traditional and digital techniques that are not only efficient, but also encourage designers to rediscover the advantages of work made by hand.

The book's organization follows a linear progression; each chapter builds on the previous one. Some readers may feel I favor traditional drawing over digital techniques. I have used computers intensively for the last 20 years and I believe they are essential to modern practice, but I am concerned that traditional skills are slipping away. My career as a visiting design consultant, illustrator, and educator has allowed me privileged views into architectural firms and schools around the country. Many, if not most, have almost entirely abandoned using traditional methods.

Acquiring traditional skills and understanding their importance is the foundation for using hybrid techniques. Since traditional techniques usually precede the use of digital techniques in the hybrid process, I emphasize traditional skills in the first part of the book. The second part addresses ways to integrate traditional and digital techniques. I also cover non-technical strategies for lighting, composition, and color. Art combines both technique and insight. To present one without the other would not give a complete understanding of what is required to achieve the results I've indicated. Except for a brief review of 3D modeling software, I do not cover computer-aided drawing and 3D modeling applications. Since there are numerous software programs to choose from, and they all are constantly evolving, it is beyond the scope of this book to include such information.

I have attempted to keep the text concise; other sources cover some of the included information in more detail. My goal is to help beginners quickly become proficient. In order to emphasize the essentials, alternative methods for saving time or achieving a particular result may be left unexplored. As digital software evolves, some of the methods I advocate may require revision.

Gilbert Gorski
South Bend, Indiana

Notes

1 Merleau-Ponty, M., *Phenomenology of Perception*, Routledge (London and New York), 1962.
2 Wilson, F. R., *The Hand*, Vintage Books (New York), 1999, p. 291.

Acknowledgments

A number of people helped contribute to the creation of this book and deserve my thanks. Insightful conversations with illustrators and architects Dennis Allain, Wesley Page, and, especially, Christopher Grubbs, helped shape a number of the ideas presented in the text. Scott Baumberger generously contributed a detailed illustrated description of his technique for rendering SketchUp models. As the book neared completion, a few colleagues and friends kindly agreed to read all or parts of the text. Ibrahim Chaaban and Will Bruckert, information technology specialists with the University of Notre Dame, offered advice on technical issues relating to software and hardware. Robert Becker contributed a number of insightful observations concerning the relationship of traditional and digital illustration. Professors Allan DeFrees and Dennis Doordan, also with the University of Notre Dame, both offered very valuable suggestions. While any errors or grammatical issues are entirely my own, I want to especially thank James Packer, Professor Emeritus, Northwestern University, Chicago, for his careful reading of the final manuscript.

Finally, I would like to thank my past students who, sometimes through trial and error, helped me shape and refine the included demonstrations – and occasionally taught me a few things as well.

This book is dedicated to my students.

1
Getting Started

When ideas are detached from the media used to transmit them, they are cut off from the historical forces that shape them.

(E. L. Eisenstein)[1]

Why Use Hybrid Techniques?

While many designers now work exclusively in a digital environment, some use both traditional and digital techniques simultaneously, and a few remain committed to only using traditional techniques.

The latter group misses an essential truth: if work is to be significant, the media used to transmit and project ideas cannot be excluded from the production of those ideas. Today, nearly all ideas are conveyed digitally; non-digitized forms of communication are becoming marginalized. To create with only traditional tools fails to recognize the important relationship between media and message.

The first group also misses an essential truth: if work is to be significant, the media used to transmit and project ideas cannot be excluded from the production of those ideas. Humans are also part of the media; interactions we have with each other as well as our environment give our lives meaning. To create with only digital tools fails to recognize the important relationship between media and meaning.

Since the Renaissance, documenting architecture on paper elevated the act of creating architecture from the physical to the cerebral. Treatises on architecture took their place on library shelves as collections of human thought. Traditional drawing has held a privileged place as the tool best reflecting the designer's thinking process.[2] Original drawings are like original paintings, "in which one follows the traces of the painter's immediate gestures. This has the effect of closing the distance in time between the painting of the picture and one's own act of looking at it."[3] Physical models are another important tool, but they don't provide the same connection back to the thoughts of the designer, as they are almost always created by assistants. By contrast, digital models are often created by the designers themselves, giving them a direct, efficient, and powerful investigative tool. However, the use of digital tools has diminished the use of traditional drawing, leaving the digital artifact as the only evidence of the designer's thought process. Whether it is

an image on a screen or a computer-generated print, these artifacts do not connect us as intimately with the artist's creative process as do hand-made drawings.

With any art – poetry, dance, music – personal expression is facilitated through mediums – words, human bodies, instruments – that are capable of subtlety or exaggeration. For the last five centuries, architects have investigated manipulations of light and shadow, mass and proportion, texture and rhythm, principally through traditional drawing, a medium that facilitates nuanced expression. For all their advantages, computers do not easily allow for expressions of subtlety or exaggeration. While traditional drawings or paintings created by different individuals always look a little different, computer-generated 2D and 3D images almost always look the same. If a process uses visualization tools that yield similar images, will not the same process tend toward yielding similar solutions?

The creative process works best when it involves random variables. Some have found ways of using digital tools to introduce chance and risk back into the process. Primarily relying on innovations with software code that yield unpredictable results, these designers engage the process as editors, responding to whatever accidents or surprises the computer generates. This approach, however, distanced from a process more directly controlled by human intellect, can become detached from social memory and often yields forms that have a limited potential for practical application other than isolated pieces of sculpture.

In a way never possible with traditional techniques, digital tools facilitate investigations into the possibilities of visual phenomena: transparency and reflection, texture and color, light and shadow, and movement – both of the sun and the viewer. These investigations, however, require advanced skills and it is unfortunate that few designers pursue acquiring them. The majority seem to fall into two groups: those using sophisticated software for exploring the novelty of new forms, and those who settle for software with less robust modeling capabilities, either because they possess Building Information Modeling capabilities, or because the software is easy to learn, inexpensive, or free. Either way, in responding to ever-present pressures for improved efficiency, both groups accept the computer's proclivity to gravitate toward predetermined solutions by: over-relying on existing 3D files; over-using certain tools that yield quick results while forgoing design possibilities that are more difficult to manage; and increasingly relying on various forms of artificial intelligence built into the software to simplify or remove human skill and decision-making from the process.

Contemporary media's embrace of digital imagery accelerates society's trend toward replacing reality with recorded images. Convenience drives the explosion of devices that facilitate this phenomenon. Compensating for limitations imposed by shrinking interfaces, digital media favors highly graphic subjects: strong geometry, dramatic contrast, or vivid color; this at the expense of portraying more nuanced subjects that require physical encounters to be appreciated.

1.1
Hybrid drawing technique: a process of first conceptualizing with hand-made drawings, and then using digital tools to confirm, refine, and document.

Getting Started

Both traditional and digital tools have a place in the design process. Appreciating the strengths and limitations of each tool is the key to understanding how to integrate them and why this is important.

Traditional Drawing Limitations

1. Favors concepts that are documented through ortho-graphic drawings: plans, sections, and elevations.
2. Abstracts the process of creating 3D objects in a 2D environment.
3. Challenging to create complicated 2D and 3D geometry: intricate or repetitive patterns and subtle textures.
4. Traditional techniques can be cumbersome to merge into a digital environment.
5. Yields images corresponding to a single viewpoint.
6. Focuses creativity in one individual.
7. Individual means of expression invites subjective evaluation.
8. Requires many years of practice.
9. Integrated analytical capabilities are limited.
10. Changes can be difficult.
11. Does not easily facilitate fabrication of building components and systems.
12. Involves risk; variables concerning tools and individual skills can yield unpredictable results.

Computer Advantages

1. Documents and quantifies organic or irregular objects; is not encumbered by 2D representation.
2. Facilitates creating 3D objects in a quasi-3D environment.
3. Anything imaginable can be realistically simulated in a digital environment.
4. The digital environment is the standard.
5. Capable of simulating movement with animation.
6. Capable of linking and simultaneously combining many contributors' efforts.
7. Standardized means of expression allows for objective evaluation.
8. Facility with computer software can be mastered in less time.
9. Can be used to analyze material and environmental performance.
10. Changes are easier.
11. Can be utilized to facilitate fabrication of building components and systems.
12. Removes risk; standardized tools yield predictable results.

Traditional Drawing Advantages

1. Sketching forms better visual memories by slowing the process of assimilation and inviting the other senses to reinforce experiences.
2. Matches right-brain manual skills with right-brain thinking tasks.[4]
3. Practiced hand–eye coordination develops muscle memory; knowing how to draw is never forgotten.
4. Process is grounded by human biology.
5. Hand drawing is spontaneous; it is hard-wired to the brain.
6. Emphasizes individual expression; no two people draw exactly alike; if the process of drawing yields images that are personally unique, it is more likely the designs they describe will also be more unique; work that is unique is memorable.

Computer Limitations

1. Instantly acquired digital images compromise memorization; cameras and humans see things differently.
2. Mismatches left-brain manual skills, such as sequencing keyboard commands, with right-brain thinking tasks.
3. Keyboard commands; recalling locations and sequences are forgotten without constant practice.
4. Process is grounded by software designers.
5. Interface between mind and machine lacks nuance.[5]
6. Suppresses individual expression; all CAD drawings look alike; if the process of creating in a digital environment yields images that are similar, it is likely the designs they describe will also be similar; work that is similar is unmemorable.

7 Allows for serendipity, abstraction, and fuzzy thinking.

8 Allows for discovery through improvisation; the hand completes what the mind begins.

9 Observing the entire drawing at once confirms the relationship of the parts to the whole.

10 By progressing from small sketches to larger drawings, a process of considering overall concepts first and small details later is encouraged.

11 The pressures traditional drawing places upon the design process, a convention used since the Renaissance, are well understood.

12 Layered drawings, erased lines, tentative lines, or hard lines – like analog time – engage the designer with the past, present, and future of the process.

13 Specialized drawing skills give the designer control of the design process.[6]

14 Conventions of communication have evolved over 35,000 years and have become assimilated into our culture.

15 Involves risk; variables concerning tools and individual skills can yield unpredictable results.

7 Images always look finished.

8 Most discoveries are made through software innovations or accidents, the computer generates what the mind can't anticipate.

9 Rapidly zooming in and out compromises a sense of scale and the relationship of the parts to the whole.

10 Overall concepts and small details are simultaneously considered.

11 Responding to what looks best on a monitor, managing polygon counts and computer processing speed, and relying on the quick but limited results afforded by inexpensive software imposes both subtle and significant pressures upon the creative process.

12 Like digital time, computer-aided drawings indicate only the present, and leave no trace of the process.

13 As computer applications become easier to master, digital drawing skills become common and diminish the designer's authority; clients become their own architects.

14 Conventions of communication are new, evolving, and not completely understood.

15 Removes risk; standardized tools yield predictable results.

Digital Tools

The following equipment is required to create in the digital environment:

- computer, keyboard, and mouse
- back-up external hard drive(s)
- scanner
- monitor
- printer
- stylus tablet.

It is beyond the scope of this book to cover these items in depth; rather, my purpose is to provide enough information for a beginner to inform their choice when using and purchasing these items.

Getting Started

Computers

Components to consider when purchasing a computer:

- Central processing unit or CPU: the processor's speed, measured in megahertz (MHz), indicates how quickly the CPU can execute commands; the other hardware components, however, also contribute to determining a computer's overall speed. Multiple processors allow multiple programs to be run simultaneously.
- Motherboard: the computer's main circuit board holding the CPU and memory, it connects to all the other computer components, such as the internal hard drive and external devices.
- Random access memory or RAM: where the computer stores short-term memory for completing commands. RAM is necessary for memory-intensive operations required by graphics or 3D modeling applications. Generally, the more RAM the better, although there is a point where some software cannot utilize additional RAM.
- Hard drive: where software applications and personal files are stored. Solid-state drives offer significant advantages over drives using moving parts: they run quicker, are quieter, and are more resistant to wear and damage.
- Video or graphics card: over and above what is normally built into the motherboard, an enhanced graphics card boosts performance for operations involving high-resolution images or 3D modeling applications.

The capabilities of each component collectively affect the computer's overall performance. With the exception of 3D modeling, the reader can accomplish all the demonstrations in this book with a mid-level desktop or laptop personal computer. However, the purchase of a more robust computer will make work more efficient, and time is valuable. Those interested in pursuing 3D modeling should consider a system like those computer gamers use.

Back-up External Hard Drives

As we continue to create more and ever larger files, most people quickly outgrow their computer's internal hard drive storage. Even if storage is not a concern, it is important to back up information and files stored on the computer's internal hard drive. At any given moment it is not likely – but possible – for a computer's built-in hard drive to fail, sometimes resulting in the loss of everything stored on it. Not anticipating this is foolish. In fact, it is best to back up important files on two external hard drives, either on personal portable units or on websites offering "cloud" storage. If you choose to keep files on your own personal units, leave one permanently at your home or office, while the other is for traveling with you. This way, if your computer and back-up are in the same place and become lost or stolen, another back-up drive is still available. Back-up drives continue to get physically smaller, less expensive, with more storage capacity; but they are fragile and can be damaged if dropped. "Cloud" storage is becoming increasingly popular as it can provide access to multiple users and offers unlimited capacity.

Applications involving large 3D files sometimes should not be run from the external hard drive, but copied to the computer's desktop and run from that location, returning it to the external hard drive when finished.

Scanners

For information regarding scanners and scanning techniques, refer to Chapter 4.

Screens and Monitors

Advancements in screen size, color accuracy, and lower cost continually improve one of the critical links with digital media. It is important to recognize, however, that monitors are all a little different. What may appear very satisfying on one screen can look unsatisfying on another. While the discrepancy can sometimes be an issue with color, more often it's a problem with the screen's contrast. Since we constantly trade images, any image observed on one monitor must be configured to satisfy an average range of how other monitors will portray it. When calibrating a computer monitor, compare it with a number of other monitors to avoid setting the levels at too far an extreme.

Printers

More unpredictable than monitors, no two printers create the same hard copy. Even the same printer can give different results over time. One should assume that the image observed on a monitor will be different – sometimes quite different – from a printer's hard copy. Although there are methods and devices for calibrating a monitor with a printer, often the best idea is to run a few test prints of a small area of the original. Usually it is only a matter of adjusting contrast, but occasionally color adjustments are also required. These should be done with a copy of the saved original, since an image adjusted for a satisfactory print can end up looking unsatisfactory when viewed on a monitor.

Some printers can print on thick sheets of textured paper or illustration board. A few even print with fade-resistant waterproof ink, presenting opportunities for continuing with wet media work over digitally printed images. We cannot predict the longevity of digitally stored images. For this reason it is prudent to create prints of important images with fade-resistant ink on acid-free archival paper.

Stylus Tablets

It is not possible to draw well with a mouse. While traditional drawing techniques offer more control, stylus tablets have made it possible to draw in a digital environment. Those using one for the first time may find it awkward to watch the screen and not the tip of the drawing instrument, but with a little practice most people readily adapt. Some tablets are pressure sensitive, allowing a single stroke to change thickness as it is created. Traditional drawing relies on the texture of the paper's surface to provide some resistance and steady the pencil or pen as a line is created. While stylus tablets are rather "slippery", some stylus pens have interchangeable felt tips that somewhat replicate the missing resistance. The larger, more expensive models work best, while some of the introductory models are simply unusable. One monitor allows the designer to draw right

on the screen, replicating the experience of creating lines while looking at the tip of the drawing instrument. I own one but find the stylus pad more comfortable to work with.

Software

What to use is a personal preference; amazing work can be found by people using a variety of different software. For the examples I created that are included in this book only two applications were used: Photoshop for coloring and manipulating images and Form-Z for creating and rendering 3D models.

Anyone planning to learn how to use or purchase a 3D modeling application should anticipate what they want to achieve with it. Generally, the more robust software applications offer comparable modeling and animation capabilities, yet some have shorter learning curves, while others excel at modeling organic forms, while still others have superior rendering engines. An incomplete list of recommendable software includes:

- Autodesk Maya, Rhinoceros 3D (Rhino): both applications are very popular, especially with those engaged in creating organic forms.
- Houdini, Autodesk 3DSMax: two software applications regarded by many as superior modelers; the latter is known for its robust rendering capabilities.
- Form-Z: originally created by and for architects, it is a robust modeler and has superior controls for manipulating views. It has also recently undergone a complete redesign, making it easier to learn and use.
- Cinema4D: many are attracted to its short learning curve, versatility, and ease of use.
- Revit: this software can take time to master, but is finding widespread use among architectural firms, primarily for its Building Information Management (BIM) capabilities. Some of its users are also achieving good results with the software's modeling and rendering tools.
- SketchUp: a free software, its short learning curve and extensive online library have made it very popular; however, even the SketchUp Pro version has limited modeling and rendering capabilities.

Traditional Tools

One of the advantages of using digital tools is that they are portable and require minimal space. Traditional tools, on the other hand, have specific space and storage requirements.

Drafting table: minimum 36" × 48" or larger. It is important that the table surface does not warp or flex. While not essential, a table with an adjustable tilting surface can be more comfortable for working. Some tables with taller legs facilitate working while standing. In addition to the drafting table, a second reference table is also desirable.

Parallel rule: minimum 42", 48" preferred. Mayline makes a high-quality parallel rule – avoid any model with rollers, which can mar a drawing's surface.

Vinyl board cover: a partially self-healing soft vinyl surface is used to cover the table, allowing pencil lines to be applied with more pressure. Borco and Vyco are two widely

used brands. Usually one side is a pale green and the other is white. Most people prefer using the green side as it is easier on the eyes. Be sure to carefully clean the drafting table before setting down the vinyl covering as small particles trapped between the covering and table create raised areas that will attract graphite dust on both the vinyl's surface as well as drawings placed on top of it.

Drafting lamps: adjustable swing-arm lamps – preferably two – are essential for illuminating fine work. They should include the proper hardware for attachment to the desktop. The best models combine florescent and incandescent light bulbs, which together mimic the color of sunlight.

Drafting leads: 2 mm are preferable; thinner leads afford no control over line thickness and density. These are available in a range of hardness. From soft to hard: 6B, 5B, 4B, 3B, 2B, B, F, HB, H, 2H, 3H, 4H, 6H. I find HB, H, and 2H the most useful. Lead characteristics are not consistent among manufacturers.

Lead holders: designed to hold a 2 mm lead. Some people own a number of variously colored lead holders that correspond to the different leads they use.

Lead pointer: the desk-mounted rotary types are the easiest to use.

Wood-cased pencils: an alternative to mechanical pencils, they can be more comfortable to hold, less expensive, and when used with a high-quality electric sharpener, quite efficient.

Erasers: kneaded erasers are preferred as they do not leave particles behind. White plastic erasers are also useful for removing more stubborn lines.

Eraser shield: a small, thin metal shield perforated with variously sized openings for exact removals.

Drafting brush: essential for sweeping away graphite dust and eraser particles.

Triangles: recommended 12″ 45, 12″ 30/60, 16″ 30/60, 12″ adjustable. Some prefer triangles made with raised nubs – inking triangles – which keep the bottom edge of the triangle away from the paper surface when using ink. These can be harder to clean, and may not be necessary since scanning techniques now give pencil drawings some of the same characteristics as ink drawings.

Scales: three 12″ triangular scales are recommended: architectural, engineering, and metric. A 12″ flat 1/32–1/16″ is also very useful.

Compass set: an adjustable bow compass with a beam bar extension as well as inking attachments is recommended. Avoid the inexpensive sets as they can be unusable.

French curves: most useful are a variety of longer curves with differing profiles. Adjustable curves are generally unsatisfactory.

Templates: circle and ellipse templates, with a variety of sizes up to 2″, are recommended.

Paper: two types of paper are recommended: yellow trace paper and vellum (or 1000 H Clearprint). Vellum is thicker, whiter, and has the advantage of withstanding multiple corrections without tearing, but is a little more expensive than yellow trace and not quite as translucent.

Getting Started

Notes

1 Eisenstein, E. L., *The Printing Press as an Agent of Change: Communications and Cultural Transformations in Early-Modern Europe*, Cambridge University Press (New York), 1979, as quoted by Robbins, E., *Why Architects Draw*, MIT Press (Cambridge, MA), 1994, p. 9.

2 Starkey, B., "Post-secular Architecture," in *From Models to Drawings: Imagination and Representation in Architecture*, edited by Frascari, M., Hale, J., and Starkey, B., Routledge (London and New York), 2007, pp. 231–241.

3 Berger, J., *Ways of Seeing*, British Broadcasting Corporation and Penguin Books (London), 1972, p. 31.

4 Related to the author in a conversation with Al Rusch.

5 Woolley, M., "The Thoughtful Mark Maker: Representational Design Skills in the Post-informational Age," in *Design Representation*, edited by Goldschmidt, G. and Porter, W. L., Springer-Verlag (London), 2004, p. 199. Woolley is one of many who anticipates improved digital interfacing tools:

> intelligent ... pencils ... an increasing necessity if designers are to address the process of continuous data This missing interface has meant that a generation of designers has been relatively weak at building directly on their traditional skill-base and has had to adapt to the machine, rather than harness existing hand/eye skills to machine intelligence.

We should pause to ask, however, if trying to contain the entire conceptual process in a digital environment is necessary or even desirable.

6 Robbins, E., *Why Architects Draw*, MIT Press (Cambridge, MA), 1994, pp. 38–49.

2
Traditional Drawing Techniques

I still sketch out concepts before doing anything. We use lots of tracing paper before going to the computer. Once it's in the computer I walk around and say, "What's that?" You have to separate image from reality.

(Richard Meier)[1]

The Importance of Sketching and Drawing
A sketch should be used to observe, conceptualize, and communicate.

Observing

Most designers and architects no longer create observational sketches. Time is short and more can be covered by using cameras to remember for us. But how useful are these photographs? If we take the time to really look at them again, they still remain 2D fragments of a world as the camera sees it, divorced from the smells, tastes, sounds, and tactile sensations that make visual experiences memorable and meaningful. Visual memories are best reinforced when they involve the other senses. Taking time to sketch from life helps us remember what we are looking at by slowing us down and making us look a little harder. A library of instantly accessible images does not help a designer create. Pausing to look at an image during the creative process interrupts that process. Inspirations must already be part of the designer; they must be committed to memory, only then can they be re-imagined as individual expressions.

Creating

The pencil in the architect's hand is a bridge between the imagining mind and the image that appears on the sheet of paper: in the ecstasy of work … the image emerges as if it were an automatic projection of the imagining mind. Or, perhaps, it is the hand that really imagines.

(Juhani Pallasmaa)[2]

The design process typically involves putting forth ideas that are evaluated and revised. A circular loop of imagining possibilities, evaluating those possibilities with visualizations,

Traditional Drawing Techniques

and posing new possibilities that build upon what is revealed, continues until an idea becomes satisfactory. During the conceptual phase, a process that accommodates some amount of undirected speculation can often lead to new ideas. Hidden in the corners of our imagination are feelings we all collectively share. Sketching is a way to search out those unfamiliar areas and reveal what is essential. Sketching denies the temptation of pursuing an idea to completion too quickly. A sketch creates a place for serendipity and interpretation, allowing unrelated ideas to link and become visible. Sketching invites improvisation; ideas emerge from the necessity of the moment. The creative process can make impatient demands on the ebb and flow of work; a pencil in the hand – hard-wired to the brain – is spontaneous.

Communication

Two lawyers present opposing arguments before a jury. The one with a stronger case can still lose if his opponent makes a more eloquent and convincing argument. Sketches, drawings, and illustrations are an architect's visual arguments and no words can substitute for eloquent and evocative images. Just as lawyers practice and perfect their oratory skills, architects also perfect their drawing and image-making skills. Something magical occurs when a designer creates a beautiful drawing; it draws people into its creator's way of seeing and thinking. While sketching has always been essential for solitary work, it is also effective in collaborative situations when rapidly developing ideas can be made visible to all involved in the process.

If fame and money are any indication, cinema is one of our era's most important art forms. The film industry attracts some of our brightest individuals and we can learn from their methods. Movie directors have historically begun their work with storyboards: a series of hand-made illustrations depicting the proposed scenes in a movie. One might suspect that digitally animated films could avoid this process, but it's quite the opposite – even more drawings are required. Pixar's film *Ratatouille* generated over 500,000 sketches and drawings alone.[3] Movie producers would not invest this much effort unless there was value in it. For an art that depends upon communicating with a wide audience, handcraft is an important part of the process. A principal animator for the *Star Wars* movies remarked that Hollywood designers who master both traditional and digital techniques are "golden".[4]

Sketching and Drawing

It is important to make a distinction between sketching and drawing. If sketching is valued for observing and creating in a loose and spontaneous way, drawing asks for a higher degree of certainty. It is traditional drawing in particular that has been displaced by digital tools. One argument to be made for retaining traditional drawing is that each different tool employed in the design process requires a new point of view. Pursuing drawings or watercolors, physical or digital models, as end results in themselves, loses sight of the primary goal, which is creating something that anticipates a three-dimensional reality. Occasionally changing the tool and continuing the process with

another approach can provide new insights and restores a healthy irreverence for the artifacts different tools produce.

It is our primary assumption that there is an intimate complicity between architectural meaning and the modus operandi of the architect.

… poetic architecture is singularly difficult to construct, especially in a world where the only "legitimate" modus operandi is an instrumental technology.[5]

(Alberto Perez-Gomez, Louise Pelletier)

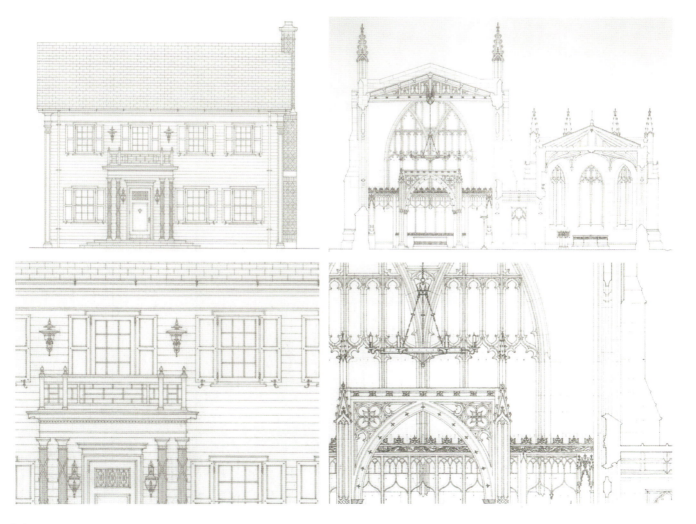

2.1
Left: *Hemlock House*, elevation, pencil (4H) graphite on vellum, 24" × 36". *Right*: *Gothic "Hall Church"*, section, pencil (6H) graphite on cold press watercolor paper, 24" × 36", by Duncan McRoberts.

Traditional Drawing Techniques

It All Begins with the Line: Techniques for Creating Evocative Drawings

If at one time art schools advocated strict preferences for making drawings, most academic programs today allow and even encourage students to develop more personally expressive styles. This freedom of expression, however, can sometimes get in the way of predicting reality. It is therefore important to develop a clear and accurate drawing technique. Historically accepted conventions for creating drawings should be followed to support the creative process, not confuse it.

At a fundamental level, drawings are an assemblage of lines describing edges; an abstraction that has only a tangential relationship to reality but has everything to do with graphic communication. These edge lines form the foundation of the drawing; a simple but masterful line drawing can be more evocative than a more elaborately developed shaded drawing composed of misinformed or ungraceful lines.

Strategies for Creating Line Drawings

1 Use drawing tools that allow the character of the line, principally its thickness and density, but also its quality, to change during the creation of the stroke – an important subtlety lost on those who rely on felt-tip pens or thin-lead mechanical pencils; instruments that yield only one line weight and only one type of line.

2 The best drawings are economical; the fewer the lines the better. While it is usually necessary to reinforce tentatively placed lines with additional darker lines, this can quickly lead to overworking and risks missing the elegance of a simple yet assured drawing.

3 A line describing an edge should give insight into the nature of the subject – form, contour, surface, and even emotion – entirely accomplished by controlling:
 • line thickness;
 • line intensity: light, dark;
 • line quality: soft-edged, sharp-edged, fragile, ragged, crisp, shaky;
 • drawing instrument: pencil, pen, brush, chalk, charcoal;
 • drawing surface: smooth, rough, absorbent, dense, slippery, soft, hard;
 • human dexterity: assured, tentative, nuanced, decisive.

Seemingly a simple thing, a beautiful drawing is the result of controlling many variables, perhaps explaining why a beautiful drawing is as elusive as it is satisfying.

The drawings shown in Figures 2.2–2.5, now considered works of art in themselves, were made in anticipation of creating something else: a painting, a building, or a fresco.

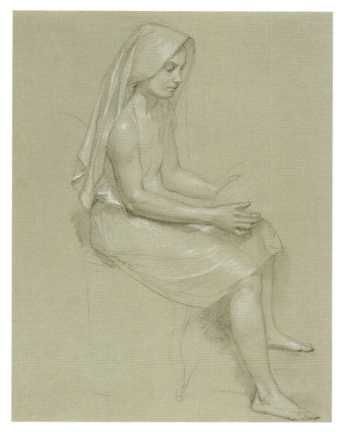

2.2
Study of a Seated Veiled Female Figure, by William Bouguereau, drawing on buff paper with white highlights.

2.3
Study for a Block House, by Frank Lloyd Wright, architect, pencil on tracing paper, 22" x 28".

- Black and white pigment on gray-toned paper suggest modeling with minimal effort.
- Combines a variety of thick and thin, light and dark lines to define edges.
- Darker lines give emphasis to inside corners, or delineate an edge away from the light source.
- Darker lines define gradually turned contours; lighter lines indicate sharper edges.
- Economical use of lines; nothing overworked.

- Darkest lines describe the silhouette of contiguous masses; lighter lines describe corners and edges within silhouetted masses.
- Lighter lines indicate receding elements.
- Shadows indicated by closely spaced lines are applied freehand.
- Outside and inside corners described by the intersection of two lines are emphasized with lines that thicken at their terminus.
- Darker lines emphasize edges away from the light source or edges in shadow.
- Closely spaced lines are lighter.
- Construction lines indicate the method of laying out the perspective; the process of creating the drawing is preserved.

Traditional Drawing Techniques

2.4
Study for an Ideal Mansion, by Robert Atkinson, architect, pencil, 17.5" × 26".

- Darkest lines emphasize the silhouette of principal masses.
- Lighter lines describe corners and edges within a silhouetted mass.
- Lighter lines indicate texture and contour.
- Incomplete shading in the roof serves as a compositional device to avoid strong geometric shapes unbalancing the composition.
- Sunlight originating from behind the viewer illuminates both the major and minor façades of the building; minimal shadows help model the architecture while preserving the drawing's planar quality.
- Freehand lines are used to indicate organic elements.

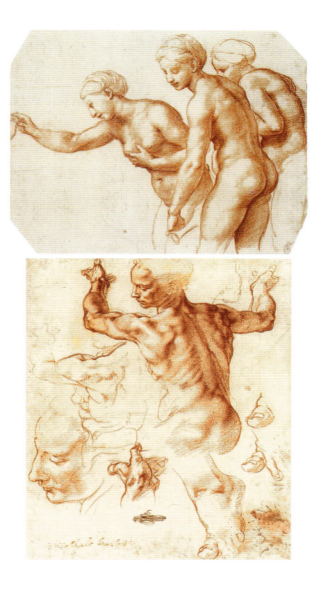

2.5
Figure studies. *Top*: Raffaello Sanzio da Urbino; *bottom*: Michelangelo Buonarroti, both red chalk on paper.

Two drawings, almost alike, created by contemporaries using the same media: red chalk.

- Lost edges: the eye completes lines that disappear.
- Shading created by closely spaced lines follows surface contours.
- Heavy lines used to define edges away from the light source.
- Sophisticated sensitivity to reflected light.
- Lines swell and diminish through the stroke.
- Darker lines define gradually turned contours found in the subject; light lines indicate sharper edges.

Traditional Drawing Techniques

Freehand Drawing

If aspiring designers develop only one skill, it should be to gain proficiency with freehand drawing. No other tool is as portable or spontaneous for conceiving and expressing ideas. My favorite drawing instrument still remains the simple wood-cased soft-lead pencil; it allows for the simultaneous creation of light and dark lines as well as thin and thick lines. The pencil allows the character of the line to be changed while it is being created, and, most importantly, it can be erased.

Exercise: Drawing a Shoe

When first starting out with freehand drawing, an ideal subject should:

- provide an opportunity for expressing forms and surfaces;
- require no prior drawing experience and generously allow for inaccuracies with proportion;
- be readily available;
- have a personal connection with the artist.

In this exercise we use one of our shoes, the older the better. It is important to draw from life as opposed to drawing from photographs. Even though experienced figure painters have been questioning the use of photography for years, many people still do not believe there is any difference between drawing from life or from photographs. As someone who has frequently resorted to drawing from photographs, I find there is a subtle but fundamental difference. It may relate to how we use our binocular vision to understand form. When we draw from 2D images, we usually don't know much about the camera that was used; our sense of depth, the horizon line, and true vertical become compromised. Drawing from life accesses our innate and superior abilities over the camera to make more accurate observations, thus improving the accuracy of what we draw. Slight movements, of our own body or of the subject (figure drawing is a good example), require us to capture fleeting memories of the subject. The process of reinterpreting reality through our minds and hands yields drawings possessing a quality that can transcend those made by copying photographs.

Step 1: one minute. Always progress from the general to the particular; first capture the overall form, and only then move on to the details. Use very faint lines to establish the general relationships. Don't worry about making mistakes; the important thing is to be fluid and work quickly. Don't hold the pencil too close to the tip; allow the wrist to aid the fingers in capturing the main gestures. Pause occasionally to observe the geometric forms described between edges and intersections. Are subject and drawing in agreement? It is a natural part of the process that as the form emerges some lines will appear misplaced. Manage the impulse to keep drawing over incorrect lines with too many additional darker lines; this will eventually yield inelegant drawings composed of bundles of thick, dark lines. If the discarded guidelines become confusing, use a kneadable eraser to lighten or eliminate them, although I actually prefer finished

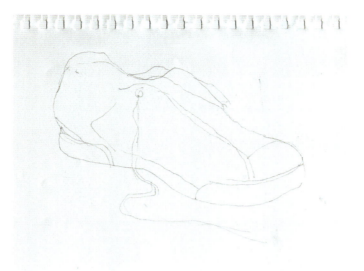

2.6
Drawing a shoe: step 1.

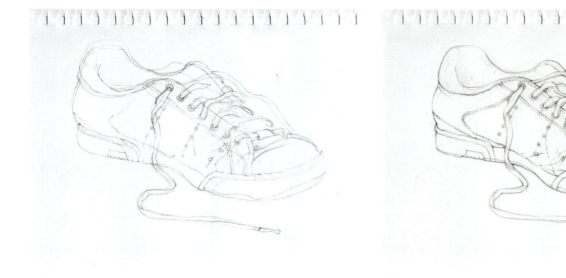

2.7
Drawing a shoe: step 2.

2.8
Drawing a shoe: step 3.

drawings that retain some of the original misplaced lines; they impart a sense of the process.

Step 2: 15 minutes. As more detail is added, some accuracy problems may become noticeable and require changing. By keeping all the lines very faint, these corrections are easily made. For clarity, this image and the previous one are reproduced here with the darkness of the lines exaggerated; in actuality they are much fainter. Employing a scanner and using *Curves* in Photoshop can dramatically change an image, in this case nearly making this faint sketch appear complete.

Traditional Drawing Techniques

Step 3: 15 minutes. I include the time here to give a sense of my own personal process. For some it might seem fast, and for others too slow. Over the years, I have learned to slow down a bit and work more methodically. Notice how a few proportion problems with the left-hand side of the shoe were fixed before a commitment was made with the final decisive dark lines. As in the drawing examples by Michelangelo and Raphael, observe how the same strategies are employed: lost edges, exaggerated silhouettes, and emphasized inside corners and intersections. All of these details contribute to successfully capturing the form and surfaces of the subject.

2.9
Student work. *Clockwise from top left:* Lisa Schumaker, Stephanie Escobar, Patrick Alles, Yukiko Inoue, Taylor Stein, Kathleen Joyce.

Exercise: Freehand Drawing Parallel Lines

"I can't draw a straight line!" – an expression you might have heard from someone who believes they do not possess even the most elementary drawing skills. Indeed, drawing straight lines is not so easy; some famous artists cannot draw a straight line either. This is a simple exercise in drawing straight lines, a skill very few ever practice but one all designers should possess. In this example five different fine-liner pens, ranging in thickness from thin to thick, were used. This exercise can also be attempted in pencil, although for some people a pen can be easier to control. However, ink lines cannot be erased.

• Begin by placing vertical freehand pencil guidelines to contain the lines. Before proceeding, take a moment to observe the guidelines and determine if they are parallel to the edges of the paper. We are usually very good at noticing inaccuracies in other people's drawings but are unable to see them in our own. If you're not sure things are correct, try turning the drawing upside down or look at it in a mirror, a trick used by artists including Leonardo da Vinci, Andrew Wyeth, and Norman Rockwell.

2.10
Freehand drawing: creating straight lines.

Traditional Drawing Techniques

- Continue by drawing a series of horizontal lines. It is actually easier to make a series of lines appear straight and parallel by allowing each individual line to slightly waver up and down a bit. Before modern printing techniques, engravers achieved light and dark values solely with a series of closely spaced lines. Close inspection reveals these lines had a warble to them – an "exaggerated wiggle" if you will – that when viewed together produced perfectly even tones.

- Duplicate the series a number of times. As you move from the top of the sheet to the bottom you may find it necessary to make some adjustments to keep the lines straight and equally spaced. This occurs because we are looking at the paper at an angle, and as we move our eyes down the sheet of paper the angle changes, affecting our sense of proportion.

- Repeat the same exercise by creating vertical lines. Some find this a little easier as the motion of drawing a line up and away from your body is more natural.

- If the first attempt is unsuccessful, keep practicing. This skill requires manual dexterity and is only acquired with practice.

Drawing the Figure

Drawing, and figure drawing in particular, was once an integral part of an adolescent's education: "drawing was seen as a critical language of industry in late nineteenth century France, as a result, drawing was part of the general education-curriculum in French Schools."[6] Even as late as the 1980s, the curriculum at the School of Architecture at the Illinois Institute of Technology required students to take four two-credit classes of life and figure drawing. We seem to have forgotten why drawing the nude figure is especially important. When drawing trees, buildings, and even clothed figures, proportional mistakes can easily go unnoticed. We are, however, genetically programmed to critically observe the human figure. Drawing the nude reveals every small inaccuracy, teaching one how to draw more accurately.

A Few Strategies for Drawing from Life

The easiest method positions the drawing surface on a vertical surface, preferably one that requires the artist to stand. Locate yourself an arm's length from the drawing surface, and recreate at the same scale on paper what is observed. This strategy allows for making visual measurements. Some artists use their thumb or pencil also at an arm's length, to compare subject and drawing. A classical drawing trick employs a weighted string or plumb bob to judge vertical alignments. Another employs a small mirror. By positioning it correctly, a reverse image of both the model and the drawing can be simultaneously observed – very useful for uncovering discrepancies.

A second strategy, useful when attempting to recreate a subject at full size, is to position the drawing surface close to the subject. Stepping back away from the drawing allows one to simultaneously compare both subject and drawing.

Often, however, because an easel is unavailable, the drawing is on our lap or a table top, making more difficult the comparison of drawing and subject. In this situation it is all the more critical that we carefully consider the relationships of the subject's forms

and contours. First, try capturing the unifying gesture of the model's pose. Observe the abstract shapes that define the position of the torso in relationship to the arms and legs. Notice how the weight of the subject is balanced and distributed, both with seated and standing figures. Do not become too concerned with shading – beginning students should first try and capture a likeness entirely with edge lines.

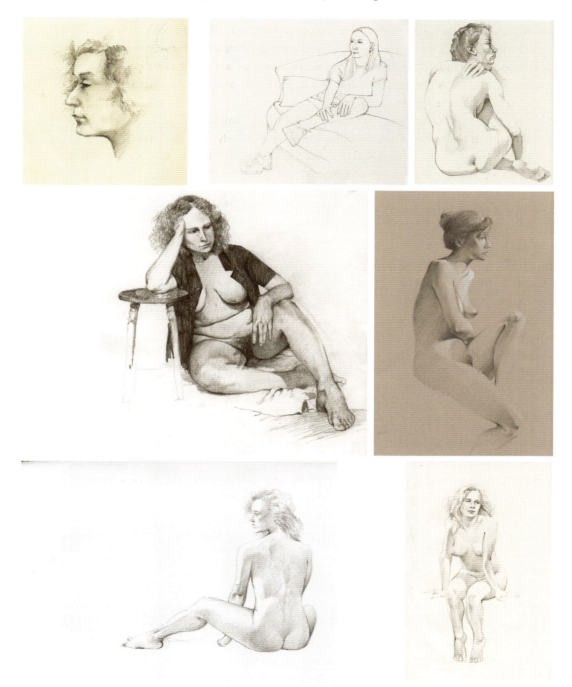

2.11
Figure drawings.

Traditional Drawing Techniques

Drawing Geometry from Life

Before attempting to draw things that don't yet exist, practice drawing things that do exist. While not always practical, it is preferable and easier to draw from life rather than from photographs. Either way, reducing the subject into geometric components is a good strategy. The first step is to sketch in the horizon line and locate the vanishing points. Remember: ***all parallel lines in perspective share the same vanishing point***. If parallel lines are also parallel to the ground plane, then the vanishing point they share is on the horizon line. If not, then the vanishing point they share is somewhere above or below the horizon line. If one of the vanishing points lies off the paper, sketch in a series of estimated guidelines that more or less radiate from the common unseen point.

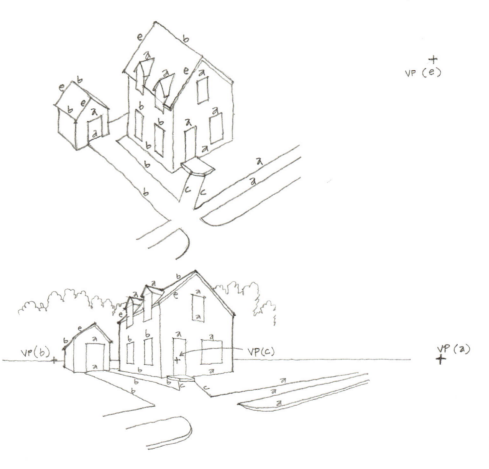

2.12
Parallel lines in an axonometric drawing and in a perspective.

It is best if the drawing is the same size as the subject that is observed. If I'm drawing from life with the sketchbook on my lap, I sometimes hold the drawing up to the observed subject to confirm the initial guidelines are placed correctly. Circles and cylinders are always easier to draw if a square describing their geometry is sketched in first.

2.13
**Reducing the subject to
geometric components.**

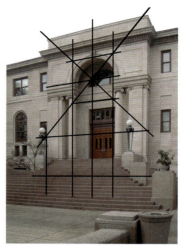

2.14
**Step-by-step development of an
observational drawing.**

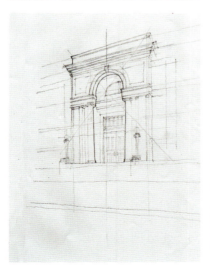

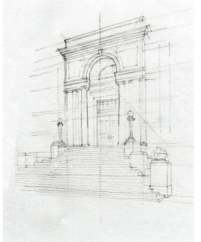
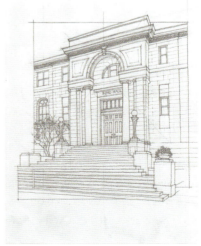

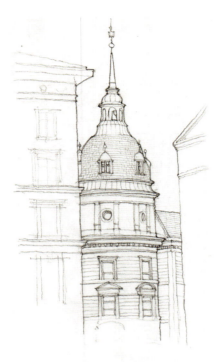

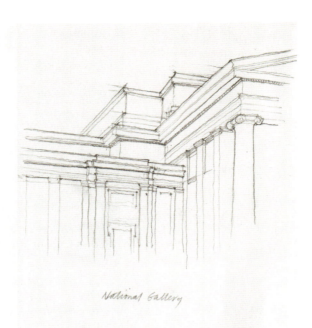

National Gallery

Vienna 10 2011

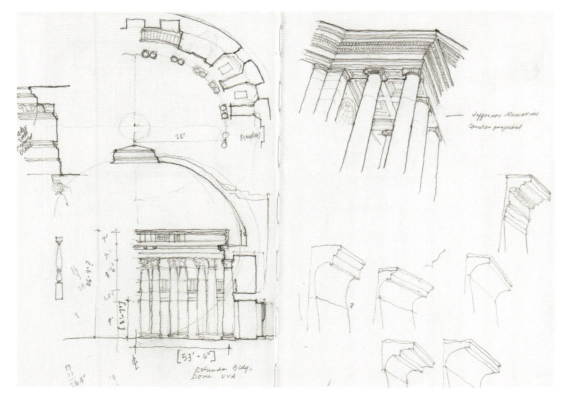

2.15
Field sketches.

Drawing with Instruments

Exercise: Drawing Equally Weighted Lines

Originally designed for architecture students at the Illinois Institute of Technology, this exercise strengthens a beginner's ability to control the consistency of pencil lines on paper.

Using the parallel rule or T-square, create seven identical lines 3/8" apart, 12" in length. Repeat this six more times, each time increasing the density and thickness of the lines, so that each series is progressively darker. Provide a 1" spacing between each series of lines, centering the composition on a 30" × 20" sheet of paper. Feel free to use a selection of pencil leads, ranging from soft to hard. As a line is created – for a right-handed person, draw from left to right – the pencil must be slowly rotated. Otherwise the lead will become chiseled as it wears down, producing an increasingly thicker line.

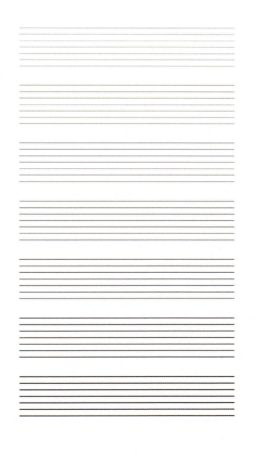

2.16
**Drawing with instruments:
developing control.**

Traditional Drawing Techniques

Creating Scaled Drawings from Field Measurements

Beginning students studying at the Ecole des Beaux Arts were required to measure existing buildings and create scaled drawings from their field observations. Thus began their education in understanding how 2D drawing relates to 3D reality, both in terms of scale as well as using graphic conventions for communicating forms and surfaces.

A challenge present-day students and even some professionals encounter with computer-aided design is managing and appreciating the scale of the elements they are drawing – how the parts relate to each other and to the whole. The ease by which digital tools facilitate zooming in and out of a drawing can disrupt a sense of continuity in the design process. The use of appropriate line weights to graphically convey a sense of depth and form when creating plans and elevations is also often mishandled. Managing line weights in a digital environment can be cumbersome and most people do not

2.17
Monticello: field measurements.

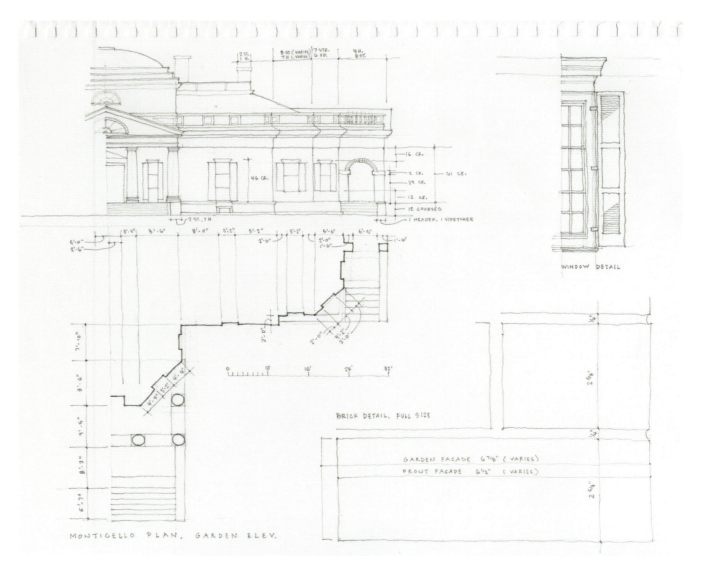

MONTICELLO PLAN, GARDEN ELEV.

give this the attention it deserves. The resulting digital 2D drawings are often not as successful as traditional 2D drawings in visually communicating 3D information.

This exercise employs Thomas Jefferson's Monticello as the subject. It is best to pick a subject close by so that return visits are possible, as it takes experience to avoid missing important information. In this case photographs served as a reference when field measurements failed to provide enough information. Counting brick courses allows dimensions of elements out of reach to be determined.

This partial elevation drawing anticipates using Photoshop to complete the rest of the façade, saving time and yielding a more accurate image.

2.18
Monticello: partial west elevation, traditional drawing made with instruments.

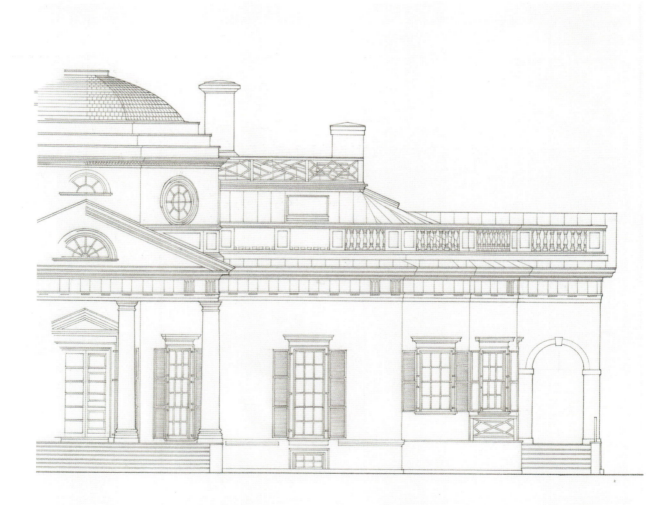

Traditional Drawing Techniques

Notes

1 As quoted by Stephens, S., "Perspective News," *Architectural Record*, 9, 2013, p. 28.

2 Pallasmaa, J., *The Thinking Hand*, John Wiley & Sons Ltd. (Chichester), 2009, p. 17.

3 Carnevale, R., "Behind the Scenes on *Ratatouille*", bbc.co.uk, in *Drawing/Thinking: Confronting an Electronic Age*, edited by Treib, M., Routledge (London and New York), 2008, p. 171.

4 Alex Lindsay, Pixelcorps, speaking at the American Society of Architectural Illustrators' 20th International Conference, Washington, DC, 2005, as quoted by the author.

5 Perez-Gomez, A. and Pelletier, L., *Architectural Representation and the Perspective Hinge*, MIT Press (Cambridge, MA), 1997, p. 8, p. 86.

6 Nesbit, M., as paraphrased by Robbins, E., *Why Architects Draw*, MIT Press (Cambridge, MA), 1994, p. 28.

3
Perspective Drawing

Human eyes see things differently than do cameras. Indeed, any 3D reality captured on a 2D surface is subject to optical laws that differ from the ones that govern human vision. For now at least, all shared visual information – printed images, television, and cinema – are conveyed with 2D media. Renaissance architects discovered methods for describing a plan and elevation of a subject as a 2D perspective. Whether one uses a camera or a computer, the rules that govern how 3D information is collected on a 2D surface are the same as those discovered during the Renaissance.

A camera with a wide-angle lens distorts visual information at the edges of images it records. For instance, a photograph taken of a group of people with a wide-angle lens will cause those individuals at the left and right sides to appear heavier than those near the center because visual information in a wide-angle view stretches horizontally at the edges as the width of the view increases. A convention for constructing perspectives on paper has been to confine the cone of vision to between 30 and 60 degrees. A view wider than 60 degrees will begin to exhibit the same distortion noticeable in wide-angle photographs.

By contrast, you can prove to yourself human vision is not as affected by wide-angle distortion. If you stand in the corner of a room with walls at 90 degrees and put your hands up to the left and right of your eyes, it will be observed that a cone of vision exceeding 90 degrees does not cause any appreciable distortion. Because humans collect visual information with stereoscopic means, and process that information with eyes and brains that have evolved to make all this work as efficiently as possible, human vision is more successful at recording undistorted wide-angle views than cameras or drawings. This is an important consideration when designing with either traditional or digital tools. The composition of an anticipated design – a plaza for instance – may be prejudiced by tools that cannot portray things as they will appear in reality to the human eye.

Two-dimensional images are described by light rays converging on a point that are intercepted or collected onto a flat plane: the film in a camera, a digital screen, or a flat piece of paper. This plane can occur anywhere between the object and the viewer; it can be the size of a postage stamp or a billboard. It can even be projected onto a plane behind the object.

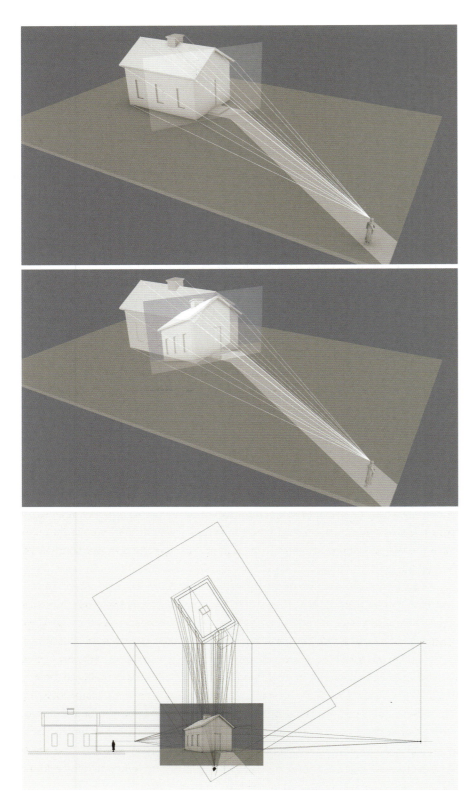

3.1
**Collecting 3D information onto a
flat plane.**

The process of constructing a complicated perspective from plans and elevations can be tedious; it is a job made much easier with digital 3D modeling applications. However, before the traditional method is entirely dismissed, there are some good reasons to learn and practice constructing perspectives manually.

Just because a computer knows how to construct a perspective doesn't mean the operator knows how to do it. Often when working either alone or with clients, a tremendously valuable skill a designer can possess is the ability to quickly draw a reasonably accurate image of a conceptual idea. Constructing perspectives with station points and measuring lines is an excellent way to better understand the rules that govern perspective when creating quick, eyeballed sketches. I also believe the practice of constructing perspectives on a 2D surface can strengthen a designer's mental ability to conceptualize 3D space.

Artists possessing virtuoso skill are often called geniuses. However, the definition of genius is beginning to change. Research indicates that any increase in an IQ above a threshold of 120 bears no correlation to predicting genius. As Steven Pinker has suggested, geniuses are wonks who have paid their dues by mastering the minutia of their fields.[1] Ability comes with practice and is not a condition at birth. Among architects, Frank Lloyd Wright is generally considered a genius. What is remarkable about Wright is his ability to create and describe spatially complicated buildings entirely with a process using drawing, unaided by models or computers. In his book *Many Masks* Brendan Gill writes:

> Sullivan and Wright possessed a gift in common that was innate and unteachable.... The rare gift I speak of was the ability to conceive plan and elevation as one, to move mentally in three dimensions through the volumes of space that a given project called for and to perceive the proportions of those volumes so directly that almost if by magic – certainly without prolonged and painful effort – plan and elevation can be set down in the two dimensions of a sheet of paper.... It was usually the case with a Sullivan design that it was translated into working drawings with few appreciable differences from his first studies on paper. Wright worked in a similar fashion, bragging that once he had a building on paper he was ready to set about furnishing it.[2]

I would disagree with the first line of this statement. Wright's prodigious output as a draughtsman is well documented and I believe the exercise of constructing so many perspectives strengthened Wright's ability to think in three dimensions. This is not an "innate and unteachable" skill, but one that can be developed. Wright professed to conceptualizing *Fallingwater* entirely in his head, a feat confirmed by Edgar Tafel.[3] The evidence is anecdotal, but other architects known for spatially complicated buildings – Le Corbusier, Louis Kahn, and Paul Rudolph, to name a few – all mastered perspective drawing, and despite their busy practices, found time to personally create these drawings.

Acquiring skills requires effort, something most people don't seem to find the time for. Yet if everyone follows the same path – because it is easy – it is likely they will all end up in the same place: creating work that is like everyone else's.

Perspective Drawing

Demonstration: Creating a Perspective: The Office Method

Step 1. Begin by locating a fixed point, called the *station point*, somewhere near the lower edge of the drawing. This point corresponds to the position of a person. A line drawn straight up from the station point corresponds to the person's *line of sight*. Position and rotate the plan of the subject, perhaps on another sheet of paper some distance away from the station point, centered on the viewer's line of sight. In this demonstration we have positioned the building so that the *cone of vision* is about 30 degrees. Moving the station point closer to the building requires a wider cone of vision. Remember: any cone of vision wider than 60 degrees will begin to exhibit noticeable distortion; elements outside the 60 degree arc will appear to stretch horizontally. The wider the cone of vision, the greater will be the distortion. Moving the station point farther away from the subject results in a smaller cone of vision; too far away and the perspective will begin to resemble photographs taken with a telephoto lens.

Step 2. Create a line that locates the *picture plane*. The placement of the picture plane is arbitrary; the size of the image will be determined by the position of the picture plane. Moving the picture plane closer to the station point will result in a smaller image; moving it farther away will result in a larger image. It is possible to locate the picture plane so that it intersects the subject, such as at a corner, or it can even be positioned behind the subject.

Step 3. Establish the *left vanishing point* and *right vanishing point* by drawing lines that are parallel to the major planes or axis of the object from the station point to the

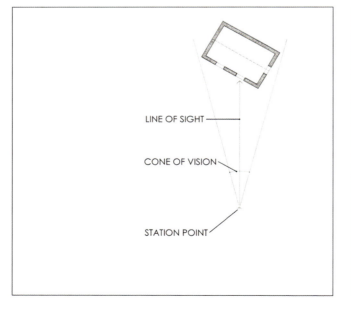

3.2
Creating a perspective: the office method. Step 1.

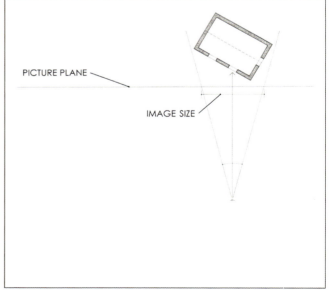

3.3
Step 2.

picture plane. Anticipate rotating the subject or adjusting the position of the picture plane so that both left and right vanishing points remain on one's desktop.

Step 4. Position an elevation, at the same scale as the plan, in an area of the drawing so that it is convenient, yet out of the way from where the perspective is to be created. This will establish the *ground plane line*. The *horizon line* is determined by whatever distance above the ground the view is desired; in this case it corresponds to normal eye level. Project down from the picture plane to the horizon line the left and right vanishing points.

The next step (A) is when things can become confusing! It is important to understand that the picture plane represents a vertical plane where accurate measurements can be made that correspond to the scale of the plan and elevation. If we had placed the picture plane so that it coincided with the corner of the building, we could have immediately begun measuring the heights of the building's components. For the purposes of this demonstration, however, we placed the picture plane in front of the building. We did this because eventually we will need to know the process for locating points behind the picture plane in future renderings when the subject is more complicated. To establish a relation between the plan and picture plane, we draw a line (A) parallel with the main axis extending from the building's corner to the picture plane. From that intersection, a vertical line extending down creates the *vertical measuring line*. It is along the vertical measuring line and the ground plane line (or *horizontal measuring line*) that we can make measurements at the same scale as our plan and elevation.

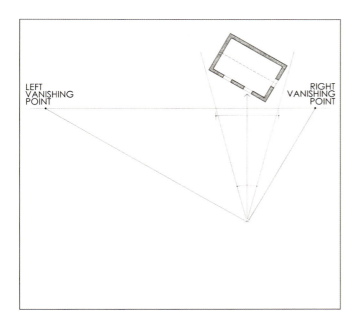

3.4
Step 3.

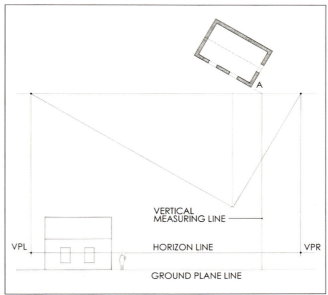

3.5
Step 4.

Step 5. Project lines from the building elevation's corners horizontally to the measuring line; at the point of intersection, project lines back to the left vanishing point.

Step 6. Project lines from the plan to the station point. At the point these lines intersect the picture plane, project lines straight down to the ground line. The intersection of these lines with the vanishing lines established in Step 5 locates the relevant corners of the building's façade.

Step 7. Repeat Step 6 to locate the edges of the roof's ridge and remaining façade. The number of guidelines required for even a simple subject will eventually become confusing. They have been included here for clarity. When constructing a perspective, it's not necessary to draw each entire guideline, but only mark and project down the points of intersection.

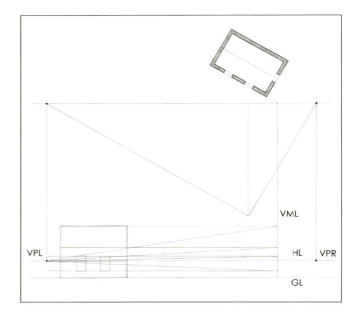

3.6
Step 5.

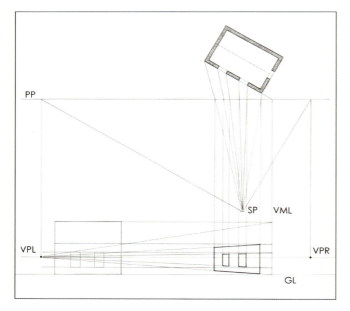

3.7
Step 6.

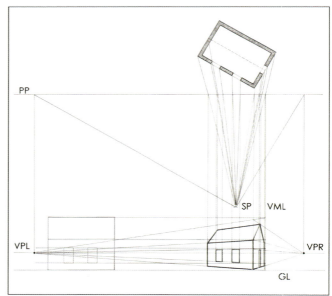

3.8
Step 7.

3.9
Layout drawing, "office method", and final illustration by Helmut Jacoby.

The layout drawing in Figure 3.9 reveals a behind-the-scenes look into the working methods of a professional illustrator using the office method. The picture plane is visible at the top of the drawing. The plan and elevation used to generate the perspective were most likely on separate sheets of paper and out of the view of this image.

Demonstration: Drawing Estimated Perspectives

"Eyeballing" refers to the practice of constructing perspectives by relying only on our sense of proportion without the aid of measuring devices. Trusting one's eyes to make accurate judgments comes with practicing drawing and comparing drawings with reality. In the previous section, the art of constructing measured perspectives is advocated as a way to see and think three-dimensionally when working in a 2D environment. Granted, a complex perspective constructed using the office method can be tedious, but the exercise gives the designer a grounding in the mechanics of laying out a perspective and developing their abilities for eyeballing perspectives. The following two freehand perspectives (Figure 3.11), each about 6" × 8", were generated from plans and elevations of the Villa Savoye (Figure 3.10), and illustrate a step-by-step approach to drawing estimated perspectives.

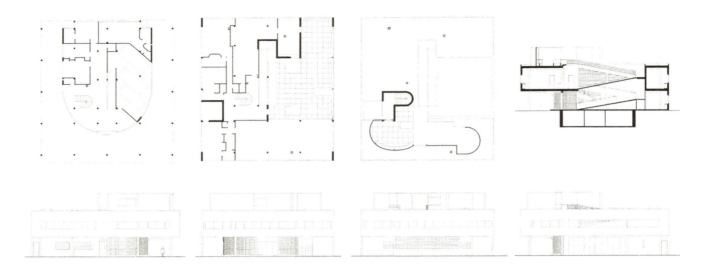

3.10
Villa Savoye: plans, section, and elevations.

Ground-level View

Step 1. We begin by first drawing the horizon line. For a ground-level view, sketch in a figure so that the figure's eyes coincide with the horizon. The size of the figure will determine the size of the perspective.

Step 2. Locate the leading corner of the building near the figure. This next step is the most challenging: lightly sketch in the elementary mass of the building. Use your best sense of proportion to determine if the sketch appears correct. Often the first attempt will be off, but we cannot make that judgment until we have a few lines down on paper. If additional attempts are required, use a kneadable eraser to keep things clear. Refer to the sketched figure to establish the heights of the main masses. Remember the first rule of perspective drawing: ***all parallel lines share the same vanishing point***. If the lines are parallel with the ground plane, then the vanishing point they share will be somewhere on the horizon line; if lines are angled with respect to the ground, then their vanishing point will either be above or below the horizon line. Locating the left and right vanishing points too close together will mimic the effect of a camera recording the view with a wide-angle lens; too far apart and the view is similar to that captured with a telephoto lens. Try creating a view close to what your eyes see.

Step 3. Add the columns at the first level. The corner columns have already been sketched in, leaving three columns per side to be located. Find the position of the middle column by placing two diagonal guidelines that connect the top and bottom of the corner columns; the intersection of these lines locates its position. Repeat this process to locate the remaining columns.

Step 4. To sketch in the rooftop elements, first try sketching a plan of those elements in the plane of the roof using the columns to help locate their position. Once the plan of the roof elements is established, extend the walls up. When drawing curves and semicircles, first draw the square that contains the circle.

Steps 5. As the fenestration on the second level is added, it becomes apparent that the first-level columns were drawn too tall and are shortened at this point.

Step 6. The vertical mullions are sketched in using the column spacing as a guide.

Step 7. An ink pen is used to reinforce the important lines; a soft-lead pencil would have also worked well. When this image is scanned, the pencil guidelines can either be preserved or eliminated using the *Curves* tool. If a computer model were to be constructed of this same view, it would probably reveal a number of inaccuracies; however, this view was constructed in a fraction of the time required to create a computer model and does a serviceable job in describing the architecture.

Second-level View

Step 1. Do not be intimidated by more complicated views. If the same steps illustrated in the first example are followed, any view, no matter what the subject or viewpoint is, can be captured in an estimated sketch. As before, we begin by drawing the horizon line, a figure for scale reference, and a leading edge of the composition.

Step 2. The diagonal elements of the ramp are sketched in after first locating their terminus points. Notice how the mid-point landing of the ramp needs to be constructed even though the roof will eventually obscure our view of it.

Step 3. The rooftop elements are sketched in by referring to the figure and width of the ramp as a guide to estimate their positions. As before, the plan of these elements is first drawn in and then the vertical lines describing their mass are extended up.

Step 4. The remaining detail is sketched in. Grids can be a little tricky. Remember that guidelines describing diagonal lines intersecting the corners in a grid will converge on shared vanishing points. Use those diagonal guidelines to help establish the grid.

Step 5. Ink lines are used to reinforce the important edges. After looking at this for a while, inaccuracies become apparent; for instance, the floor-to-floor height below the roof level is too high. But this is, after all, a quick sketch – mistakes are OK and we improve by learning from them.

1

2

3

4

5

6

7

3.11
Step-by-step estimated perspective drawings, Villa Savoye.

This exercise asked students to create perspective views from plans and elevations (Figure 3.13) of an unbuilt project by the architect Leon Krier. Some of these examples are estimated perspectives, and some represent more accurately constructed views using the office method. Color is added either with traditional watercolor technique or with Photoshop.

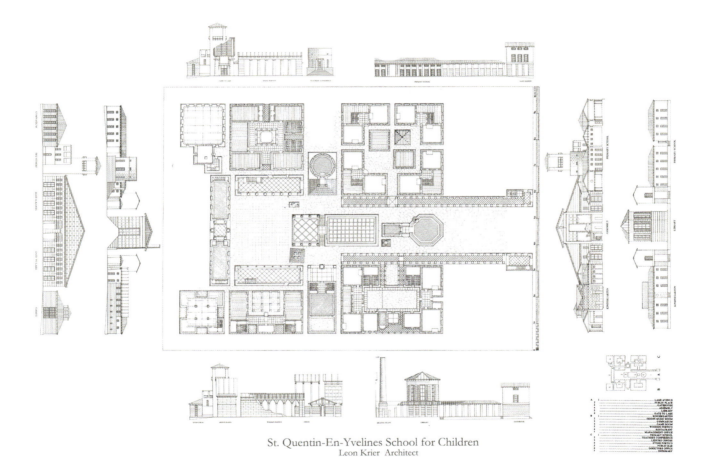

St. Quentin-En-Yvelines School for Children
Leon Krier Architect

3.12
St. Quentin-En-Yvelines School for Children, by Leon Krier, architect, plans, sections, and elevations.

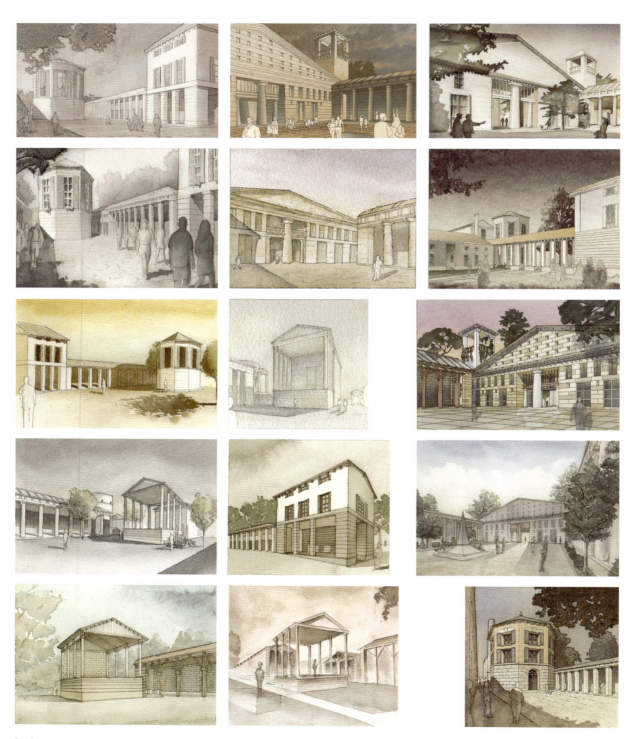

3.13
Student work. *Top row, left to right*: Geoffrey Barnes, Paul Hayes, Paige Mariucci; *second row*: Brendan Hart, David Hayes, Bill Hull; *third row*: Danny Sacco, Taylor Stein, Christopher Snyder; *fourth row*: Danny Sacco, Maria Harmon, Chris Fagan; *fifth row*: Maria Harmon, Olga Bryazka, Daniel Ostendorf.

Notes

1 Pinker, S., *How the Mind Works*, Norton (New York), 1954.
2 Gill, B., *Many Masks: A Life of Frank Lloyd Wright*, Putnam (New York), 1987, p. 81.
3 Tafel, E., *Apprentice to Genius: Years with Frank Lloyd Wright*, McGraw-Hill (New York), 1979, pp. 1–3.

4
Digital Scanning Techniques

Scanning Original Artwork

A digital scanner is the critical link between the traditional and digital environment. Not all scanners are created equal. Even the best scanners will not capture the entire range of values and colors present in an original piece of artwork, but they will come much closer than inferior ones. A scanner's fidelity becomes most apparent when scanning very light or dark colors or values. Scanners lacking the ability to differentiate between subtly nuanced values will produce scans with exaggerated contrast; light grays turn white and dark grays turn black. The same thing also happens to colors; subtle variations become one continuous color. Presently the best scanners are flatbed models. Although roller scanners can accommodate larger originals, their fidelity to nuanced color and values is not equal to what the best flatbed scanners can provide. Roller scanners also cannot handle originals created on thicker paper or board. On the other hand, the disadvantage with flatbed scanners is size. While there a few scanners presently available with larger scanning beds, most are limited to about 11" × 17" or smaller. Many illustrators now consciously work on smaller originals, in part so that they can scan their own work. With some very large originals, neither roller nor flatbed scanners are practical. The only alternative is to enlist the services of a photo studio that is equipped to photograph flat artwork. Using anything other than professional equipment will only yield unsatisfactory results.

All of the demonstrations included in this book were captured with professional 11" × 17" flatbed scanners.

Step-by-step Scanning

Scanner settings: It is beyond this book's scope to review all the different scanners available and describe how they work. Typically, every scanner will have somewhat different controls for capturing an original. To keep things simple, scan in full color, 24 bits/channels or higher, with a pixel per inch (PPI) value of 180–360 – depending upon the size of the original – saved as a TIFF file. An increased PPI does not appreciably add to a scanner's ability to differentiate subtle tonal shifts. If the scanner offers additional options, it's often wise to use the default settings, as almost all of these controls can be better managed in Photoshop. It is best to scan originals a little on the flat side, that is,

with the contrast slightly reduced. Contrast and color saturation can always be manipulated later with Photoshop. An image with too much contrast cannot be reversed. The two most commonly used formats for saving digital copies of artwork are TIFF and JPEG. These formats are the most compatible for sharing among different computers and software. JPEG files compress when saved, taking up less storage space on the hard drive and also allowing for higher-resolution files to be sent as attachments in emails. The disadvantage – and there is some disagreement concerning this – is that JPEG image files degrade as files are opened, adjusted, and closed again. TIFF files, on the other hand, do not compress when saved but also do not degrade. DPI originally referred to a printer's capability to create even tones, described as dots per inch. Many people erroneously equate a scanner's capability to capture detail with DPI, but it's more accurate to describe this as PPI, or pixels per inch. The combination of describing an image in both inches and pixels per inch indicates the resolution of a file. It can be a mistake to scan an original with too high a PPI value as this may create an image file too large to be easily managed with a computer, and can contain more detail than will ever be required.

Before placing the artwork on the scanner, make sure the scanning surface – either the roller or the flatbed glass surface – is as clean as possible. It can be challenging to place the artwork so that it is perfectly parallel with the edges of the scanner's window. Don't worry if it's slightly skewed; alignment problems can be corrected in Photoshop. If the original exceeds the size of a flat-bed scanner's window, multiple overlapping copies must be generated.

Most flatbed scanners have a hinged cover. It's best to use a scanner that allows the cover to be disengaged when working with large originals. There are two good reasons to keep a bright, white piece of cardboard or thick paper handy to separate the artwork from the underside of the cover. Sometimes the cover can become marred or dirty, which can project through drawings made on semi-transparent paper. Another reason is that a few manufacturers provide scanner covers with the underside colored black. If multiple scans of an oversize original are required, it is possible the black surface may show up in some scans and not in others, causing the automatic exposure feature to record each scan quite differently, making the process of stitching them together difficult.

Once the image is scanned, save all copies to an appropriate folder. In this demonstration, the original artwork is about 18" square, exceeding the 11" × 17" window of the flatbed scanner, thus requiring four separate scans.

The final step requires stitching the separate scans together. More recent versions of Photoshop provide a method to allow this to happen automatically. Go to *File > Automate > Photomerge*. Use the *Browse* feature and simultaneously select all the files to be merged by clicking them while holding down the CTRL key. Tap the OK button and the four scans are seamlessly stitched together.

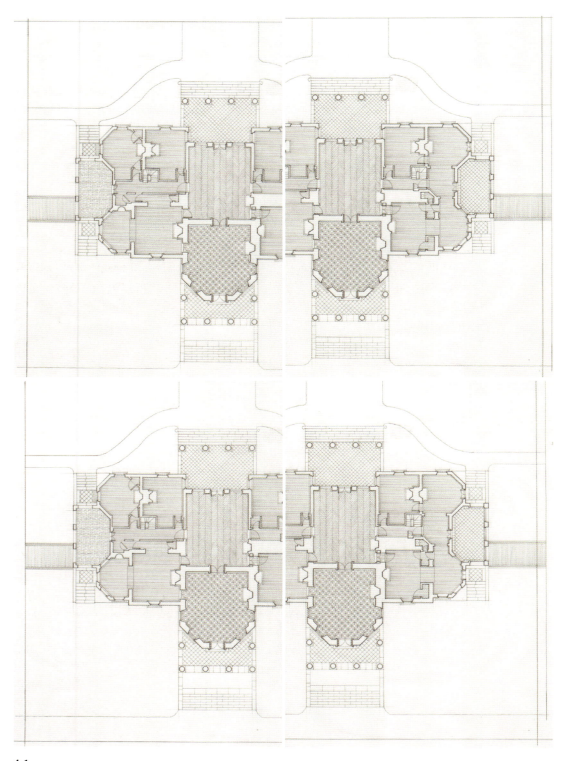

4.1
Four overlapping scans of the original drawing.

4.2
***Photomerge* dialogue box**.

Most likely the image is still slightly crooked with respect to the edge of the screen. To align it correctly, activate the *Measure* tool, found underneath the *Eyedropper* tool. Select one long, continuous horizontal element in the original. Position the cursor at the left-hand side of the beginning of the element, and while holding down the left mouse button, stretch a new temporary line to coincide with the right-hand most part of the element. Release the mouse button, and observe the new temporary line created.

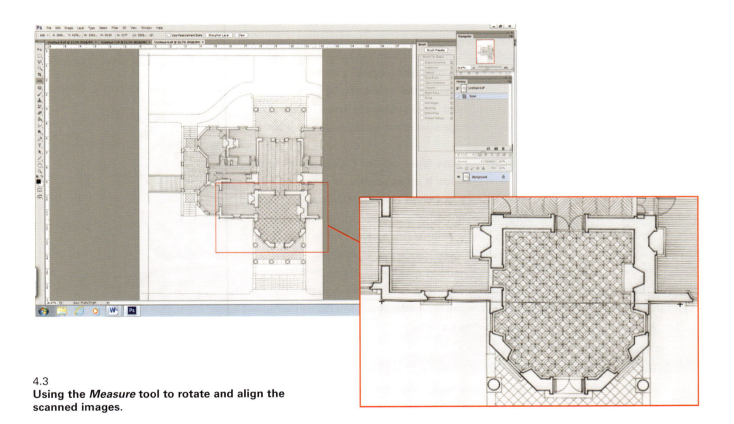

4.3
Using the *Measure* tool to rotate and align the scanned images.

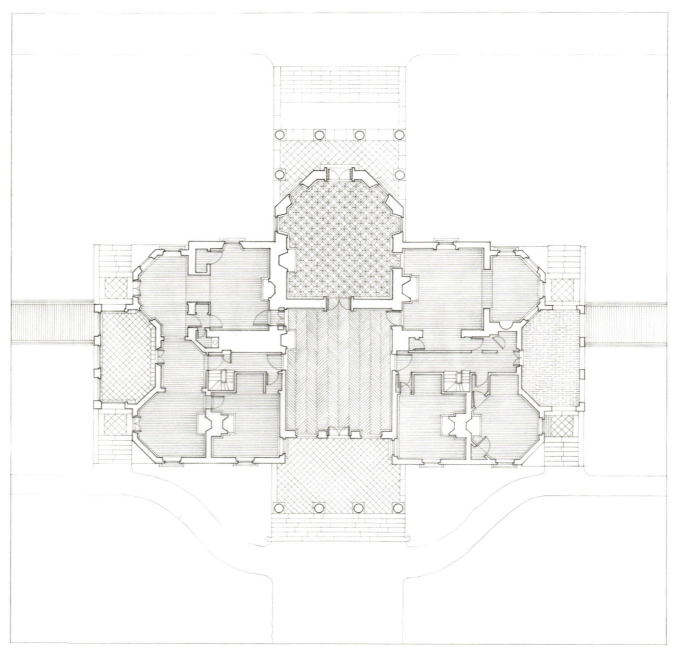

4.5
Final image.

5
Digital Coloring

The materials of art have their own logic.

(Bruce Cole)[1]

Precedents for Applying Color Digitally

The art of creating images has significantly changed with the advent of digital techniques. Many illustrators working today – even those with traditional training – have abandoned traditional techniques in favor of using computers. Reasons for preferring digital techniques are numerous: computers can make the process more efficient, neater, and portable. But in my opinion one of the most compelling reasons is the ease by which computers make changes possible. Using Photoshop's *Layers* and *History* features removes much of the stress that is involved in a technique such as watercolor, where a momentary lapse in judgment can have disastrous results that cannot be taken back. As with all new techniques, the first generation of artists using them is quick to explore what is possible. Some digital artists have mimicked traditional techniques in oil paint and watercolor with remarkable facility, although such expertise requires practiced skill and is beyond what most designers require for their work. We will touch on some of these advanced techniques later, but our immediate purpose is to present an efficient and effective process for adding color and texture to a traditionally made line drawing, while at the same time moving beyond the predictably similar results most people using digital techniques typically achieve.

The process about to be described may require a mental shift of sorts by the Western reader accustomed to seeing more realistic images. The precedent for this approach began hundreds of years ago and continues to inform print and graphic art created today. In the late nineteenth century, Japan was opened to trade with the West. Almost immediately some architects and artists began adapting a new style in their work, similar to that of Japanese woodblock prints – Michel de Klerk, Otto Wagner, Jules Guerin, and Frank Lloyd Wright to name a few. In Wright's case, his first-hand exposure to Japanese aesthetics not only influenced his illustrations but, arguably, his conception of space as well.

Digital Coloring

Color woodblock prints place certain demands on the artist. Each different color must be applied by hand, or sometimes requires the paper to be run through the press multiple times. This additional effort pressures the artist to minimize the number of different colors and use them effectively. Color must also be isolated in defined areas, and can only be applied in one of two ways: either as a solid color or as a color that changes in a linear way, from one edge to the other. Photoshop offers tools that mimic the technique of the Japanese artists, making it possible to create similar work in much less time and with less experience. As is often the case with different techniques, constraints inform the work and, in the case of woodblock, can give the work a strong graphic quality.

5.1
Picture of Kambara, by Toyokuni Utagawa.

A restrained palette heightens the sense of winter (Figure 5.1). Limited areas of brighter color become an important compositional element.

5.2
Flower Performance, by
Kunichika Toyohara.

Although the print in Figure 5.2 contains more color than the example shown in Figure 5.1, the manner of the application – either as solid colors or gradient colors – remains consistent. The 2D quality of the art as a work on paper is reinforced by how patterns in the figure's clothing are abstractly flattened, remaining independent of the contours of the folds of the fabric.

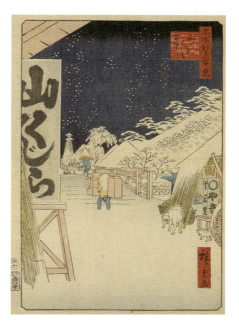

5.3
Bikuni Bridge in Snow, by
Hiroshige Ando.

Examine the sky of Figure 5.3 and notice how the grain of the wood becomes part of the artwork.

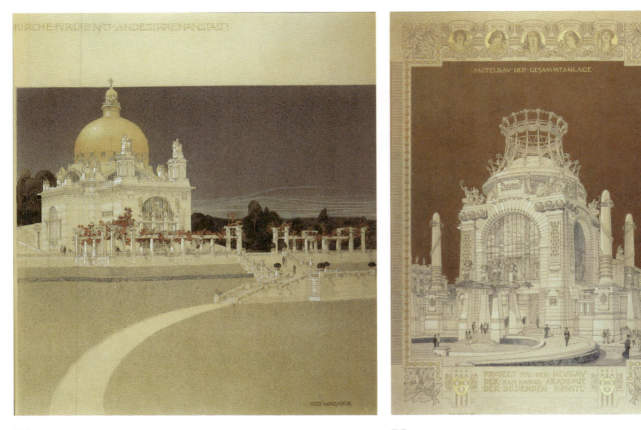

5.4
***St. Leopold's Church at Steinhof: Perspective**, by Otto Wagner.*

5.5
***Academy of Fine Arts: Ceremonial Entrance Hall**, by Otto Wagner.*

Figures 5.4 and 5.5, by Otto Wagner's office, share many similarities with Japanese prints. In the image of St. Leopold's Church at Steinhof, the 2D surface of the paper is emphasized in a number of ways: the spire of the church pushes through the top border of the image, the foreground plane is abstracted to a simple positive/negative graphic, the "clouds" are also abstracted as curvilinear lines, the image is resolved by solid fields of color with almost no modeling, and the application of splattered color requiring some sort of masking recalls the process of creating the image. The second image is remarkable for its restrained palette and the integration of borders and lettering, again referencing print-making techniques.

In the left-hand image in Figure 5.6, texture – rather than color – provides visual clues for framing and emphasizing the architecture. The right-hand image, devoid of color, depends almost entirely upon lines describing edges and employs a few subtle tones to organize and clarify elements in the composition.

A restrained palette strengthens the graphic quality of the image in Figure 5.7. The brightest color – which is still quite muted – is applied to a limited area, emphasizing the entrance. Notice how the shape of the flags is repeated in the scarf of the woman in the foreground.

5.6
Left: *The Second Villa Wagner,
Preliminary Design; right*:
Ferdinandsbruke, by Otto
Wagner.

5.7
*The Trade Exhibition Hall
(second project), Perspective,* by
Otto Wagner.

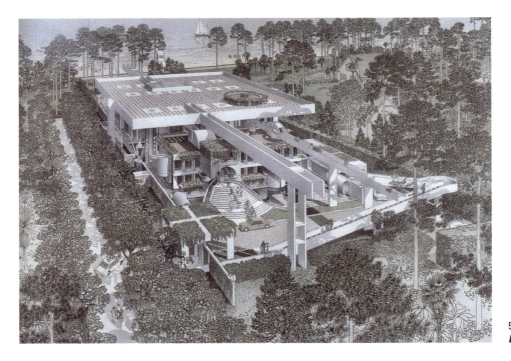

5.8
Entelechy II, by Helmut Jacoby.

Figure 5.8 is by Helmut Jacoby, an architect and illustrator who enjoyed a prolific career creating renderings for some of the most prestigious offices around the world. His work can be seen as a bridge between the techniques advocated here using Photoshop and those of the work of Wagner and the Japanese printmakers. His technique first requires a detailed ink line drawing to be created on an illustration board. Once the drawing is complete, airbrushing and frisket paper masks are employed to apply tone. Many of Jacoby's illustrations are executed entirely in varying shades of diluted black ink, but just as often very subdued colors are used. A limited color palette has a number of advantages:

- For many it can yield better work; a full color palette requires much more experience and effort to successfully control.
- Working with no color or minimal color allows one to concentrate on value relationships.
- An application of subtle tone emphasizes the line work rather than diminishes it.
- Images are elegant in their restraint.

The technique described in the demonstrations on coloring plans and elevations (Chapter 6) shares the same constraints facing the woodblock printmakers and Jacoby. Before adding color to a line drawing, the designer must first determine where color is to be applied and how many colors are needed. Each color will require something called a mask that isolates color to defined areas. A mask can work in two ways: it can either expose the area within its borders to receiving color, or it can block the area within its

borders from receiving color. If creating masks appears daunting, Photoshop includes a tool called the *Paint Bucket* that makes the task much easier by allowing defined areas to be instantly filled in with a color. This tool has revolutionized the making of comic books and graphic novels. As with the woodblock print, applying color digitally works best when creating solid blocks of color or areas of color that change in a linear way: either from light to dark or one hue to another. A simple image may only require one mask, while a complicated perspective will require many more. The time available and the nature of the image will determine what is appropriate. As with woodblock print-making, it is always possible to add some detail with hand-applied brushwork; in a digital environment, a stylus tablet and digital brush are required.

Photoshop Basics

Photoshop is arguably the single most important software developed for artists and photographers. It has evolved through numerous releases and has been thoroughly described by a host of publications and internet sites. The purpose of this book is not to provide a definitive guide to using Photoshop, but rather to serve as an introduction – to keep things simple and allow a beginner to immediately become productive. As skills are developed, more detailed sources can be consulted.

At first glance the screen can appear intimidating. Don't worry; for the exercises in this book, we don't need to know everything. The following is an abbreviated guide to Photoshop's screen interface. A list of the most essential tools and a brief description of their functions is included. Later, specific exercises demonstrate how they are used.

5.9
Screen setup.

Digital Coloring

Screen Setup: this is a screen shot of my preferred working environment. I've settled on this through many hours of using Photoshop and have been encouraged to show it here by discovering it is also the preference of other users I have encountered. Preferences for which dialogue boxes are open or closed can be accessed through *Window*, located in the top command bar.

| Ps | File | Edit | Image | Layer | Type | Select | Filter | 3D | View | Window | Help |

5.10
Command bar.

File

New	
Name: Untitled-1	OK
Preset: Custom ▼	Cancel
Size: ▼	Save Preset...
Width: 18 Inches ▼	Delete Preset...
Height: 12 Inches ▼	
Resolution: 360 Pixels/Inch ▼	
Color Mode: RGB Color ▼ 8 bit ▼	
Background Contents: White ▼	Image Size:
☽ Advanced	80.1M

5.11
Image file window.

- *New*: Create a new image file; the dialogue box should be set to indicate the size of the desired image in inches. This, in combination with the image resolution, describes the file's size. An image 10" × 10" with a resolution of 50 pixels per inch yields a 732 K file size. This is the same size as an image 5" × 5" with a resolution of 100 pixels per inch. Bigger is not always better; often a file size of 20 MB is quite suitable. It is unusual for a file above 100 MB to be necessary or useful. A large file slows down the computer, and when layers are employed, risks creating files that become unmanageable.
- *Browse, Find*: to locate and open an existing file.
- *Save, Save As*: to save a new or changed file, or to save a file with a different name or in a different format, such as JPEG or TIFF. Refer to Chapter 4 on digital scanning techniques.
- *Page Setup, Print*: to create hard copy.

Edit

- *Cut*, *Copy*, *Paste*: works similar to word-processing applications.
- *Free Transform*, *Transform*: for manipulating the overall proportions or orientation of the image; *Scale*, *Skew*, *Distort*, *Warp*, and *Perspective* are all very useful.

Image

- *Mode*: *Grayscale* to be used for black-and-white images; *RGB* is most typically used for color images in Photoshop; *CYMK* is a color profile often required for professional printing.
- *Adjustments*: *Curves*: a very useful tool for adjusting the relative contrast and color intensity of an image – it is more precise than *Levels* or *Brightness/Contrast*. The best way to understand *Curves* is to experiment with it. Try placing the cursor at the center of the diagonal line and, while holding down the left mouse button, moving the cursor diagonally up or down. Observe how the mid-range tones become lighter or darker without affecting the very lightest or darkest tones. To increase contrast, try moving the points at the opposite edges of the graph, either singly or in tandem, horizontally toward the center. To decrease contrast move the same points vertically away from the corners. *Color Balance*: useful for subtle color adjustments. *Hue/Saturation*: used to reduce or manipulate color saturation and hue.
- *Duplicate*: for creating a copy of an image.
- *Image Size*: adjusting the image size is accomplished by changing either the size in inches, the resolution, or both. Digital images are composed of individual squares or pixels of tone or color. Changing the size of the image effectively adds or subtracts pixels, asking Photoshop to sample the existing pixels and create new ones that average out the old ones. This is more precisely controlled by selecting *Nearest Neighbor*, *Bilinear*, or *Bicubic*. Try downsizing an image containing text and observe how things change.
- *Canvas Size*: for adding onto or subtracting image area. When added, the new area will assume the color of the lower color-picker chip.
- *Rotate*: self-explanatory.

Layer

- *New*, *Duplicate*: think of layers as a stack of images on a checkerboard tabletop, all perfectly aligned, some possibly filling up the entire area with visual information, others only partially filled and the remainder left clear (indicated by observing the checkerboard pattern). When adding a new layer, it is possible to assign it a color, make it clear, or duplicate an existing layer. Layers are useful for collaging images together, isolating specific areas for adjustments, and creating masks; see more about using *Layers* in the book's exercises.

Digital Coloring

Select

- *All, Deselect, Reselect, Inverse*: selecting only part of an image for adjustments is often useful. More on how to create selections will follow with *Color Range* and *Tools*.
- *Color Range*: often it is desirable to select only a single color or tone for adjustments. Use the *Eyedropper* tool to select a single color in the image (see more in *Tools*); the pop-up dialogue box includes a slider and preview window for adjusting how aggressively colors close to what has been picked will also be selected – to the left less aggressive, to the right more aggressive. Earlier versions of Photoshop require selecting color with the *Eyedropper* tool before opening the dialogue box, while recent versions require using the tool after opening the dialogue box.

Filter

Photoshop includes numerous applications for modifying the appearance of an image. These can be used singly or sequentially. A few favorites:

- *Artistic*:
 - *Poster Edge*: useful for transforming a continuously toned image into one described by edge lines; it works better than *Find Edges*. See the demonstration *Advanced Photoshop techniques* (p. 127).
 - *Watercolor*: depending upon the subject and size of the image, this filter can yield pleasing effects.
- *Blur*. *Gaussian Blur*: allows for the greatest control when blurring. *Smart Blur*: can yield painterly effects.
- *Noise*: *Add Noise*: useful for certain textural effects.
- *Sharpen*: when used judiciously, can make a low-resolution image appear to contain more detail.
- *Stylize*: *Diffuse*: softens edges, useful for adjusting hard edge lines to appear as if drawn with pencil.
- *Other*:
 - *Maximum*: useful for reducing the thickness of lines or achieving special effects.
 - *Minimum*: useful for increasing the thickness of lines or increasing the extent of a mask.

View

- *Extras*: shows guidelines. To create a guideline, either vertical or horizontal, activate the *Move* tool and place it over the ruler bar, hold down the left mouse button and pull the guideline into position. Multiple guidelines can be employed at one time. To eliminate guidelines, either put them back with the same method used to introduce them, or go to *View* and uncheck *Extras*.
- *Rulers*: displays a vertical and horizontal ruler.

Window

This controls which palettes (dialogue boxes) are open (checked) or closed. My preference is to have the following open:

- *Tools*
- *Navigator*: a quick way to zoom in and out; it also indicates what part of the image is shown on the screen.
- *History*: lists actions taken in sequential order and allows one to go back to an earlier point; 25 actions is the default maximum, though this can be increased via the program *Preferences*.
- *Layers*: shows all the layers and their order from top to bottom, the top-most layer obscuring the one below; layers can be turned on or off, made partially transparent, activated, deactivated, hidden, reordered, deleted, and merged with other layers.
- *Status Bar*: indicates the enlargement percentage of the image appearing on the screen and the current or active file's size.

Tools

5.12
Tool bar.

The tool bar represents a portion of Photoshop's tools; additional tools are hidden below the tools visible here and can be accessed by clicking and holding on the tool currently visible. Since this is a introductory guide, some tools will not be covered.

5.13
Select **tools.**

Select Tools: these tools are useful for precisely selecting geometric areas in an image.

Digital Coloring

5.14
Move tool.

Move Tool: for moving a selected area, or to reposition an entire layer.

5.15
Lasso tools.

Lasso Tools: for selecting parts of an image with an irregular shape. The *Lasso* tool creates a continuous freeform outline by holding down the left mouse button. The outline will complete a closed shape at whatever point the left mouse button is released. The *Polygonal Lasso* tool creates an outline composed of straight segments controlled by left mouse clicks. As the *Lasso* tool approaches a point close to where the outline was begun, a small circle will appear next to the tool, indicating that one additional mouse click will close the shape. Both tools can instantly assume the characteristics of the other during the creation of an outline by pressing or holding down the Alt key.

5.16
Lasso tool modifiers, *from left*, single, cumulative, subtract, difference.

Select and *Lasso Tool Modifiers*: these are to be used in conjunction with these tools:

- single: allows only one outline at a time to be created;
- cumulative: preserves each previous outline as new ones are created;
- subtract: useful for removing parts of a previously selected area;
- difference: preserves only the intersecting area of two selections.

5.17
Magic Wand tool and dialogue box.

Magic Wand: useful for selecting a contiguous area; use in conjunction with the dialogue box that controls how aggressively tones or colors similar to the color sampled with the *Eye Dropper* are also included. A value of 0 is least aggressive; 255, the highest value allowed, is the most aggressive.

5.18
Crop tool.

Crop Tool: for trimming the edges of the image.

5.19
Brush **and** *Pencil* **tools.**

Brush and Pencil Tools: somewhat similar to their traditional counterparts, these tools allow tone and color to be applied to an image with a large variety of effects. While it is possible to use these tools with a mouse, drawing in a digital environment is made much easier with a stylus and pressure-sensitive tablet.

5.20
Brush **and** *Pencil* **tool dialogue box.**

5.21
Brush **size and shape window.**

To adjust the size of the brush, click on the black square immediately to the right of the word *Brush*, in the palette near the top of the screen. A dialogue box will appear. Moving the slider left to right increases the size of the brush; this can also be accomplished by using the keyboard – press [to decrease the brush size and] to increase it. The opacity and flow can also be controlled; often it is useful to reduce one or both of these to 10 percent or less. Multiple brush applications using a reduced opacity will progressively become more opaque as they overlap.

Digital Coloring

To change the shape of the brush tip, click the two small >> just to the right of where the pixel size of the brush is indicated. This dialogue box offers multiple choices for an array of brushes. While round and square brushes are very useful, a variety of specialty brushes are also available. If those are not enough, a number of websites offer instructions for making your own.

Additional ways to adjust the characteristics of a brush are accessed by using the *Brush* modifier window.

5.22
Brush presets manager box.

5.23
Brush modifier window.

Click the square symbol immediately to the left of *File Browser*. Again, the purpose of this section is only to provide an introduction to Photoshop; using one or more of these modifiers is rather advanced, but a few of the upcoming exercises will refer back to this option.

5.24
***Clone Stamp* tool.**

Clone Stamp Tool: useful for replacing one area of the image with another area. Activate the *Clone Stamp* tool and position it over the area to serve as the original. Press the Alt key and the cursor changes to a target. Click the left mouse button to lock the target, release the mouse button and move the cursor to the area to be replaced. Hold down the left mouse button to begin cloning in the new area. This tool works in a way similar to the *Brush* tool; the size of the brush, as well as the opacity and flow, can also be adjusted.

5.25
***Eraser* tool.**

Eraser Tool: works much like the *Brush* tool in that the size and opacity of the eraser can be adjusted. The eraser eliminates whatever is on the active layer. When working on the original layer or background layer, the eraser will reveal whatever color is currently indicated as the background color in the *Color Picker*. If the background layer is turned off or has been deleted, the eraser will then reveal a checkerboard pattern of white and gray squares indicating the area is now clear.

5.26
***Gradient* and *Paint Bucket* tools.**

Gradient and *Paint Bucket Tools*: these two tools are useful for quickly filling in large areas of color.

5.27
***Gradient* dialogue box.**

Beginners to Photoshop often have trouble with the *Gradient* tool as the default setting applies a gradient from full color to white. I only use the *Gradient* tool in one way: to simulate how an airbrush works; from full color to clear. To set this function as the default, access the *Gradient Editor* window by clicking in the small rectangular field immediately below the words *Image* and *Layer* in the command bar.

5.28
***Gradient Editor* window.**

Choose the second square from the upper left corner, indicating a tone changing from opaque to clear, or *Foreground to Transparent*. The smoothness and rate of falloff can also be adjusted. To the right of the rectangle from where we brought up the *Gradient Editor* window are five small rectangles indicating different ways to apply tone with the *Gradient* tool, as well as indicating which tool is active. I only use three of these tools:

5.29
***Gradient* dialogue box, *Linear Gradient* selected.**

- *Linear Gradient*: applies color as a continuous field from opaque to clear. Move the cursor to a desired location in the image and, while holding down the left mouse button, extend a line away from that point. The path and length of line describe the zone where color is to be applied. Releasing the mouse button completes the application of the color. Note that the opacity of gradients does not need to be applied at 100 percent. Multiple applications at a reduced opacity, even as low as 5 percent, can yield effective results. The opacity can be adjusted in the window just to the left of the five different gradient parameters.

5.30
Gradient dialogue box, *Radiant Gradient* selected.

• *Radial Gradient*: applies color as a circular field, with maximum density at the center progressing to clear at the outer edge.

5.31
Gradient dialogue box, *Radiant Gradient* selected.

• *Reflected Gradient*: creates a gradient that changes from clear to opaque and back to clear again; it is useful for shading cylindrical elements.

5.32
Paint Bucket tool.

Paint Bucket Tool: instantly fills in any contiguous area defined by a perimeter – either by a line or another area of tone or color. The tolerance controls how aggressively the applied color fills into areas that are marginally defined by a boundary; values of 0 to 255 indicate least aggressive to most aggressive settings.

5.33
Blur, Sharpen, and Smudge tools.

Blur Tool: similar to the *Paint Brush* tool in that the size and strength of the application is adjustable; very useful for softening the edges of collaged elements.

Sharpen Tool: similar to the *Blur* tool in function, but yielding the opposite result; useful for simulating detail in a low-resolution image.

Smudge Tool: when used with an appropriate size and strength, blurs or softens various elements of an image such as parts of clouds, human complexions, or can be used for obtaining more unusual effects – remember finger painting?

5.34
Dodge, Burn, and Sponge tools.

Dodge Tool: useful for lightening an area of an image; the tool's size, precise range, and exposure (or strength) are adjustable.

Burn Tool: useful for darkening an area of the image.

Sponge Tool: either desaturates or, conversely, intensifies the color of an area of the image; tool size, flow, and strength are adjustable.

Digital Coloring

T	Horizontal Type Tool	T
↓T	Vertical Type Tool	T
T	Horizontal Type Mask Tool	T
↓T	Vertical Type Mask Tool	T

5.35
Type tool.

Type Tool: adds text to the image. Font type, size, and color are adjustable. The new layer containing the lettering must be rasterized before additional manipulations are possible. This is accomplished by merging the layer onto another layer, or by right-clicking the newly created text layer in the *Layers* window and selecting *Rasterize Layer*. A slight blurring of the edges of the letters will occur. Rasterized images are best for photographs or shaded drawings, while vector-based images are preferable for line art illustrations and print font faces. All illustrations in this book are rasterized.

	Rectangle Tool	U
	Rounded Rectangle Tool	U
	Ellipse Tool	U
	Polygon Tool	U
/	Line Tool	U
	Custom Shape Tool	U

5.36
Shape tools, *Line* tool, and *Custom Shape* tool.

Rectangle, *Rounded Rectangle*, *Ellipse*, and *Polygon Tools*: similar to the *Marquee* tools, except that the foreground color indicated in the Color-picker will instantly fill the shape created.

 Line Tool: creates straight or angled lines. To create vertical or horizontal lines, hold down the Shift key. The width of the line expressed in pixels, and the color, are adjustable. Similar to the *Type* tool, the lines created must be rasterized before additional manipulations are possible.

 Custom Shape Tool: includes a selection of symbols, such as directional arrows, that can be placed and sized with this tool.

	Eyedropper Tool	I
	3D Material Eyedropper Tool	I
	Color Sampler Tool	I
	Ruler Tool	I
	Note Tool	I
1₂3	Count Tool	I

5.37
Eyedropper, *Color Sampler*, and *Ruler* tools.

Eyedropper Tool: samples and selects the color in an image. It can be adjusted to select a single pixel (point sample) or a 3 × 3, 5 × 5, or higher pixel average. The color selected appears as the foreground color in the *Color Picker*.

 Color Sampler Tool: locates and marks a number of points, expressing them as numerical equivalents; it is useful for making precise comparisons between different areas in an image.

Ruler Tool: position the cursor at a point in the image and, while holding down the left mouse button, extend a line to another point in the image. Releasing the mouse button creates a line numerically described in the top information panel. This tool is useful for measuring distances and for rotating images so that they precisely align with the borders of the image. For more information, see Chapter 4.

5.38
Hand tool.

Hand Tool: moves the image while zoomed in.

5.39
Zoom tool.

5.40
Color indicator.

Colour indicator: the top color or foreground color is the active color and indicates the color that will be applied with the *Brush* or *Gradient* tool. It also indicates the color selected with the *Eyedropper* tool. If the active layer is the background layer, the bottom color indicates the color that will replace an erased area. It is also a handy place to store an alternate color for use with the *Brush* or *Gradient* tools. To flip the foreground and background colors, click either the lower left black-and-white rectangles, or the upper right arrows. To change the foreground color, click the foreground box and the *Color Picker* window appears.

5.41
Color Picker window.

Digital Coloring

All the possible tonal variations of this particular shade of blue are represented in Figure 5.41. The upper left corner corresponds to pure white; the lower left corner corresponds to pure black. The upper right corner represents the purest, most vivid form of this color, while the lower right corner, although appearing nearly black, is an equal mix of this color with black. A small circle observable in the field indicates the color presently reflected in the foreground *Color Picker*, and is also numerically represented in the window. The selection can be changed by left-clicking to another point in the field. Color or hue can be changed by placing the cursor over the opposing triangles along the vertical color hue bar and, while holding down the left mouse button, sliding the triangles up or down.

Note

1 Cole, B., *The Renaissance Artist at Work: From Pisano to Titian*, Harper & Row (New York), 1983, p. 57.

6
Hybrid Coloring Techniques

When applying color, there are a number of advantages Photoshop offers over traditional media:

- It is fast: color can be added to large areas in seconds.
- The image appears finished at every step. If only a limited amount of time is available to add just one or two tones, an image with color will still be better at graphically communicating information than one with no color. On the other hand, an image can be further enhanced as time allows.
- Areas of color can be isolated on different layers that can be adjusted independently: turned on or off, made semi-transparent, or manipulated with Photoshop's other tools and filters.
- Photoshop has something called *History*, which allows one to change one's mind and go back to an earlier point in the process if things go wrong.
- At any point in the process, the image file can be saved before proceeding with additional changes. I find it is most useful to include the current date in the file name when creating and saving alternate versions.
- Even after the image is completed, it is often an easy matter to continue to make changes as a design or illustration evolves.

Demonstration: Adding Color to a Plan

After opening a file, verify that the image is in color and has the correct parameters. Go to *Image > Mode* and make sure RGB color and 16 bits per channel or more are checked. If you later discover that one or more of Photoshop's filters will not operate, try reducing to 8 bits per channel, although this change will also slightly reduce the range of colors. This demonstration uses a scan of a traditionally made drawing. If a CAD-generated drawing is preferred, be sure that any vector-based image is rasterized – that is, save the file in a JPEG or TIFF format. CAD-generated images can be further manipulated to appear hand-made by using two procedures: try *Filter > Stylize > Diffuse*, or *Filter > Noise > Add Noise*, and then *Filter > Blur > Gaussian Blur*.

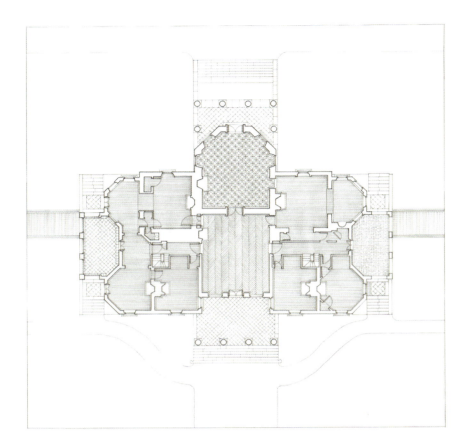

6.1
Line drawing of plan.

6.2
Resizing the image.

Next, you may want to resize the image. If you continue at this point with an image that has a size exceeding 20–40 MB, your computer may have trouble completing the coloring process. The file size appears in the lower left-hand corner of the screen. As layers are added in Photoshop, a second number appears, indicating the new size, reflecting the added information. The more layers added, the larger this second number becomes. Adding new layers to a large image may eventually overwhelm the capabilities of a computer, causing it to slow down or freeze. A message indicating that the scratch disk is full means the hard drive Photoshop uses as its short-term memory is insufficient to proceed further. A secondary hard drive can be assigned as the scratch disk via *Preferences*.

For this demonstration, the image will be resized to about 30 MB. Go to *Image > Size* and a dialogue box appears. We only want to change the file size or resolution, not the original size described in inches. The image is presently identified by the *Pixel Dimensions* at the top of the dialogue box as 53.4 M. To reduce the file size, change the resolution from 360 to 280 pixels per inch and the *Pixel Dimensions* now indicates a size of 32.3 MB. If the resized image is inspected more closely, the line work will appear a little less defined – jagged edges defining curves will be more pronounced. However, it is important to remember how the image will ultimately be used. For reproductions in 11″ × 17″ brochures, or PowerPoint presentations, a 32 MB file will have more than enough resolution. As a test, open up the *Ruler* bar, go to *View > Rulers*, and observe that our original 12″ × 12″ image can be enlarged to over four times its original size – 24″ × 24″ – before we begin to notice degradation in the image.

Now is a good point to save the image with a different name, thus preserving the original line drawing as a separate file.

Before proceeding further, we notice a change that needs to be made to the plan: the path at the north does not engage the steps but runs by them. Two methods are available to make the change. One employs the *Clone Stamp* tool. Refer to Chapter 5 for more detailed information on using tools.

6.3
Making changes with the *Clone Stamp* tool.

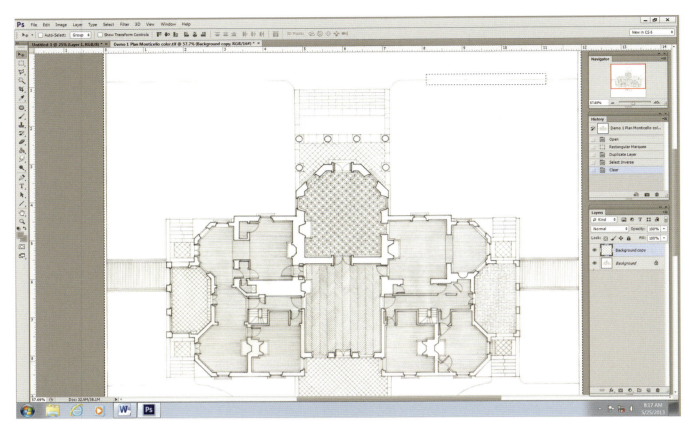

6.4
Isolating an area of a duplicate layer for making changes.

A second method involves duplicating the entire image and isolating a particular area that can then be repositioned. Go to *Layer > Duplicate Layer*. A dialogue box appears, suggesting a name for the new layer; change the name if you like, and then click OK. Turn off all other layers except the one currently in use. Use the *Rectangular Marquee* tool to isolate a section of the line as indicated. The dashed lines around the area will slightly move – sometimes called the "dancing ants" – indicating the area is active. Since we want to preserve only the selected area, go to *Select > Inverse* and the entire area outside of the rectangle is now selected. Tap Delete on the keyboard and go to *Select > Deselect*. Observe in the *Layers* window that most of the image in the background copy layer has been replaced by a checkerboard grid. Think of each layer as a piece of clear plastic that is either completely or partially covered by an image. The checkerboard is the table top beneath all the layers. Seeing it indicates the area is clear and there is no image present on any layer currently activated. Clicking the eye on the background layer – turning it on and off – confirms the original selected area remains.

Activate the *Move* tool to reposition the selected area as required; in this case, the *Clone Stamp* tool was needed to clean up some small areas at the foot of the steps. Once the image is correct, activate the new layer, go to *Layer > Merge Down*, and combine the two layers.

6.5
Introducing a color field.

Hybrid Coloring Techniques

There are a number of ways to introduce color. In this case, we will access a file of previously prepared color fields. A textured tone created with a watercolor technique will complement the hand-made nature of the original drawing. Open the desired file and resize it so that the new image size is slightly larger than the plan image. Next, pull or disengage the file from the bar at the top of the image and drag it down into the working field of the Photoshop screen by using the *Move* tool while holding down the left mouse button.

6.6
Adjusting the opacity of the color field.

Once the watercolor field is floating over the top of the plan image, use the *Move* tool again to drag it over into the plan image. Put the watercolor field back into the organizing bar at the top or simply close it, being careful not to save it with any new changes, and switch to the plan image. Position the watercolor field so that it completely covers the plan. There are two methods to get the line drawing to become visible. One is to change the attribute of the new layer from *Normal* to *Multiply*. This works well as long as the opacity of this layer is never adjusted, as this will corrupt the image. The other method is to adjust the transparency of the watercolor field by using the opacity slider in the *Layers* palette – try 45 percent. This demonstration follows the latter option.

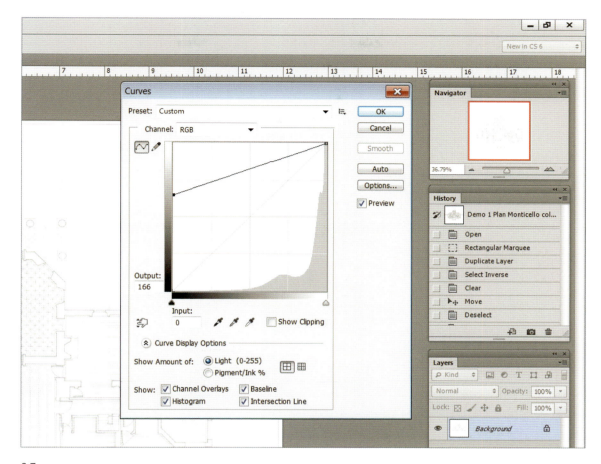

6.7
Adjusting the contrast of the color field with *Curves*.

If the texture of the watercolor field disappears as the layer's opacity is adjusted, adding more contrast can bring it back. Go to *Image > Adjustment > Curves*, slide the bottom left-hand corner target to the right, and slide the upper right-hand corner target to the left while holding down the left mouse button. Observe the results. At this point if no more time is available, the image could be presented as finished. In this demonstration we will continue on. Each successive step will incrementally enhance the image's communicative qualities; it's just a matter of how much time is available. *I strongly recommend containing all color on just one layer*. It is often prudent to make adjustments or additions on a separate new layer, but then that adjustment layer should be immediately merged with the primary color layer. Having too many color layers can be difficult to manage and can lead to technical problems that are frustrating to sort out. If you have trouble committing to a color, don't forget that the masks can always be reactivated to affect additional changes.

6.8
Creating a mask for the walls.

Coloring an image with Photoshop is similar to using an airbrush: one or more masks are created that correspond to areas to be either colored or shielded from color applied to an adjacent area. The first step is to create some masks. In this demonstration, we will employ four different colors requiring three masks (the fourth color is the base color). First, turn off the watercolor layer by going to the *Layers* window and clicking the eye next to the layer. The eye disappears in the dialogue box and the layer disappears on the screen. To create the first mask, go to *Layer > Duplicate Layer*. The reason for this next step will soon be apparent. With the new layer selected, go to *Image > Adjustments > Curves*.

Position the cursor over the target at the corner of the diagonal line that corresponds to the darkest range, and while holding down the left mouse button, move the end of the diagonal straight up or down. (Different versions of Photoshop can reverse the light and dark values in *Curves*, so you have to pay attention to which is correct for you.) This action has the effect of lightening all the darkest tones to a fairly light gray. Click OK.

With one of the new layers activated, engage the *Paint Bucket* tool. Try beginning by setting the tolerance to 25. The tolerance level controls how aggressively color will fill between lines or areas of tone. The small triangle to the top left of the *Paint Bucket* icon is the point of application. Position the tool and use the left mouse button to apply the color. When filling in areas to create a mask, always use an absolute black. We use black because later, when selecting areas defined by masks, the process can sometimes leave behind a slight residue of color along the edges of the mask. Black yields a faint gray that usually harmonizes – or can more easily be manipulated to harmonize – with the existing line work in the original base drawing. To create the first mask, we proceed to fill in all the solid walls using the *Paint Bucket* tool. It's important to have good drafting technique. If the lines in the original drawing are inconsistent or do not meet at corners, the color applied with the *Paint Bucket* will bleed through, and some remedial drafting may be required. Alternatively, reducing the tolerance level of the *Paint Bucket* tool possibly avoids the bleeding problem, but risks the undesired consequence of not filling the black tone all the way to the edge of the lines. A remedial technique to expand the black field will be covered shortly.

6.9
Isolating the black poche.

 This mask should only contain the areas that are solid black and nothing else. To eliminate the rest of the image, first check that the foreground color chip in the tool bar is absolute black. Next, go to *Select > Color Range*. Newer versions of Photoshop may require selecting the foreground color after accessing the *Select* dialogue box. Set the fuzziness slider in the dialogue box to about the mid-point to control how aggressively an absolute black is selected: to the left, only black is selected; to the right, black and additional dark gray tones that are close to black are also selected. In this case, we want to select as much of the black and near-black tones as possible without selecting any of the light gray lines in the rest of the plan. The dancing ants appear again; go to *Select > Inverse* and press the Delete key on the keyboard. Newer versions of Photoshop may require selecting a color in a pop-up menu to replace the area deleted. If for some reason the background area does not disappear, the *Eraser* tool can also be employed, but first make sure that the layers below the active layer are not turned on, fooling you into thinking nothing has happened.

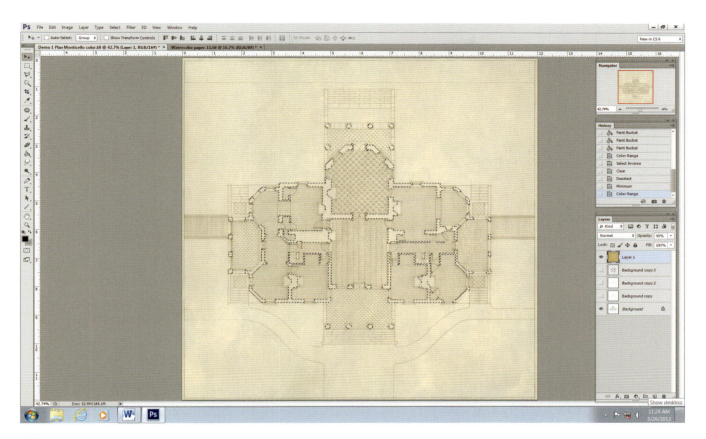

6.10
Selecting the wall poche on the color layer.

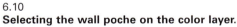

Once the black areas are isolated, a method to manipulate the mask so that it fills in between the base image lines more aggressively is to go to *Filter > Other > Minimum*. The dialogue box facilitates expanding the image outward by one-pixel increments. In this case, one pixel appears adequate. This technique is particularly effective with masks generated from more sketch-type drawings that have smudges, erased areas, or numerous guidelines. Next, go to *Select > Color Range* and this time set the fuzziness slider all the way to the right. With the black walls now selected, switch to the *Layers* dialogue box. Turn off the mask layer, turn on the watercolor layer and the original line drawing layer, and activate the watercolor layer.

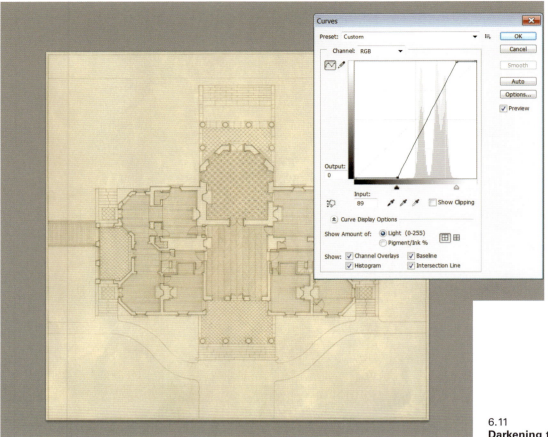

6.11
Darkening the wall poche.

With only the areas describing walls now selected, observe the dancing ants. Again, make sure the watercolor layer is active. We have two options to color the walls and will try each of them in sequence:

1 Go to *Image > Adjustment > Curves* and reposition the targets as indicated to darken the walls. If at some point the dancing ants become distracting, they can be turned off while still allowing the area to remain selected by holding down the CTRL key and tapping the H key. Just remember to turn the dancing ants back on or deselect the area before proceeding to another task.

2 Another technique to darken the walls requires creating a new layer and adding color with the *Brush* tool; this is sometimes quite effective since the original watercolor layer is only at 45 percent opacity and limits how dark the tone can be adjusted when only using *Curves*. In this instance the color is applied not at 100 percent opacity, but at about 40 percent. When applying semi-transparent color, it is important to pick from the edges of the color selector, where the color contains no white or black, so that the color tints with maximum saturation, allowing the original texture of the watercolor layer to be preserved.

6.12
Making adjustments to the wall poche.

If the color becomes too uniform and is no longer sympathetic with the color layer's texture, there is a method to reintroduce texture: go to *Filter > Noise > Add Noise*.

The application of the noise filter may cause the area to appear unsympathetic with the rest of the image. For a further adjustment, go to *Filter > Blur > Gaussian Blur*. Finally, the opacity of this layer can be adjusted slightly if required.

It's best to minimize the number of layers at all times, keeping the file size small and the computer more responsive. With the new color layer still activated, go to *Layer > Merge Down* and the active layer immediately becomes one with the layer below.

Hybrid Coloring Techniques

6.13
Making a mask for the lawn areas.

Next, we create a mask for the areas of grass by repeating the steps taken to create the mask for the walls.

6.14
Introducing a second color field for the lawn areas.

To add the grass, select the areas in black on the corresponding mask layer, turn off the mask layer, and turn on and activate the watercolor layer. Go to *Image > Adjustment > Color Balance*, and use the sliders to change the color to green. This technique, however, does not always achieve what is desired, as the *Color Balance* option produces limited results. Another method to adjust the color of the grass areas requires selecting a new (green) watercolor field from our files as we did previously with the base watercolor field. Open the field in Photoshop, and with both the composite image and the new color field disengaged from the organizing bar at the top of the screen, use the *Move* tool to pull the selected mask over from the composite image to the new color field.

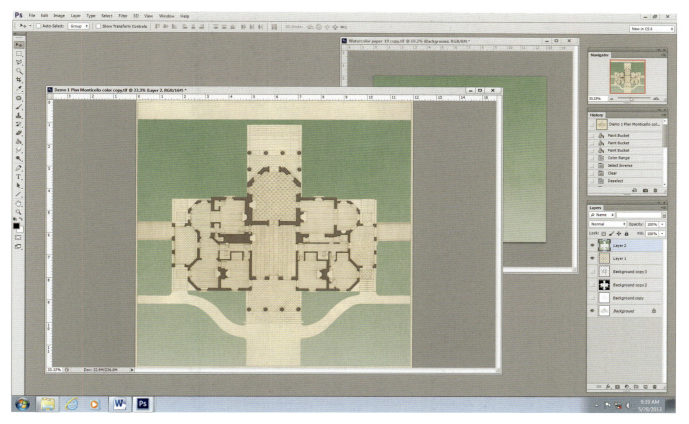

6.15
Positioning the lawn area layer.

Position the mask layer appropriately. Turn off the watercolor layer and reselect the black areas on the mask layer, turn off the mask layer, and turn on and activate the watercolor layer. Use the *Move* tool to now pull the selected area of the watercolor field back into the original composite image and position as required.

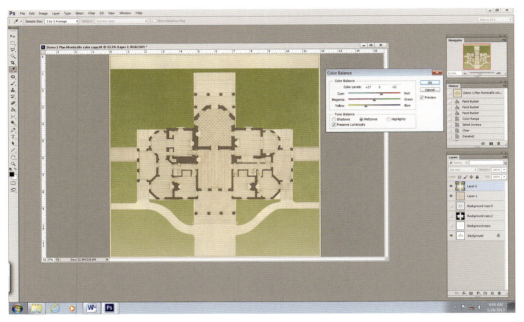

6.16
**Making color adjustments
to the lawn area layer.**

Once the new color field is in place, it will probably need a few adjustments to harmonize with the rest of the image. Try the following techniques either separately or in combination. As before, go to *Image > Adjustments > Color Balance* and use the sliders to modify the color.

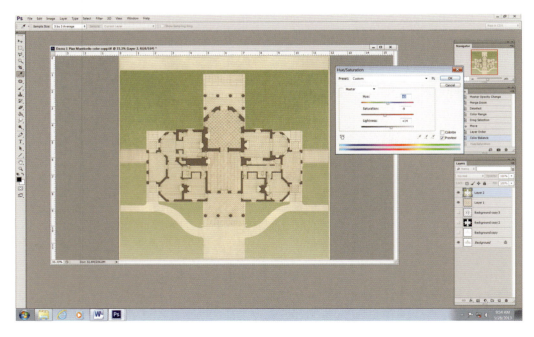

6.17
**Making color saturation
adjustments.**

Go to *Image > Adjustments > Hue Saturation* and use the sliders to make further refinements.

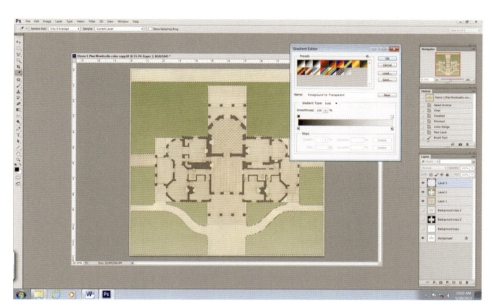

6.18
Setting preferences for the
Gradient **tool**.

The *Gradient* tools are sometimes useful to modulate the color further. First, create a new blank layer. Next, use the mask to isolate the grass areas. When using the *Gradient* tools, be sure the *Gradient Editor* is set to "from *Foreground* to *Transparent*". This is accomplished by either pressing the small triangle just below the word *Image* in the controls bar, or by double-clicking the checkerboard field in the same area to bring up the dialogue box, offering further controls.

Hybrid Coloring Techniques

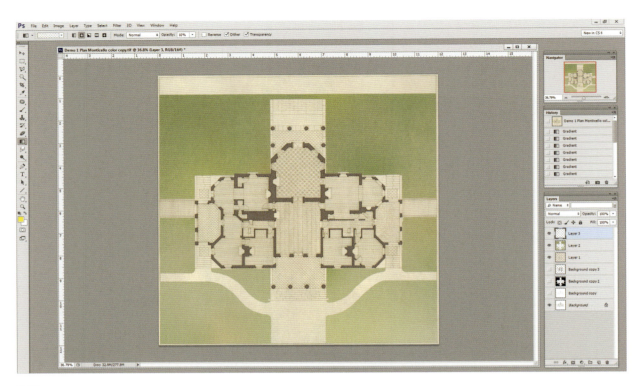

6.19
Applying additional color with the *Gradient* tool.

Try applying one or more colors with the *Radial Gradient* tool set to 10 percent opacity, allowing color to be built up incrementally.

One final mask is required to lighten and differentiate the enclosed interior spaces from the exterior. Creating this mask is a little more difficult. Since the floors are patterned, we cannot use the *Paint Bucket* tool. A time-consuming method could employ the *Lasso* tools to select the appropriate areas one room at a time. However, the mask layer for the walls presents an opportunity to create the mask for the interior spaces more quickly. First, duplicate the mask layer for the walls and turn off all other layers except for the base line layer. Activate the *Line* tool and set the weight to 3 PX. Go around the building adding black lines on the duplicate mask layer for the walls, tracing the window frames that separate inside from outside. Holding down the Shift key on the keyboard ensures that lines remain horizontal or vertical. In this case, a number of lines are on a diagonal and will have to be "eyeballed" in. Once this is complete, turn off the base line layer and select the black areas on the mask layer. Go to *Select > Inverse* and use the *Paint Bucket* tool to fill in the interior spaces with black. Go to *Select > Inverse* again and tap the Delete key on the keyboard. We now have our third mask to be used to lighten the value of all interior areas. With the area still selected, turn off the layer mask and turn on and activate the color layer. Go to *Image > Adjustments > Curves* to make the final adjustments.

6.20
**Using a new mask
to lighten the
interior spaces.**

Once again, a little housekeeping is in order. While we want to preserve the mask layers for any additional refinements, the different layers describing color can be collapsed into one. To do this efficiently, either activate the topmost color layer and go to *Layer > Merge Down* and repeat, or turn off all layers except for those with color and go to *Layer > Merge Visible*.

6.21
**Reestablishing the
line drawing.**

Hybrid Coloring Techniques

A few additional subtle refinements are possible. The first involves the original line drawing. During the process of adding color, the original lines faded slightly. Usually delicate line work adds to the subtlety of the image, but if the lines become too light, they can be strengthened. Make a copy of the original line drawing base layer and relocate it to the top of the layer stack by dragging it up with the mouse. Next, select the white areas of the image. Some trial and error may be required so that neither too much nor too little of the adjacent gray and black tones describing the lines is also selected. In this case, the slider is set to about the mid-point. Delete the white areas. You may observe a slight light-gray halo lingering around some of the edges of the lines. Go to *Image > Adjustments > Curves*. Place the cursor over the corner target corresponding to the lightest values and pull it straight up or down (this can be reversed depending on your version of Photoshop). Reposition the middle target back to the center. This technique will effectively darken all the light-gray areas adjacent to the edges of the lines without making the lines themselves appear too dark. If the color of the lines requires adjustment, go to *Image > Adjustments > Color Balance*.

6.22
Introducing a third color field for additional texture.

Another refinement introduces an additional texture layer to tie the image together. Open a new file with a sympathetic color and a pronounced texture – such as one with watercolor applied to a rough-surfaced paper using pigments that yield pronounced granulation – and as earlier in this demonstration, resize it as required and pull it over into the composite image. Position the image, reduce the opacity, and adjust with *Curves* as required.

6.23
Using a vector mask as an eraser.

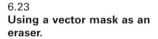

With the new layer still activated, click the *Add Vector Mask* icon and note that a new adjustment icon has been added.

Activate the *Radial Gradient* tool, set it to 20 percent opacity, set the top color chip to pure black, and begin applying a gradient to the center of the image. This incrementally erases parts of the layer where preserving detail in important areas of the layers below is desirable. Once the image is satisfactory, right-click on the white icon on the texture layer, and click *Add Layer Mask*. The icon disappears and adjustments to the texture layer are now complete. *Curves* is then used to fine-tune the contrast of the new layer. This layer can then be merged with the primary color layer.

Once the image is complete, it is wise to preserve it with the mask layers intact, which is potentially useful if, when attempting to print the image, specific areas need adjustment. After the image is saved but before the image is closed, go to *Image > Duplicate* and flatten the layers of the new copied image. Sometimes applying *Curves* at this point, with all the layers now combined, further improves contrast and color relationships. A final decision is made to go back to the previous image with all the layers intact, and brighten up the solid walls. Since so much of the image is green, changing the walls to a contrasting color is a good strategy to get the walls to stand out. Isolating them with the mask, and employing *Color Adjustment*, is one method to adjust the color.

Hybrid Coloring Techniques

As sometimes happens, new information requires changes once the image is completed. In this example, a portion of one of the porches was discovered to be grass. Isolating the area with the *Lasso* tool and then using the *Clone Stamp* tool allowed the change to be made in a few minutes.

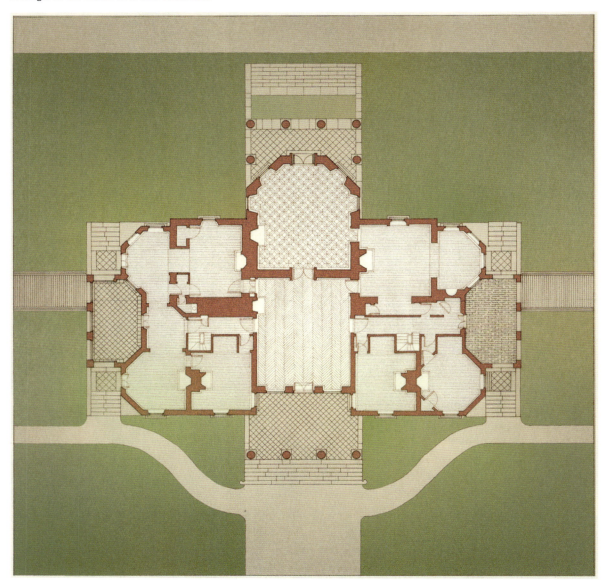

6.24
The finished plan.

Remember, the computer is only a tool; artistic insight is essential to the process. This demonstration may seem difficult at first, but once the steps involved become familiar, this illustration and similar ones can be completed in a fraction of the time required using traditional techniques.

Demonstration: Adding Color to an Elevation

Many of the steps presented here duplicate techniques in the previous demonstration and the text is abbreviated accordingly.

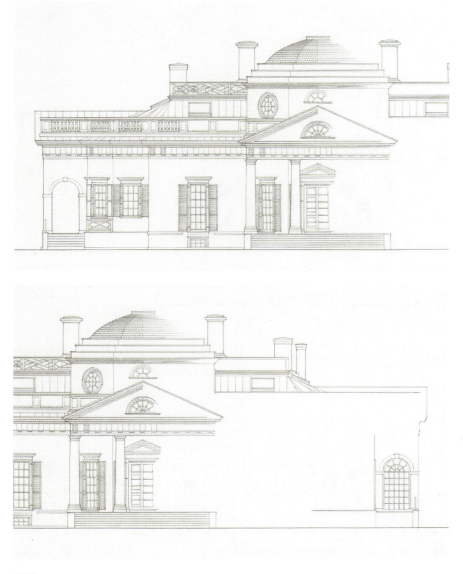

6.25
Two partial scans of the original drawing.

The original line drawing is too large to fit on an 11″ × 17″ scanner and requires two different overlapping scans. Notice that neither piece creates a complete elevation of the building. Since the subject building is nearly symmetrical and parts of it are repetitive, we anticipate using Photoshop to complete the line drawing elevation, saving time and improving accuracy.

Hybrid Coloring Techniques

6.26
Partial scans stitched together.

Stitch the images together.

6.27
Isolating an area of a duplicate layer for cloning the balustrade.

Duplicate the background layer: *Layer > Duplicate*. Use the *Rectangular Marquee* tool to select part of the balustrade and reposition it to the right. Holding down the Shift key ensures the image only moves horizontally. Go to *Edit > Transform > Scale* to adjust the width if necessary. Repeat as required.

6.28
Repositioning the duplicated area and flattening the layers.

Flatten the layers: *Layers > Flatten Image.*

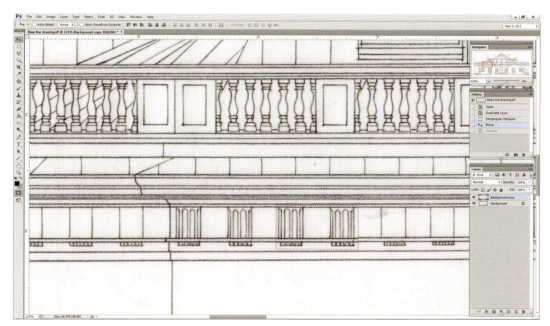

6.29
Cloning the triglyphs.

Repeat the same process to duplicate the triglyphs: duplicate the background layer, activate the new copy layer, select the triglyphs with the *Rectangular Marquee* tool, and move them into position. Go to *Select > Inverse*, tap the Delete key, *Select > Deselect*, *Layer > Duplicate Layer*, and move the new selected area into position. Go to *Layer > Merge Down*. Now there are four triglyphs on one layer. Go to *Layer > Duplicate Layer* and reposition again. Repeat this process to duplicate the remaining triglyphs.

Hybrid Coloring Techniques

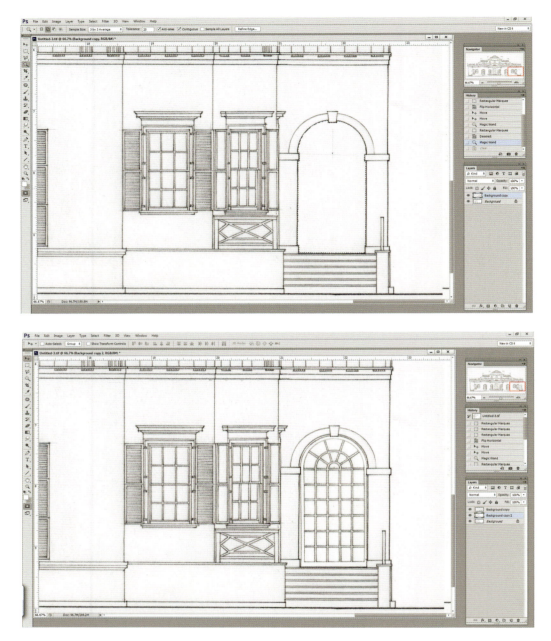

6.30
A duplicate layer mirrored with further adjustments.

Flatten all the layers. Duplicate the background layer: *Layer > Duplicate Layer*. Use the *Rectangular Marquee* tool to select the exact left half of the elevation. Go to *Edit > Transform > Flip Horizontal* and use the *Move* tool to reposition the reversed half of the elevation into place.

The elevation is not quite symmetrical; the far-left portico is glazed while the right side is open. Use the *Magic Wand* with the tolerance set to 25, click the area to be selected, and tap the Delete key. If the window frame on the background layer does not exactly line up, duplicate the background layer and reposition it as required.

Go to *Layers > Flatten Image*. The centerline where the two halves are joined may require a little touch-up work with the *Clone Stamp* tool. Save the file, but before closing it, duplicate the image, reduce the pixel size to about 30 MB, and save the new file as the base image for further coloring.

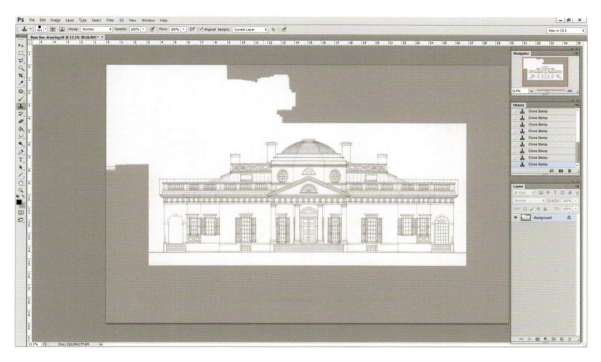

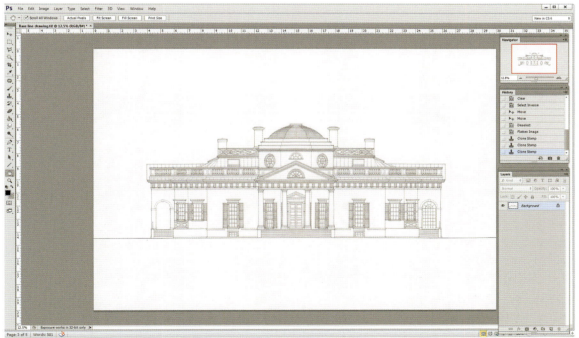

6.31
Expanding the image field.

Hybrid Coloring Techniques

The elevation requires a larger field around it than what was originally scanned, as we anticipate adding a sky and trees. Go to *Image > Canvas Size* and add about six inches all the way around the image. Since the white areas of the elevation are actually a light gray with a subtle texture, use the *Clone Stamp* tool to fill in around the image (see Figure 6.31).

6.32
Introducing a color field.

Select a color field. Open it in Photoshop and resize it as required. Pull it over into the line drawing and adjust the transparency and contrast with *Curves*.

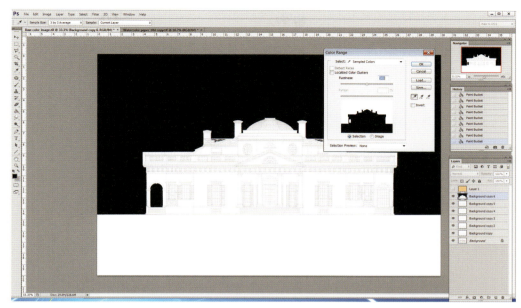

6.33
Creating a mask for the sky.

Seven colors are anticipated that will require six masks. Turn off the color layer, activate the background layer, and go to *Layer > Duplicate Layer*. Adjust the duplicate layer with *Curves*, lightening all the lines, and duplicate this layer five more times. Use the *Paint Bucket* tool to fill in the sky with black, making sure to also fill in any interior areas that reveal the sky behind them.

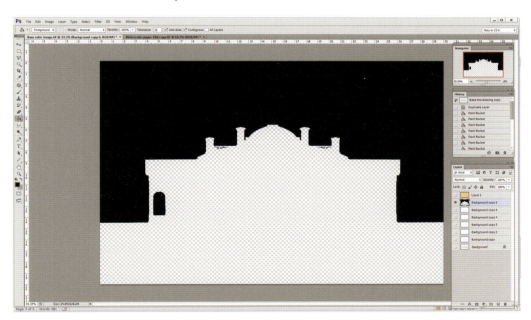

6.34
Eliminating the line drawing from the mask.

With black selected as the top color chip, go to *Select > Color Range* and adjust the fuzziness slider to a value of 100. Go to *Select > Inverse* and tap the Delete key. Go to *Select > Deselect* and turn off all other layers to verify only the mask remains.

Hybrid Coloring Techniques

6.35
Creating four more masks.

100

Repeat the previous steps to create masks for the areas of brick, shutters, roof areas, and window panes.

6.36
Creating a mask for the shadows.

Those inexperienced using Photoshop may find it challenging to create a mask for the shadows. Remember, it is an additive process. Refer to the section on tools in Chapter 5. Most effective are the *Line* tool, used with an appropriate thickness, and the *Brush* tool. Try using a square brush tip and make use of the Shift key when creating straight lines. Once outlines of shadows are established, they can be filled using the *Paint Bucket* tool. In this example, guidelines for cast shadows are established by creating a single angled line on a new layer and duplicating the line across the image to serve as a guide to ensure all cast shadows are parallel. An alternative method, one that might be easier for those more familiar with traditional drawing techniques, is to revert to the original traditional line drawing and, with a new sheet of paper, trace over the areas in shadow, making sure those areas are defined by a contiguous line. Scan the new drawing, isolating the areas outside the shadows with the *Magic Wand* tool, and use the *Paint Bucket* tool to create the mask. Bring it into the main composite file and position it as required.

6.37
Creating a mask for the white trim.

Creating a mask for the areas of the building that are painted white could also prove to be a time-consuming task. As often is the case with digital tools, taking a moment to think things through can save time. In this example, the masks already created

103

collectively isolate nearly the entire building except for the white areas. In order to utilize these layers, a duplicate copy of the entire image is made. All the mask layers except for the shadows are turned on and merged: go to *Layers > Merge Visible*. Pull the new image into the original one and align them. Turn on only the new and baseline layers. To aid aligning the two images, reduce the opacity of the new mask layer. Note that the ground plane was filled in black to complete this mask. Reverse the values in this mask by selecting the black areas, *Select > Color Range*, and then *Select > Inverse*, paint in all the clear areas with a large-tipped brush using black, *Select > Inverse*, and tap the Delete key. The final mask for areas painted white has now been created.

6.38
Adding color for the brick.

The steps to color the image closely follow the previous demonstration *Adding Color to a Plan*.

Activate the brick mask layer, *Select > Color Range*; turn off the brick mask layer, turn on the color field layer, and use a combination of *Curves* and *Color Adjustment*.

6.39
Eliminating color for the white trim.

Turn off the color layer, turn on the areas painted white mask layer, *Select > Color Range*; with the white areas selected, turn off the areas painted white mask layer, turn on the color field layer, and use *Curves* to lighten the related areas. Repeat the same steps for the roof color, shutters, and shadows.

6.40
Adding color for the roof and window shutters.

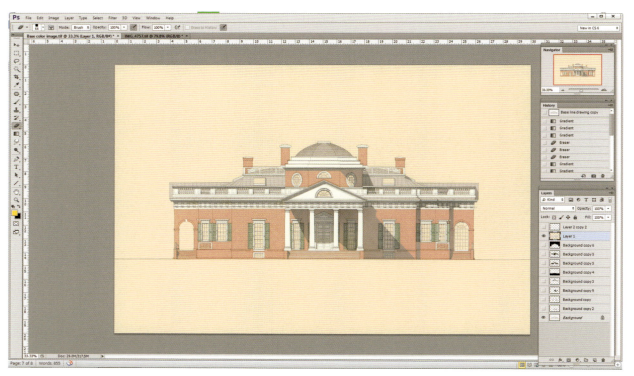

6.41
Adding color for the shadows.

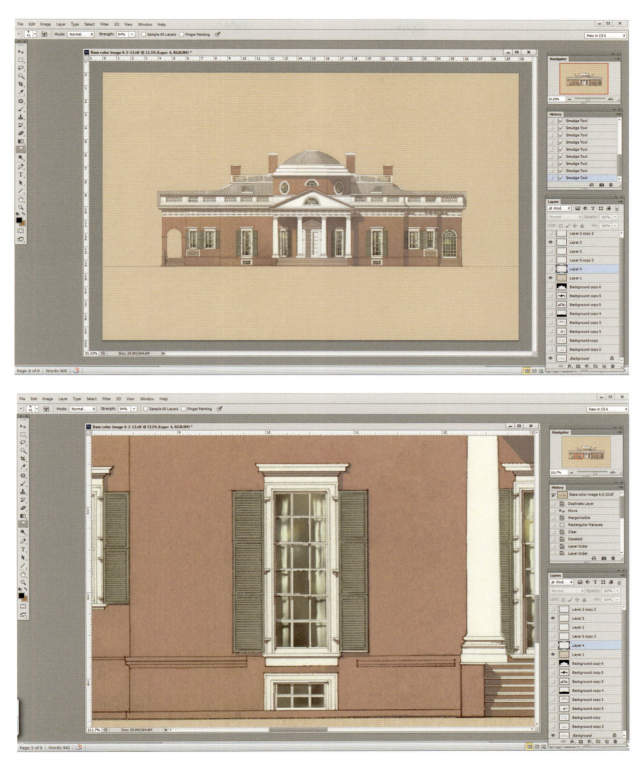

6.42
Adding detail to the windows.

Hybrid Coloring Techniques

Repeat the previous steps for rendering the windows. While the windows could be left a solid tone, the *Radial Gradient*, *Brush*, and *Blur* tools are used to add reflections and drapes to give the windows a sense of depth and life.

6.43
Adding a sky.

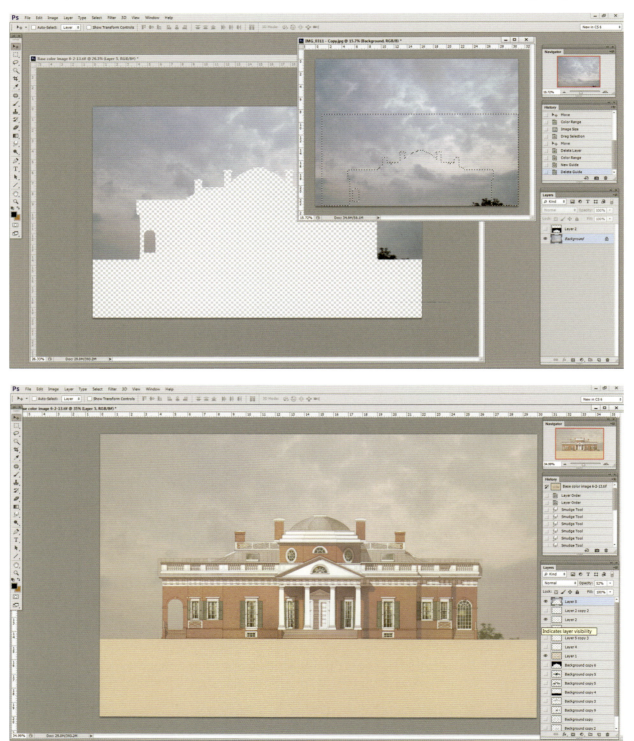

Activate the sky mask and go to *Select > Color Field* to select the area for the sky. Adding a sky with clouds requires choosing an appropriate image file, opening it in Photoshop, resizing the new sky image slightly larger than the composite image and, with both the composite image and the new sky image disengaged from the organizing bar at the top of the screen, using the *Move* tool to pull the selected mask over from the composite image onto the new color field.

Position the mask layer appropriately. Turn off the sky layer and reselect the black areas on the sky mask layer. With the black areas selected, turn off the sky mask layer and turn on and activate the sky layer. Use the *Move* tool to pull the selected area of the sky image back into the original composite image and position it appropriately.

Once the sky is in place, it will probably need a few adjustments so that it harmonizes with the rest of the image. Try the following techniques, either separately or in combination: *Color Balance*, *Hue Saturation*, and *Layer Opacity*.

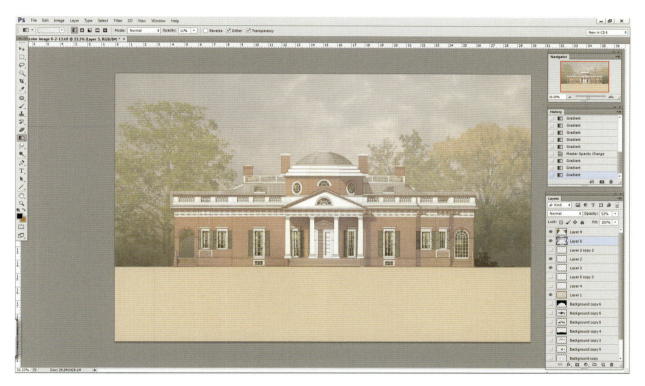

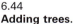
6.44
Adding trees.

To add trees, follow the previous steps. Be sure that when adding skies and trees the direction of the sunlight is consistent with the lighting on the building. The silhouetted trees for this demonstration were created from photographs. While you can make your own by using the *Lasso* or *Eraser* tools to separate a photograph of a tree from its background, a more efficient method is to find subject trees that are silhouetted against the sky. Look for subjects near a large field or body of water. Then, using the *Eyedropper* tool and *Select > Color Range*, the sky can be quickly isolated and deleted. Employing a combination of *Curves* and *Color Adjustment* eliminates the light blue or gray halo lingering around the edges of the leaves.

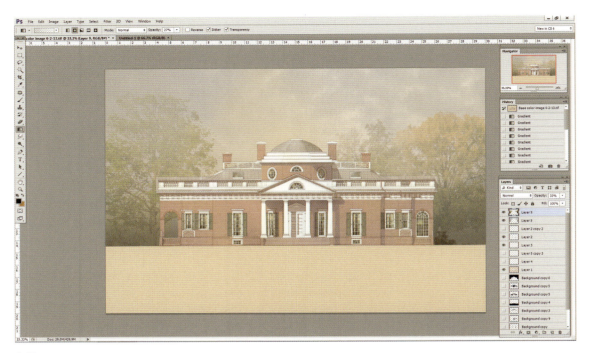

6.45
Using a vector mask for adjustments.

A vector layer mask is used on both the tree layer and the sky layer to erase parts of the image and reestablish the original background watercolor tone. See the previous demonstration *Adding Color to a Plan*.

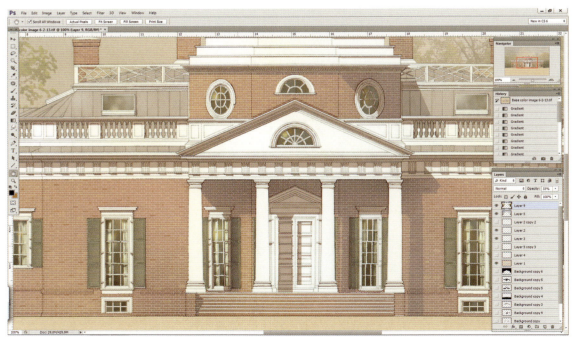

6.46
Adding mortar joints in the brick.

As with the sky and trees, a brick pattern is similarly brought into the image. The original image file had black lines on a white background. In order to change the lines to an off-white to simulate mortar joints, the area between the lines indicating the brick are isolated and deleted. *Curves* is used to change the brick lines from dark to light. When these lines are viewed against the red brick color field, they visually lighten the brick and require the brick field be darkened slightly. Light and dark variations in the brick are accomplished with the *Brush* tool set at a reduced opacity.

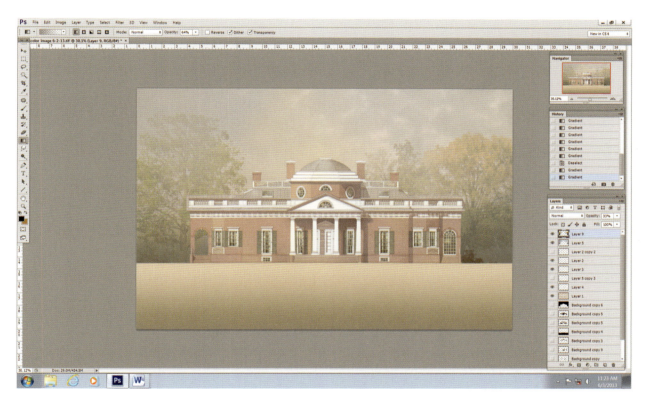

6.47
Adjusting the ground plane.

A few additional adjustments are made to the ground plane with the *Linear Gradient* tool.

Hybrid Coloring Techniques

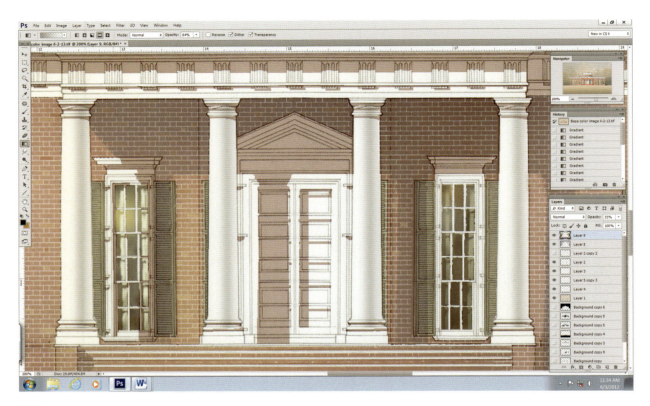

6.48
Adding modeling to the round columns.

The round columns require modeling. Create a new layer; use the *Reflected Gradient* tool to make a gradient similar to the example. Go to *Edit > Transform > Scale* to resize it as required. Use the *Eraser* tool to eliminate any overspray. Once one column is satisfactory, duplicate the layer and move it into position for the next column; repeat until all columns are finished. Go to *Layer > Merge Down* to collect them onto one layer.

To add additional texture to the entire image, a new watercolor field is opened and dragged into the elevation as a new layer. To preserve detail in the building, the center of the field is erased by using a vector mask. The opacity of this layer is adjusted for further subtlety.

Although in this demonstration the effects are minimal, reestablishing the line drawing at this point can often improve the image. See the previous demonstration *Adding Color to a Plan*.

Save this file, but before closing it, create a duplicate file. Close the original file and flatten the layers in the duplicate file. Use *Curves* to make further adjustments. Enlarge the image and use the *Clone Stamp* tool or the *Brush* tool if minor adjustments or corrections are required.

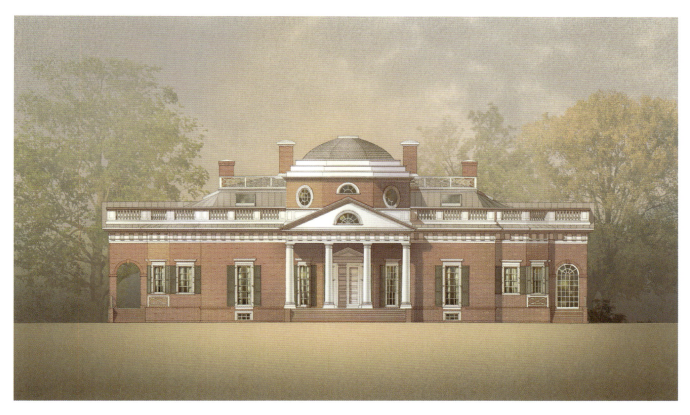

6.49
The finished elevation.

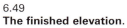

Adding color to an elevation requires knowledge about light, reflected light, shadows, and sensitivity with color. In other words, while the computer can make the process of adding color to images quicker and easier than when using traditional methods, it cannot provide artistic insight.

Hybrid Coloring Techniques

Demonstration: Adding Color to an Exterior Perspective

This demonstration assumes that the reader has already studied the previous demonstrations *Adding Color to a Plan* and *Adding Color to an Elevation*. Accordingly, this is primarily a visual guide with minimal text.

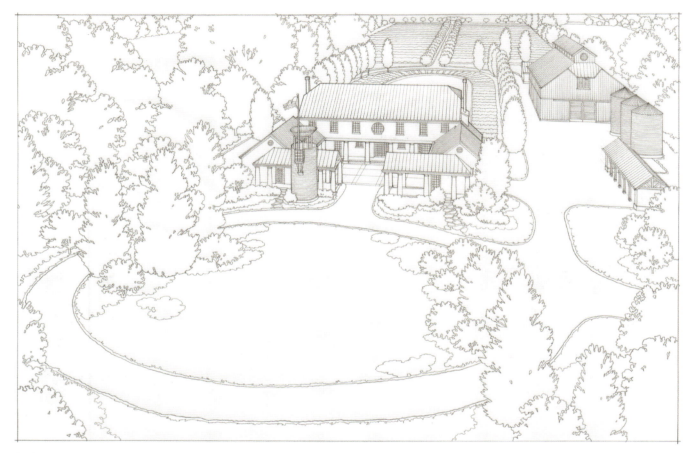

6.50
Original pencil line drawing.

Open the digitized line drawing and create three masks: one for the fir trees, one for the deciduous trees, and one for the areas of grass. Two black-and-white textures are utilized, one for the grass and one for all of the trees. The fir-tree mask is used to distinguish those areas from the deciduous trees by darkening them with *Curves*. Once the line patterns have been placed into the image, use the *Eraser* tool at a reduced opacity to lighten the sides of some of the trees facing the sun.

6.51
Clockwise from top left: mask for fir trees; mask for deciduous trees; textures inserted and modeled; mask for grass areas.

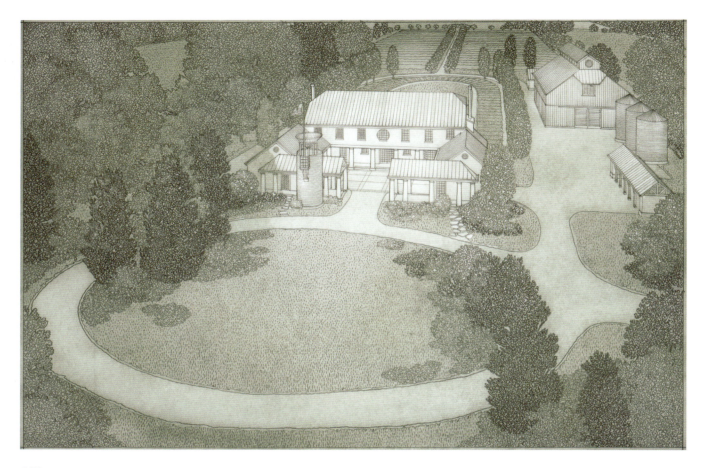

6.52
Textured color field applied and adjusted.

Select a watercolor field and add it as a layer over the line drawing. Adjust the transparency and use *Curves* to emphasize the watercolor texture. Add a vector mask and, using the *Radial Gradient* tool, erase the area over the main house and barn to maintain more detail in the layer below. Apply the layer mask. Continue to erase smaller detailed areas using the *Eraser* tool at a lower strength or opacity.

6.53
**Creating masks
for shadows and
window panes.**

Create two additional masks: one for the shadows and one for the windows.

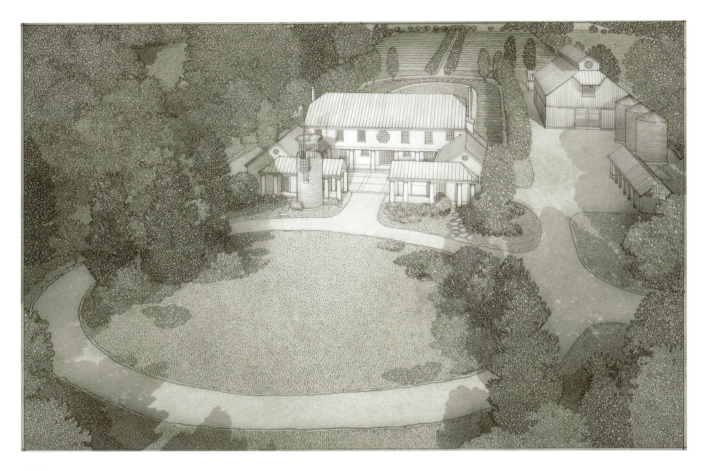

6.54
Applying shadows.

Activate the shadow mask and apply shadows on the color layer using a combination of *Curves* and the *Radial Gradient* tool set to a low opacity. Use the *Blur* tool to soften the edges of the shadow.

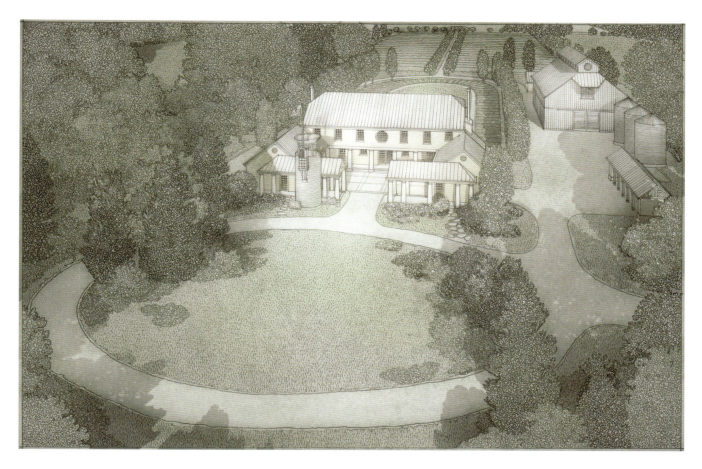

6.55
Applying color to the window panes and house.

Create a new layer and, using the *Radial Gradient* tool, apply a faint yellow to the house, and a faint yellow-green to the lawn areas closest to the house. Use the *Eraser* tool set to 100 percent opacity to eliminate any areas of overspray. Merge the new layer with the color layer. Reset the *Eraser* tool to 10 percent opacity and lighten some of the paved areas near the house and barn with multiple passes. The *Sponge* tool set to a medium opacity is used to desaturate some of the trees away from the center of interest. Finally, to darken the windows, activate the windows mask, switch to the color layer, and apply color with the *Radial Gradient* tool.

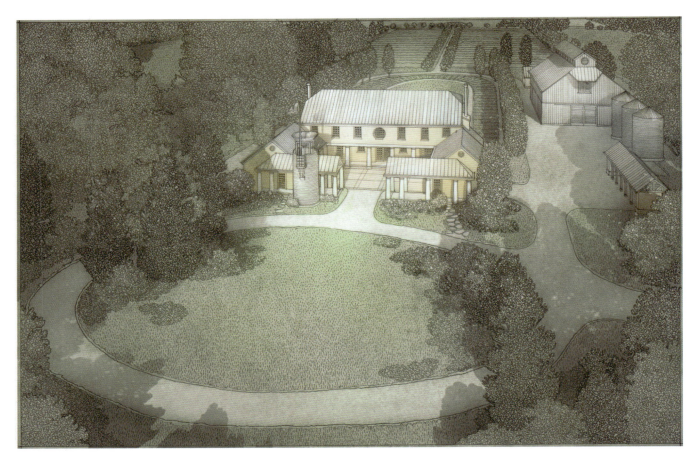

6.56
Contrast and saturation are adjusted on a duplicate image with the layers flattened.

Save the file, but before closing it, create a duplicate image. With the duplicate image, flatten the visible layers and use *Curves* to increase the contrast and saturate the colors a bit more.

Demonstration: Adding Color to an Interior Perspective
This demonstration assumes the reader is familiar with the previous demonstrations on adding color with Photoshop. The subject is the interior of Unity Temple in Oak Park, Illinois designed by architect Frank Lloyd Wright.

6.57
Interior of Unity Temple: finished rendering.

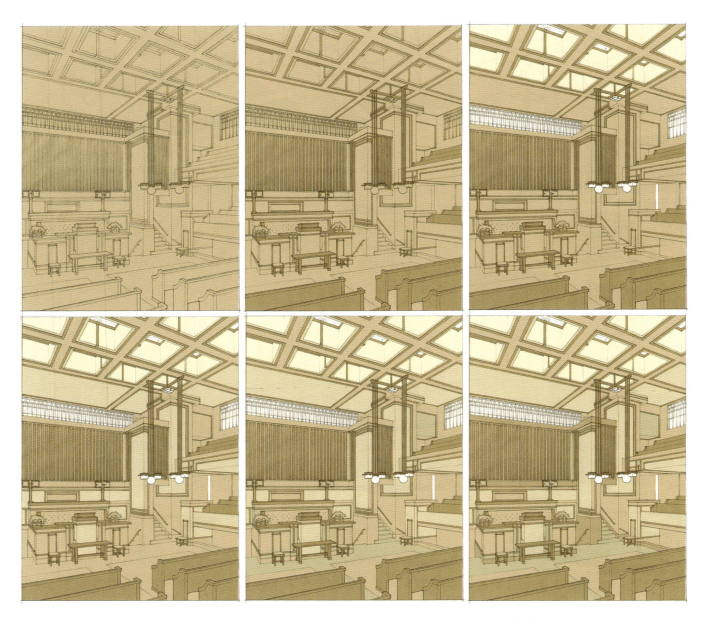

6.60
Step-by-step, adding color using masks.

Duplicate the original base layer line drawing once again. Select an appropriate water-color field, resize it to match the original drawing, and pull it over as a new layer. In this demonstration, change the setting in the *Layers* dialogue box from *Normal* to *Multiply*, so that the line drawing immediately below the new color layer becomes visible. An alternate method used in the previous demonstrations adjusts the transparency of the new color layer to reveal the line drawing on the level below.

Turn off all layers, activate the mask layer for the woodwork, go to *Select > Color Range*, set the slider all the way to the right, and press OK. Turn off the mask layer; turn on the color layer as well as the line drawing layer. Activate the color layer. Use a combination of *Curves* and *Color Adjustment* to achieve the desired color. Go to *Color*

> *Deselect* when finished. It's important at this stage to restrict all the colors and corresponding contrast to a fairly narrow range. It is much easier to make adjustments for increased color saturation at the end of the process.

Regarding the mask corresponding to the skylights and windows, once the areas are appropriately adjusted, but before the areas are deselected, use the *Eraser* tool set to 50 percent to further lighten areas of more intense light, such as the light fixtures, windows, and glass skylights.

Repeat the previous steps until the color corresponding to each mask is added. Keep all the color confined to one layer. Many beginners are tempted to keep a separate layer for each color, but doing so is unnecessary and usually leads to complications.

6.61
Step-by-step modeling adjustments.

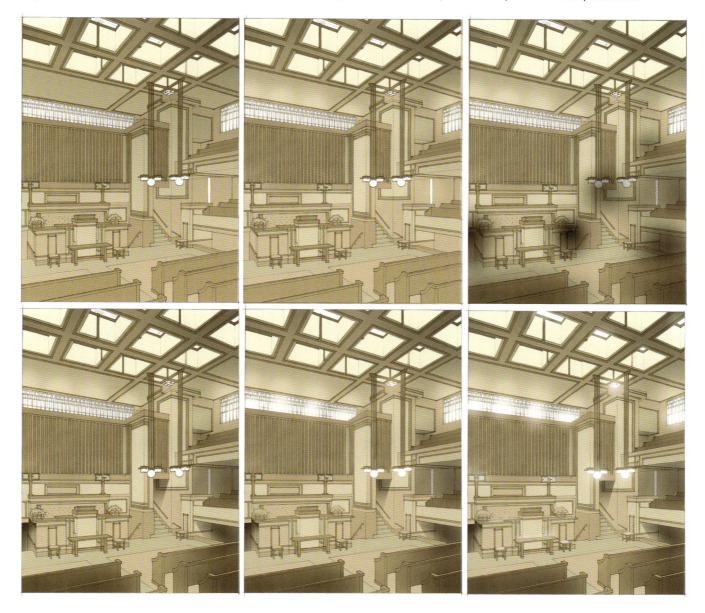

Hybrid Coloring Techniques

These next adjustments concentrate on modeling the image with gradated tones, simulating the effects of natural and artificial light. Create a new blank layer immediately above the color layer. Adding or making color adjustments on a separate layer allows those adjustments to remain independent from the color layer until it's appropriate to merge it again. Reactivate the skylight mask and go to *Select > Inverse*. Select a warm black as the top color chip and use the *Linear Gradient* tool set to 25 percent to create a tone from the top of the image to the mid-point. Use the *Eraser* tool to eliminate any unwanted areas of overspray. You may prefer turning off the dancing ants to better see the color as it is applied and adjusted; simultaneously press the CTRL and H keys, but don't forget to go to *Select > Deselect* when finished. To simulate light from the windows illuminating the ceiling, add a vector layer mask to the new adjustment mask and use the *Radial Gradient* tool set to 15 percent with multiple applications to "erase" away the dark areas. Apply the vector layer mask and merge the adjustment layer with the color layer.

Create a new blank layer. Use the *Radial Gradient* tool to add darker areas beneath the balconies and stair passages. Use the *Eraser* tool set to 100 percent to remove areas of overspray. Harsh edges can be softened using the *Blur* tool, the *Smudge* tool, and the *Eraser* tool, set to 5 percent and used with multiple passes. Merge the adjustment layer with the color layer.

More sophisticated renderings employ a variety of line weights, from dark and thick to thin and light, or even non-existent. To replicate this effect, activate the line drawing immediately below the color layer. This should be a copy of the baseline layer. Before proceeding, first try using *Curves* to adjust the lines, and then, with white selected as the active color, use the *Radial Gradient* tool set to 20 percent in combination with the *Brush* tool set to about 25 percent to lighten or eliminate lines.

To further brighten and simulate the effects of glowing light for the light fixtures and glass areas, try using the *Radial Gradient* tool set to 15 percent, applied directly on the color layer or on a separate adjustment layer.

6.62
Final touches.

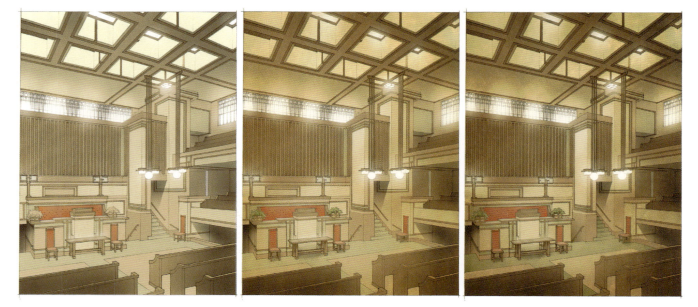

The color of the seating upholstery is intended to serve as an accent, thus it is added at this point to better judge its color against the rest of the palette. The plants and column capitals outside the windows are added with the *Brush* tool set at a reduced opacity. Some areas, such as the pew and table tops, are lightened either with the *Eraser* tool set to a reduced opacity, or by isolating those areas with the *Polygon Lasso* tool and using *Curves*. A new watercolor field with more pronounced granulation is added. Change the setting in the *Layers* dialogue box from *Normal* to *Multiply*. Add a vector mask on this new layer and, as before, use the *Radial Gradient* tool to incrementally erase away selected areas of focus to reveal the original color layer. Apply the layer mask to the new color layer. Go to *Layers > Merge Down* to combine the two color layers into one. Some of the masks are reactivated so that additional adjustments can be made, such as increasing the intensity of the green area of the rug. A few touch-ups are also required with the *Clone Stamp* tool. For a final enhancement, activate the color layer and try applying a filter: go to *Filter > Artistic > Watercolor*.

Save a copy of the file with all the layers intact. Before closing the file, duplicate the image: go to *Image > Duplicate*. With the duplicate file, flatten all the layers to one; go to *Layers > Flatten*, and use *Curves* to increase color saturation and contrast.

Demonstration: Advanced Photoshop Techniques

6.63
Daydream, finished illustration.

Hybrid Coloring Techniques

Entitled *Daydream*, this capriccio was inspired by two places: Petra and the "Narrows" at Zion National Park. Before beginning, images of possible components are assembled. Texture maps are also collected or created as required. A limited kit of 3D parts left over from a classical building project is used to generate the architecture.

6.64
Reference photographs. *Top row, left to right*: tree with moss; river rocks; *second row*: LaBrea Tar Pits excavation site; giant sequoia tree; *third row*: *Petra*: painting by Frederic Church, courtesy of Wiki Commons; *The Narrows at Zion National Park*, courtesy of Wiki Commons; *fourth row*: girl on boulder; Zion National Park.

6.65
Texture maps.

Hybrid Coloring Techniques

A screen shot of the computer model before any work in Photoshop gives a sense of the final image. Form-Z was utilized for the 3D modeling and rendering. Reflections in the water are accomplished by simultaneously using a texture map and assigning a reflectivity to that element's surface.

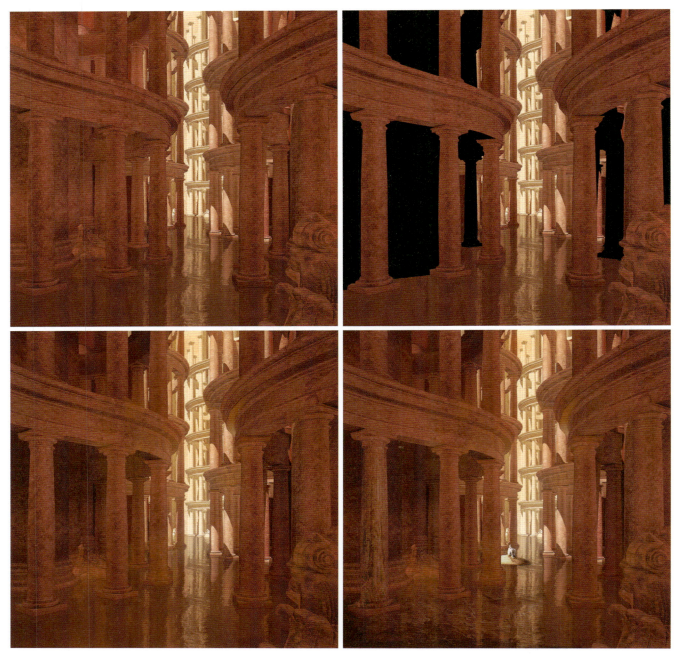

6.66
Step-by-step adjustments with Photoshop.

While it is possible to pursue further lighting refinements with the 3D modeler's rendering tools, I prefer to complete all subsequent work with Photoshop. My approach to using digital techniques is the same as when I use traditional techniques: I develop the whole image simultaneously; working large areas first and details last.

The first step requires the creation of a series of masks in order to simulate the effects of ambient light in the areas behind the colonnades, something beyond or at least challenging for most rendering engines. Once the masks are complete, create a new layer and use the *Radial Gradient* tool at a reduced opacity to apply dark red-black color to the areas in shadow.

6.67
Adding haze and textures.

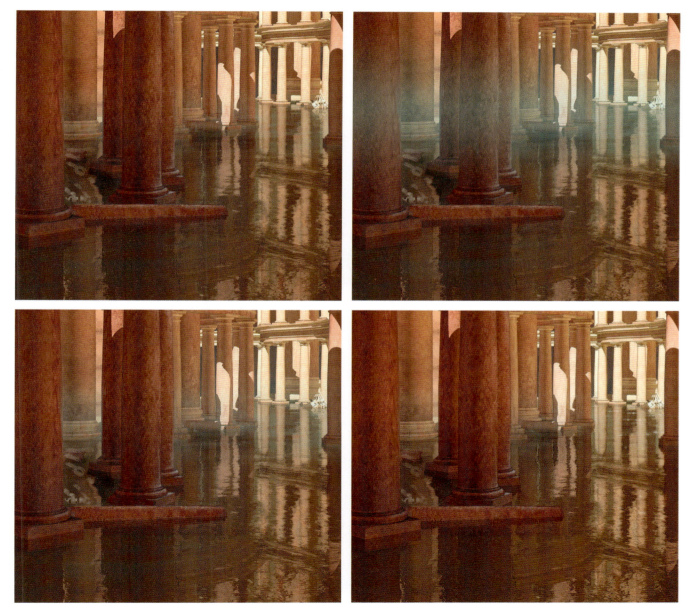

Hybrid Coloring Techniques

On a new layer, I apply a transparent blue wash with the *Reflected Gradient* tool, simulating a slight haze coming off the water. The *Eraser* tool, set to varying levels of opacity, is used to clean up areas of overspray in the near and far columns. I handle streaks and staining on the stone entablatures in a similar manner. I use the *Blur* tool to soften areas or the *Nudge* tool to correct mistakes made with the eraser. While I can always return to this process of adding glazes, the next step utilizes some of the collected images to introduce textures to the columns and stream bed.

6.68
Adding the stream bed.

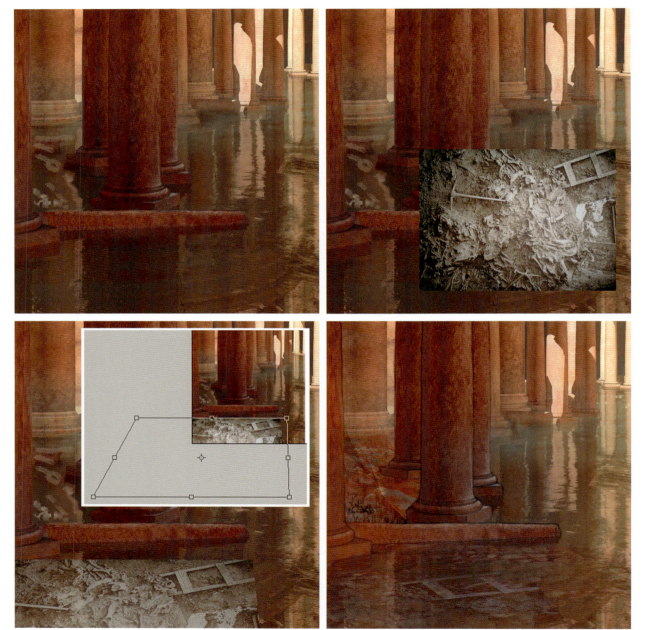

To add detail to the stream bed in the lower left corner, first pull the excavation site image into the main image. Reduce the opacity and go to *Edit > Transform > Scale* to resize it. To adjust the image to match the existing perspective, go to *Edit > Transform > Skew*. *Curves* and *Color Balance* are used to get the color to accurately match that of the background. Finally, the *Eraser* tool set to a reduced opacity further softens edges and transitions. Repeat these steps to add the tree bark texture to the columns.

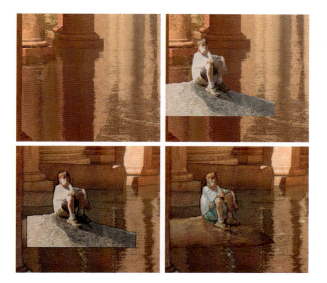

6.69
Adding the figure.

Adding the figure is accomplished in a similar way as the stream bed. It's important to select a photograph that corresponds to the original image with respect to the direction of the sunlight. Still, chances are that the focus and light quality of the photograph will not be sympathetic with the background. Try reducing the opacity of the figure as well as adjusting the *Color Balance* to get the image to harmonize. Strategies for using edge lines as an effective graphic device are introduced in the following paragraphs. One quick method to establish an edge line around a newly imported image is: go to *Layer > Duplicate Layer*, turn off the duplicate layer, reactivate the previous layer, go to *Image > Adjustment > Curves* and turn it completely black, go to *Filter > Other > Minimum* and try increasing the perimeter by one or two pixels. Turn on the top layer and observe a line describing the edge around the image. Additional work from this point is completed with the *Brush* tool; employed at both full and reduced opacity – sometimes just 5 percent – it is used to draw over the photograph and achieve a more painterly effect. Use the square bracket keys on the keyboard to quickly enlarge or reduce the size of the brush tip. Photoshop has a large collection of brush tip shapes and there are internet sites demonstrating easy methods for creating your own. I usually use one of just three brush tips: round, square, and a preset Photoshop brush with a ragged edge resembling an amoeba.

Hybrid Coloring Techniques

I revisited this image numerous times over a period of a few months, each time making further refinements. Once the image was complete, I found a few filters that can bend the look of the drawing back toward something appearing hand-made. What often distinguishes hand-made drawings from photographs or computer-generated images are lines describing edges. This graphic device traces its roots back to cave paintings. When applied to digital images, it reestablishes a link between the computer and the intuitive movements of the artist's hand. Some artists, including myself, will sometimes trace over the important edges with the *Brush* tool using a stylus and tablet. Always add lines on a separate adjustments layer. The application of a few filters softens the lines and makes them appear as though they are made with a pencil. Go to *Filter > Stylize > Diffuse*, and then try *Stylize > Blur > Gaussian Blur* to make further refinements. Also try *Filter > Noise > Add Noise* and use the *Blur* tool or the *Gaussian Blur Filter* as required. The effects filters have on an image are dependent on the size of the file. While I sometimes work with files over 100 MB, I find an ideal size for most of the filters I use is closer to 20 MB.

Quicker methods for simulating the edge line look can be obtained with Photoshop's filters, although the effects are not as convincing as when done by hand. For further refinements try the following, beginning at the top row left to right in Figure 6.70:

- A screen shot of the original rendered model before using Photoshop.
- Duplicate the base image layer, and then go to *Filter > Artistic > Poster Edges*. Try different setting options in the dialogue box to discover what works best. Once the filter has been applied, select black – the color of the lines – with the *Eyedropper* tool, and go to *Select > Color Range* and set the slider to about the middle. Once the line areas are selected, go to *Select > Inverse* and tap the Delete key, then go to *Select > Deselect*. Now, only the lines are present on the active layer and can be manipulated further by reducing the opacity or color of the lines.
- To achieve a soft-focus look, duplicate the original rendered base layer and go to *Blur > Gaussian Blur*.
- Try reducing the opacity and/or using a vector mask (see the demonstration: *Adding Color to a Plan*) to erase portions of the image to reveal more detail on the layer below.
- For this variation, go to *Filter > Artistic > Watercolor Filter*. In the dialogue box, set the sliders to: *Brush Detail*, 14; *Shadow Detail*, 0; *Texture*, 2. As in examples C and D, adjusting the opacity or using a vector mask can achieve further refinements.
- To achieve this effect, duplicate the base layer and go to *Filter > Other > Maximum*. As in the previous examples, adjusting the opacity or using a vector mask can achieve further refinements.

Creating this image required some effort, probably asking for more time and patience than most designers have. Yet, achieving similar results using traditional techniques would have taken much longer.

6.70
Techniques for simulating edge lines. *Left to right from top*: base image; with *Poster Edges Filter* applied; with *Gaussian Blur Filter* applied; image manipulated further by reducing the opacity; with *Watercolor Filter* applied; with *Maximum Filter* applied.

Hybrid Coloring Techniques

Demonstration: Rendering a SketchUp Model
Making of St. David's School Exterior – images and text by Scott Baumberger

The St. David's School project consisted of a substantial interior renovation of the existing building, along with the construction of a new south wing. The final view highlights the existing building with a slight view of the new wing just to the left, behind the brownstones to the south. The existing building has landmark status, so the renderings for the project needed to show the renovation in the best possible light, and demonstrate that the new wing would be sufficiently deferential to the existing building. Additionally, an accurate depiction of the surrounding context (including the nearby Guggenheim Museum) would be essential for the project to receive necessary approvals.

The process of creating this image is fairly typical of my workflow. I usually receive a 3D model from the architect, in this case a SketchUp model but often I'll get a model in Revit, Rhino, or even 3D Studio Max format. In-house 3D models can vary widely in quality, so my first step is to check the accuracy and completeness of the model to determine how much cleaning and pruning will be necessary for it to hold up to a rendering process. Sometimes, the viewpoint will already be determined in-house before I start work, but for this project the client looked for input on the final location of the camera and the composition of the image. For this rendering they knew they wanted a view from the northeast "catty-corner" from the site. Figure 6.71 shows a client-provided photograph of the site from the approximate location of the rendering.

6.71
Existing building.

136

Figure 6.72 shows a view of the client-provided SketchUp model with one of the early viewpoints.

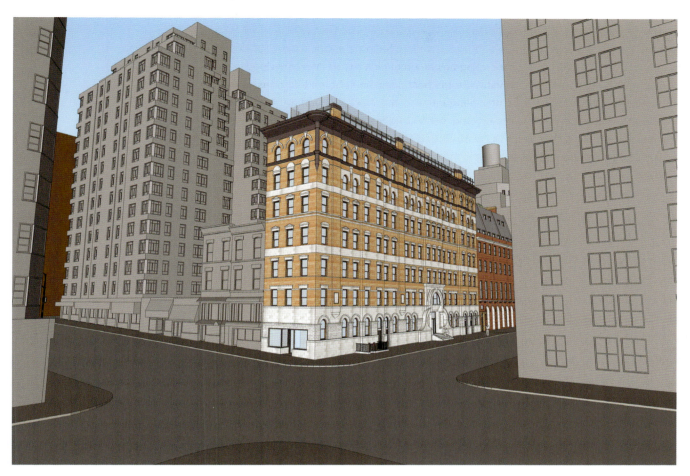

6.72
Screen shot, SketchUp model.

We quickly decided to go with a street-level two-point perspective that would give the existing building a natural, traditional feel. Along with looking at different viewpoint options, I assign generic materials to the surrounding buildings so that I will be able to isolate them later in Photoshop. I also add foreground 3D entourage – in this case, the streetlights/signals and cars. Because it's New York, I put a few taxis into the scene.

For this project I used the Maxwell for SketchUp plug-in to create the raw render passes. I use pretty generic materials knowing that most of the texturing and final color-ation will be done in Photoshop. I tackle these items in Photoshop as a way to maintain as much flexibility as possible. It takes time to adjust materials and re-render, so I avoid it as much as I can, preferring to use adjustment layers, etc. in Photoshop. We'll cover these items a bit later on. One thing to point out, though, is that I introduce a small amount

Hybrid Coloring Techniques

of glossy reflection to most of the materials. Adding this effect helps to unify the color balance in the raw rendering, and creates a somewhat exaggerated color "bounce" that gives the image a bit more of a painterly look. Once the final viewpoint for the rendering is nailed down, I export render passes from SketchUp that will become the basis for the Photoshop work to follow. Figure 6.73 shows thumbnails of the raw render passes.

At this point I can shut down SketchUp as the rest of the work will be done in Photoshop. The first step is to stack and register the passes. I put the two color passes at the bottom of the stack and then the Maxwell render on top. The color passes are there primarily to allow for quick selection set creation, such as brick, glass, or sky. The lines-only pass is set on top of the render in *Multiply* blending mode – most color work is done underneath this layer to ensure that the lines are always visible.

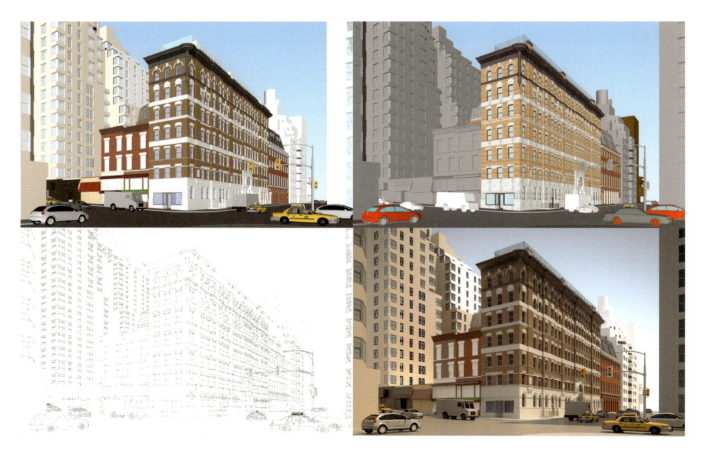

6.73
Clockwise from upper left: color-only (no textures, no edges) pass; color and texture only (no edges, set to "color by layer"); rendered output from Maxwell for SketchUp; lines-only pass using a custom hand-drawn line effect created within SketchUp.

Once this is set up, I do some quick obvious corrections to color and values throughout. I also bring in the photographic reference for the neighboring buildings and paste in the signage on the awnings and the foreground building at the lower left corner of the image. I create a layer group for the sky and, using a selection created from the color pass, I apply a mask to the group. I then fill in the sky with a few washes at low opacity to build up a soft, watercolor effect. I also paint in a few clouds at very low opacity using custom brushes created in Photoshop. Finally, I insert several large trees at the horizon to indicate Central Park, visible a block to the west. Figure 6.74 shows where we are at this point.

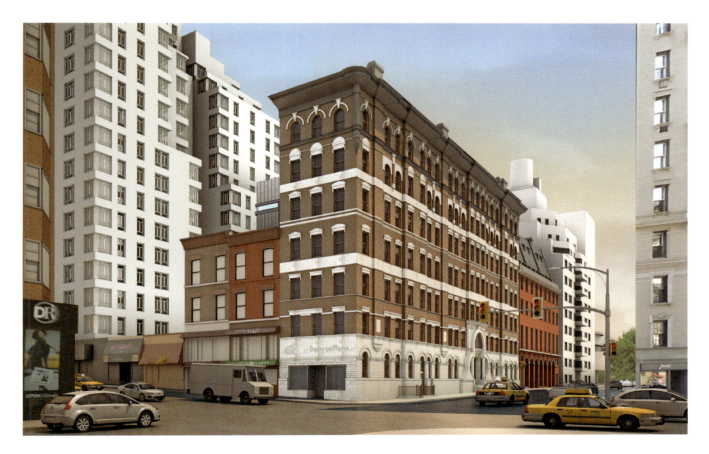

6.74
Continuing with Photoshop.

Hybrid Coloring Techniques

By now, a lot of decisions have been made on the color palette and the overall tonal balance. This is usually a good milestone in the project to involve the client to be sure I am on the right track.

Once approved, I move on to the glass and entourage. There's not that much glass in the existing building, so this step goes very quickly. I mostly used stock photos of classrooms or gathering spaces and adjusted the perspective to match the windows. The neighboring buildings are primarily residential so I used the usual stock photos of apartments and condo interiors for these windows. I tone down the contrast substantially at the other buildings as I don't want them to compete for attention.

Working back to front, I add people and trees in new layer groups on top of the stack. Several groups of people are arranged, clumping them near shop and building entrances. I get a late request to add a few school-age children in uniform near the main entrance, just to the left of the far taxi in the perspective. Trees are located along 88th Street and Madison Avenue per the site photographs. I thinned them out quite a bit so we can see through the canopies.

6.75
Adding entourage: trees and people.

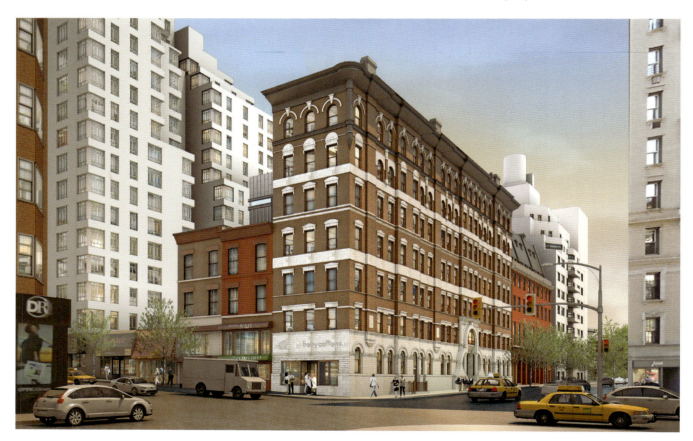

The addition of cast shadows really helps to set the trees and the figures into the scene. I create a "Shadows" layer group underneath the trees and people and set the entire group's blending mode to *Multiply*. The layers within the group are set to *Normal* – this allows for the layers to stack within the group and areas that overlap won't build up. I drag a copy of the "People" layers down to the "Shadows" group. On each layer, I adjust the lightness within the *Hue/Saturation* adjustment to zero, making them full black. Then I adjust it again using the *Colorize* option, giving it a medium blue color. Typical settings for a daytime rendering are *Hue* = 200, *Saturation* = 20, *Lightness* = 60. Compare the cast shadows in the layer group to the cast shadows from the original rendering to make sure they match reasonably well.

I do the same for the tree shadows, but I can get away with adjusting one layer and then copying it several times. Using the layer group technique, the tree shadow layers can really pile up without the areas becoming overly dark.

At this point, we get a late request from the Landmarks Commission to restore two frieze bands on the existing building. The commission provided several historic photos for reference and this is all we had to go on, at least for the purposes of the rendering.

6.76
Adding shadows for the entourage.

6.77
Historic photographs indicating missing cornices.

From the photos, I quickly model the bands and composite into the larger model in SketchUp. Once composited, I re-render the scene with Maxwell Render. I also export a color-only pass similar to the original one that I can use to quickly mask just the area of the frieze bands. After pasting the new masked render on top of the stack, I adjust the curves and levels slightly to blend it into the existing scene. I was directed to match the color and value of the large cornice as much as possible.

6.78
Missing cornices added.

Everything else is approved by now so all that is left are finishing touches. The first adjustment is to add some additional glow to the north (long) elevation of the existing building. This helps to draw the eye to the center of the image and create a focal point to the scene – in this case, the main entrance. I really like the *Glow* brush in Corel Painter for creating the effect, and I have found a way to simulate it within Photoshop. Of course, it is possible to move the file back and forth between the programs, but I really prefer to do this as little as possible. The trick is to create a new layer set to *Color Dodge* blending mode, and then add a *Layer Style* but only uncheck the *Transparency Shapes Layer* box in the *Advanced Blending* options. That's it; no need to add any other effects. By adjusting the transparency blending, the coloration and glow effect has a much softer edge, giving a more natural appearance. I paint on this new layer with a large, soft brush and a dull yellow color set to very low opacity. *Color Dodge* is an intense blending mode so it does build up very quickly.

I use this "Glow" layer so much now that I created an Action for it, so it's only one click away. Actions in Photoshop are a great time-saver. Very similar to macros in word-processing or spreadsheet programs, Actions will play a script of commands in sequence based on your "recording."

To create a recording, click on *Window* at the top command bar and open the *Actions* palette. At the bottom of the *Actions* palette are six symbols: first, click the turned page symbol, second to the right, to initiate the creation of a new Action. Label the Action appropriately. You will notice that the circular symbol is now red, indicating that a sequence of commands or actions will now be recorded. In this case, I sequence through the following Photoshop commands: (1) create a new layer above the currently active layer; (2) rename the new layer "Glows"; (3) change the blending mode of the "Glows" layer to *Color Dodge*; (4) adjust the layer style as noted above; and (5) change the currently active tool to a soft airbrush with a yellow hue. Once finished, click the square symbol to conclude the recording. I can now run this Action any time I need it – usually once or twice per rendering.

I also add a darker wash at the base of the rendering – this is done on a new layer set to *Multiply* blending mode. I paint a large foreground-to-transparent gradient using a fairly intense blue-violet. It usually takes a few tries before I get the right strength. And, of course, I can adjust the hue/saturation later. This is a common technique to vignette an image, and in general I like the bottom of the image to be somewhat darker than the rest – it seems to help ground it.

Now it's time to add the paper effects. This can be done very easily by pasting a scan of watercolor paper or something similar over the entire image and setting the new layer to *Overlay* blending mode. I have a collection of several paper textures that have the levels adjusted so that the overall tonal balance of the texture is set to 50 percent lightness. Because the neutral setting in the *Overlay* blending mode is a 50 percent gray, using a texture balance with the same 50 percent gray will not introduce a color or tonal shift in the image. I have also set up most of the textures as Patterns that can be applied very quickly to the image. This step speeds up the process significantly as I don't have to resize the texture to match the canvas, and I can adjust the scale of the texture as well at any time. The pattern will seamlessly fill the entire canvas. This also has the benefit of keeping the file sizes down. With these set up, I usually add 2–3 patterns set to *Overlay* blending mode and experiment with their strengths to create a custom look.

The last step is to add final adjustment layers at the top of the stack. I start with the *Color Balance* adjustment, just pulling on the sliders and seeing what happens. I use a pretty light touch, keeping the effect down to 10 or less. Typically, I'll pull the shadows toward blue and cyan, the highlights toward yellow. Look for colors that might be missing in the overall image – in this case, there is very little green, and so I adjust the midtones and highlights to punch up the green a little bit. Using the *Color Balance* adjustment is a great way to experiment with color and unify the rendering. I use it on almost every project.

Other things I might experiment with are *Curves*, *Level*, *Photo Filters*, sometimes even *Gradient Maps* and the well-known *Black-and-White* adjustment to increase contrast. In this case, the image felt good with just the *Color Balance*, and the client agreed!

Compare the previous image to the final version and you can see the impact of these final adjustments. They can really make a big difference in a very short amount of time. The key to experimenting at this stage is ensuring that adjustments are non-destructive.

Hybrid Coloring Techniques

By that, I mean they can be changed or turned off at any time. Certain effects, such as sharpening or the *High Pass* filter, require you to create a flattened copy of the entire image and then apply the effect. Any changes that need to happen below this flattened layer will not be visible. As a result, I apply all of the sharpening, etc. down at the bottom of the stack first – that way I can still move entourage and make other adjustments right up to the end. Changes are inevitable, and maintaining as much flexibility throughout the rendering process is essential to moving quickly and hitting deadlines.

6.79
Final adjustments.

Educated and trained in architecture, Scott has been a freelance illustrator for more than 15 years. He uses a digital process to produce imagery in a warm, evocative style that is inspired by traditional watercolor illustrations. Scott's illustrations have been featured in numerous publications, including *Architectural Record, Urban Land, Building Design & Construction*, 2004 and 2008 *NYSR Portfolios, Best of 3D Graphics, Architecture in Perspective* catalogues 15–25, as well as monographs for KPF, FXFowle, and Callison.

7
Process: Hybrid Design Techniques

Many people immediately begin the design process using computers. This approach has some advantages and they are addressed in the demonstration *Using 3D Modeling as an Investigative Tool* (p. 156). Yet using computers too early in the conceptual stage also limits possibilities. Understanding and mastering hybrid techniques gives the designer the ability to use the best tool at the right time.

Sometimes at the beginning of the conceptual process, we search to establish a clear idea. A sound approach starts with general concepts. First, create small diagrammatic sketches, gradually refining the idea by increasing the scale and detail of subsequent sketches and drawings. Keeping developmental drawings a little ambiguous engages one's subconscious and intuition in the design process. One of the traps of working entirely in a digital environment during the early phase of the design process is that it is seductively easy to begin zooming in on details, losing a sense of the relation of the parts to the whole, and also missing the element of serendipity that freehand drawing can offer.

Demonstration: Sequencing Hybrid Techniques in the Design Process
The project: Greenberry Farm, Granger, Indiana

The client wished to create a modest hobby farm on a site in a semi-rural area of northern Indiana. The program asked for the following:

- main house: four bedrooms, two and a half bathrooms, approximately 2,500 square feet;
- pottery studio: 900 square feet;
- two-car garage;
- outbuildings: barn, equipment storage, produce stand;
- landscaping: gardens, orchard, berry grove.

After analyzing the program, freehand sketching begins the process of assessing possibilities, both for the main house as well as for the site.

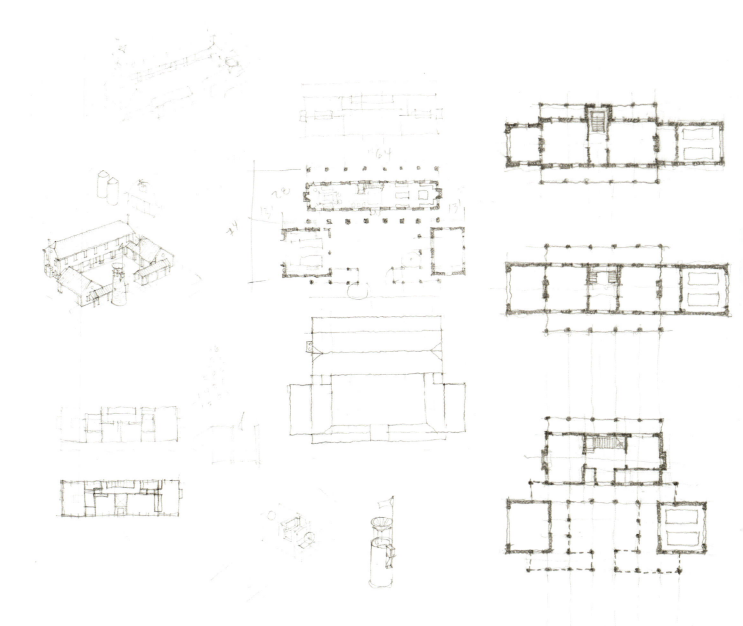

7.1
Freehand sketches.

Development of the main house floor plan follows two approaches: an open concept and a plan with defined rooms. As with many private residences, much attention is paid to the kitchen, generating numerous schemes. These are process drawings; they are not perfect and are intended to be changed. The media used is 2H, H, and HB leads on Clearprint paper, which is preferred over yellow sketch paper as it withstands numerous revisions without tearing while still providing enough transparency to layer the floor plans one over another as they are developed. By using the scanner and Photoshop,

some revisions are accomplished with "patches": smaller isolated drawings that are then inserted into the digitized base drawing. Clients appreciate seeing the progression of thought and how the design evolves. At any point in the process, the plans can be inserted into a base sheet with a title block and borders, and with a little color, shown to the client without having to stop to create new presentation drawings. Introducing one of the tonal fields from the materials folder for color has the desirable effect of diminishing the small mistakes, graphite smudges, and partially erased lines, but still retains a sense that the drawings are made by hand.

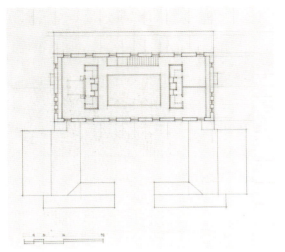

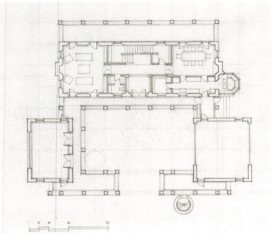

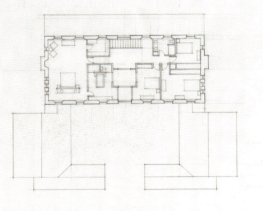

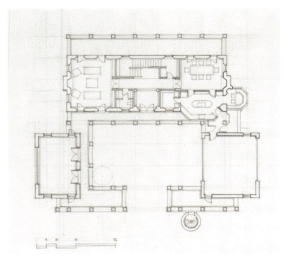

7.2
Plans, traditional drawings made with instruments.

GREENBERRY FARM,
Granger, Indiana

LOCAL AREA PLAN

200 400 800 1600 FT

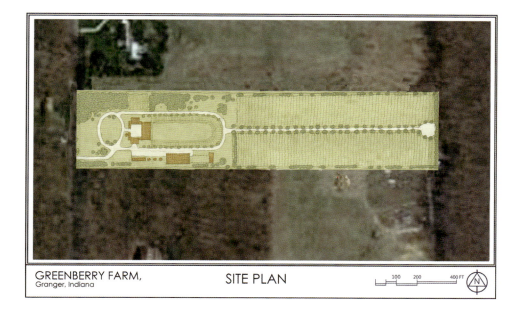

GREENBERRY FARM,
Granger, Indiana

SITE PLAN

100 200 400 FT

7.3
Freehand sketch, color added with Photoshop, inserted into satellite images.

151

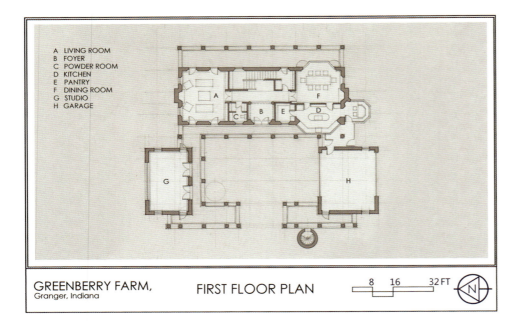

A LIVING ROOM
B FOYER
C POWDER ROOM
D KITCHEN
E PANTRY
F DINING ROOM
G STUDIO
H GARAGE

GREENBERRY FARM,
Granger, Indiana FIRST FLOOR PLAN 8 16 32 FT

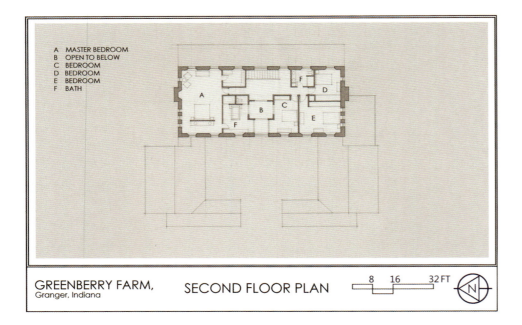

A MASTER BEDROOM
B OPEN TO BELOW
C BEDROOM
D BEDROOM
E BEDROOM
F BATH

GREENBERRY FARM,
Granger, Indiana SECOND FLOOR PLAN 8 16 32 FT

7.4
Traditional drawings: plans and elevations – color added with Photoshop.

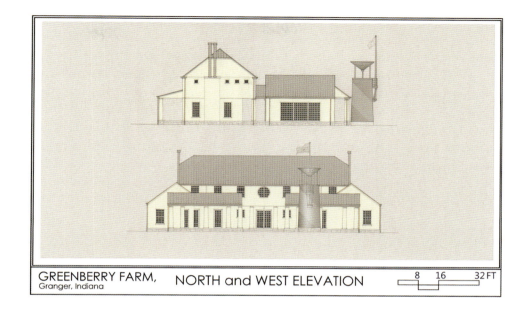

GREENBERRY FARM, Granger, Indiana NORTH and WEST ELEVATION 8 16 32 FT

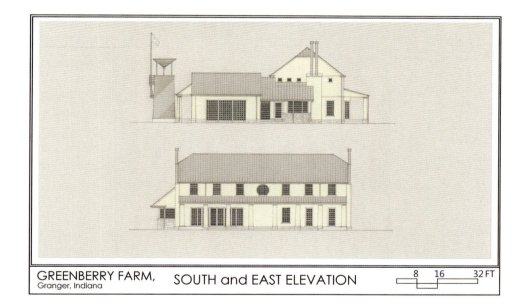

GREENBERRY FARM, Granger, Indiana SOUTH and EAST ELEVATION 8 16 32 FT

Process: Hybrid Design Techniques

A beautiful drawing is a desirable communicative tool and may also be considered art, but in the service of the creative process, pursuing a drawing as a work of art should not be the primary goal. Overemphasis on the artifact created by a particular tool – such as a drawing or a model – fails to keep in mind that our objective is the physical reality the artifact anticipates. Changing tools during the development of a design avoids this trap. One famous architect, who begins the process by sketching, eventually switches to using physical and digital models and frequently changes the scale of the physical models as the design evolves to avoid "designing to the model."[1] Skills with one of the many 3D modeling software programs can provide an effective means to move beyond the limitations that drawing places upon the process. In this example, a digital study model proved valuable in uncovering a number of issues that necessitated further refinements.

7.5
Screen shots of the computer model being built over digital images of the plan and elevations.

When creating a digital model based on hand-made drawings, map the plans and elevations onto flat planes and build the 3D model over the top of the maps in order to maintain continuity between the traditional and digital environments.

7.6
Sequential images simulating the approach to the house.

Digital study models can be used to quickly generate numerous views that can be used to simulate movement, whether in a real-time video, or as in this example, with a story board. Studying this sequence of images informed the placement of the landscaping; the aim is to heighten the drama of first observing the building from a distance and then hiding it until one draws closer. During the final approach to the main house, the windows are revealed only as the courtyard is entered.

I made a traditional line drawing of an aerial view by tracing over one of the computer-generated 3D images (see the demonstration *Adding Color to an Exterior Perspective*). Each time a different tool is used in the process, new discoveries become possible. As the design continues to become more refined, a number of advanced 3D modeling software programs can be used to realistically study variables such as color, texture and reflected light, even offering the potential to consider concerns that go beyond the third dimension, such as movement, gravity, and wind. These models, however, take more time to create and the objective at this point in the process is to remain fluid and avoid falling captive to a time-intensive process that resists changes.

Process: Hybrid Design Techniques

Demonstration: Using 3D Modeling as an Investigative Tool

Architects are sometimes challenged by a complicated building program that poses many possible solutions. The ability to visualize the program's components in three dimensions and move them around in real time can streamline the process and help quickly narrow choices. This demonstration was originally a student project for an "Eco Retreat" in the Saudi Arabian Peninsula, sited on an elevated rock outcropping with panoramic views of a sand dune field. The project lasted four weeks and served as a vehicle for studying non-Western traditional architecture.

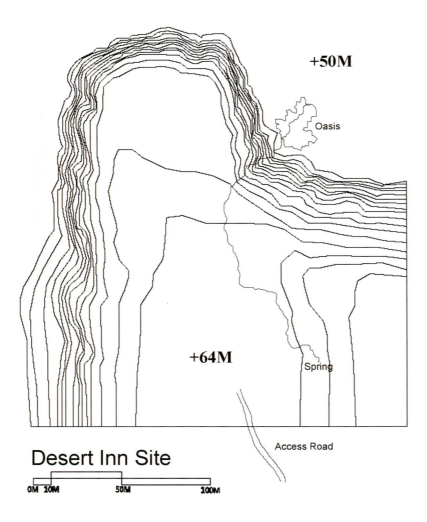

Desert Inn Site

0M 10M 50M 100M

7.7
Site plan, 3D computer model of the site, and program components.

The class was introduced to using 3D modeling software as a planning tool. Once the programmatic elements were identified and modeled, the students were able to manipulate the elements and begin the process of simultaneously considering spatial relationships and massing possibilities. Perspective views were evaluated and served as underlays for further development with freehand drawing.

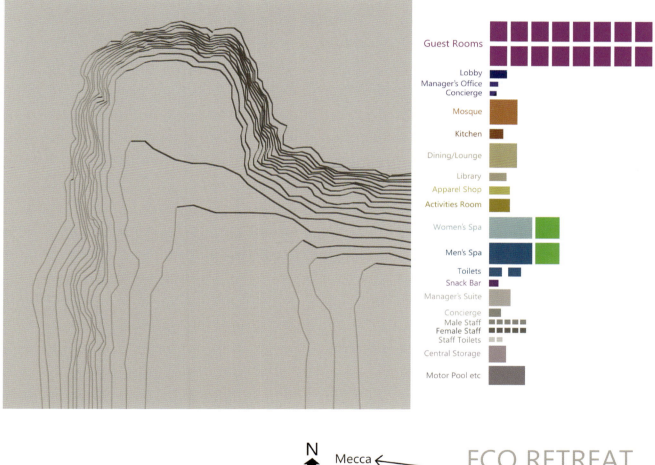

Guest Rooms
Lobby
Manager's Office
Concierge
Mosque
Kitchen
Dining/Lounge
Library
Apparel Shop
Activities Room
Women's Spa
Men's Spa
Toilets
Snack Bar
Manager's Suite
Concierge
Male Staff
Female Staff
Staff Toilets
Central Storage
Motor Pool etc

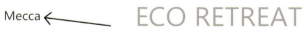

N

Mecca ←

ECO RETREAT

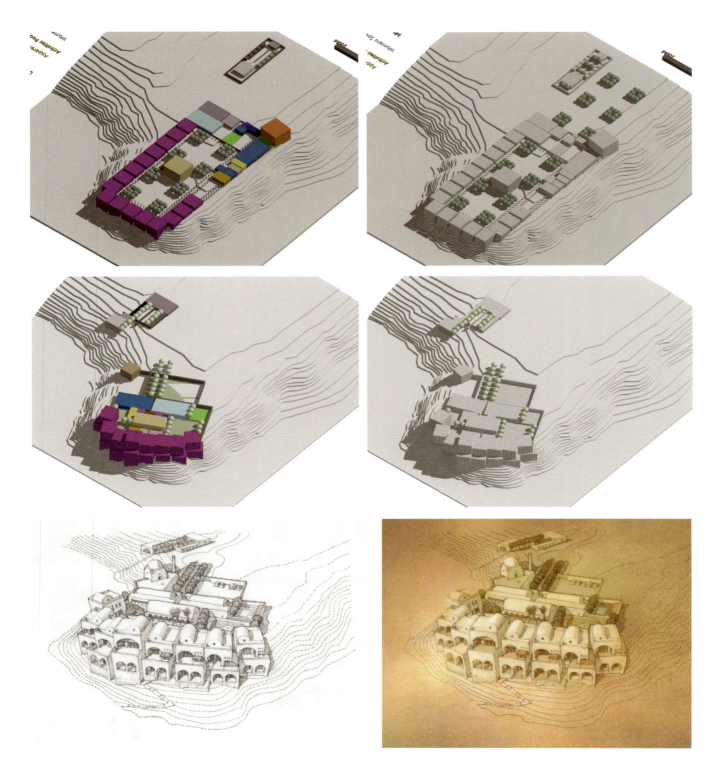

7.8
Digital massing models, traditional drawing colored with Photoshop.

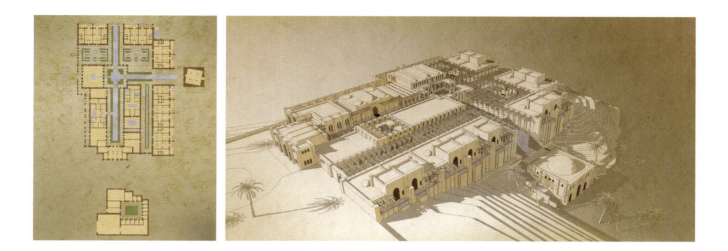

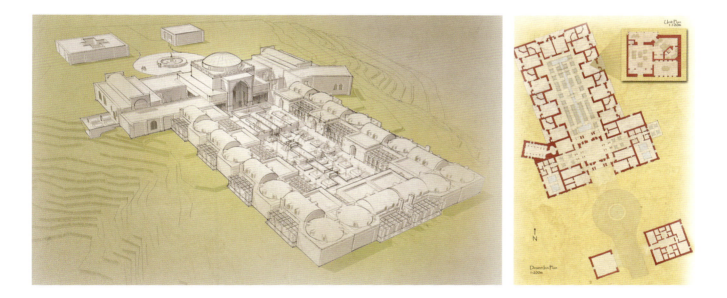

7.9
**Student work: plans and perspectives rendered with Photoshop and based upon
digital massing models.** *Top*: Paul Hayes; *bottom*: William Hull.

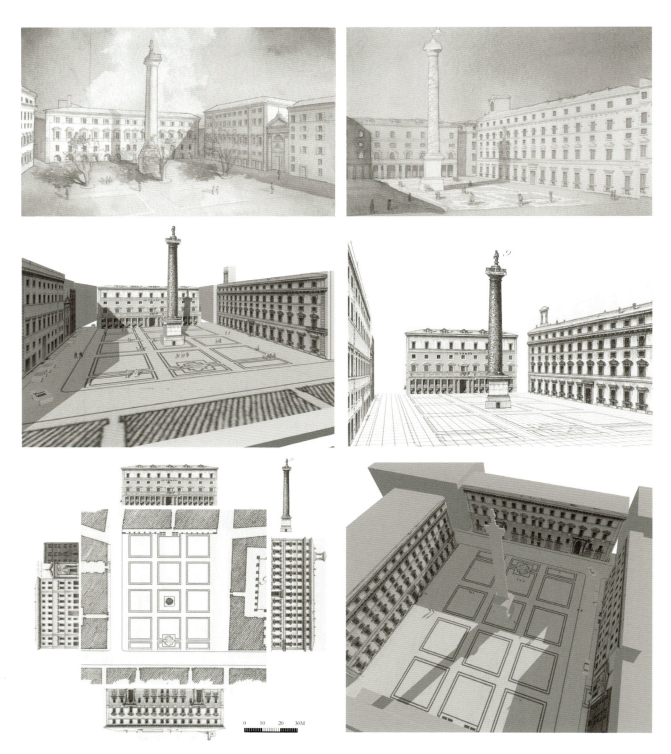

7.10
Student work: traditional watercolors based on computer models of 2D elevations and plans mapped onto 3D forms.
Top left: Diana Yu; *top right*: Claire Martell.

Combining Sketching and 3D Modeling

The ability of traditional builders to simultaneously conceive and create physical architecture facilitates the integration of construction and aesthetics in a way not possible with modern techniques. Early Gothic churches and traditional Japanese temples are good examples. As political and economic realities changed, Renaissance architects increasingly relied on drawing and physical models to streamline and shorten the design and construction process. Their creation of plans, elevations, and sections – a set of unambiguous instructions – replaced the on-site presence of the master builder. For the next five centuries, designers were locked into orthographic modes of investigation that arguably retarded the potentials that a synthesis of imagination and practical knowledge make possible. Computer modeling has replaced traditional drawing and physical models as the preferred method for visualizing designs for a number of reasons: the process is more efficient, these models are easier to change and manipulate, ground-level and interior views are easier to simulate, but most importantly, digital 3D modeling once again facilitates evaluating the design in three dimensions, as it is conceived and constructed.

Digitized Borromini

This imaginary project draws inspiration from the architect Borromini and attempts to create something he might have done if he had a computer. A rather small and undeveloped concept sketch was scanned and applied as an image map onto a flat plane using a 3D modeler. There is an intuitive sense of proportion and rhythm in the sketch that is difficult to preserve in the digital environment, except to build the model right over the top of the sketch. Translating the sketch into three dimensions revealed numerous modifications that 2D drawing could not have uncovered.

7.11
Original sketch.

Process: Hybrid Design Techniques

The original concept sketch, approximately 3″ × 3″, included only half of the elevation, which was then scanned, duplicated, and mirrored using Photoshop.

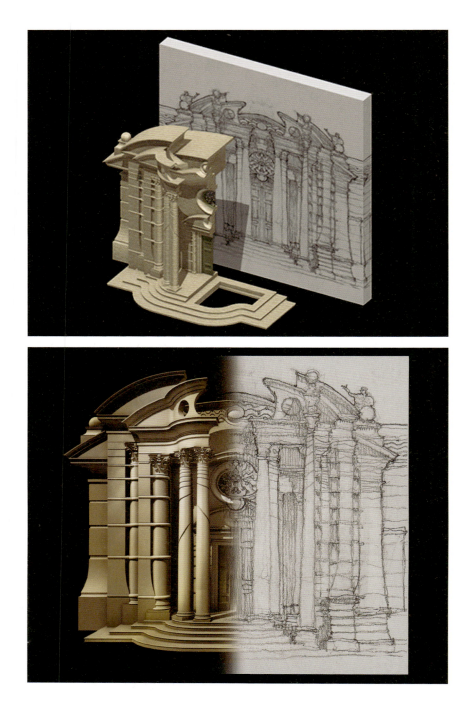

7.12
Screen shots of the computer model built over the concept sketch.

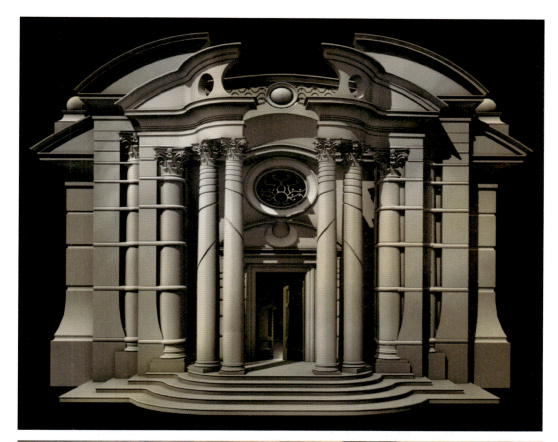

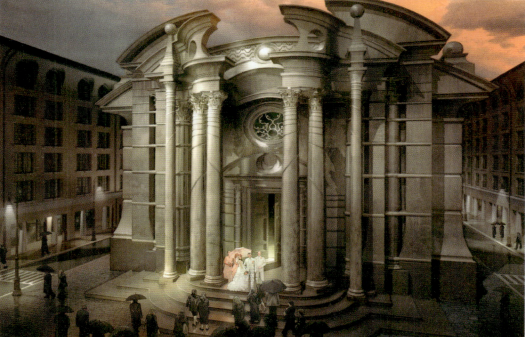

7.13
Metallic Baroque,
finished image.

Process: Hybrid Design Techniques

Recreating the Appian Way

An introductory course to 3D modeling asked students to design a mausoleum using traditional techniques. Once they were satisfied with their design, they moved into a digital environment and were required to build the 3D model over their hand-made drawing. Seeing one of their paper designs realized in three dimensions energized students to master the software. The computer revealed problems and possibilities that traditional drawing could not anticipate. The ability to quickly combine many individual efforts into a single digital model is demonstrated by asking the students to trade files and illustrate their designs among their neighbors' mausoleums; in this case, recreating a portion of the Appian Way as it could have appeared in antiquity.

Note

1 Pollock, S., director, *Sketches of Frank Gehry*, 2006.

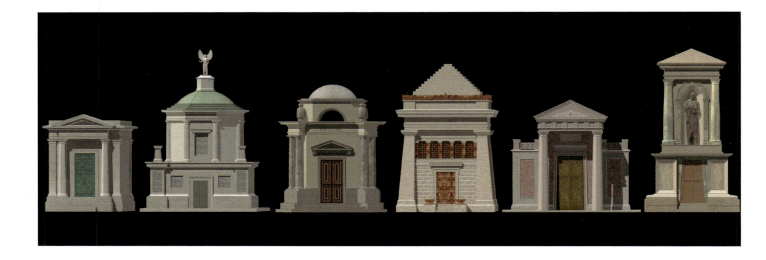

7.14
Student work: *Mausoleums, From left to right*: Sylvester Bartos, Daniel Ostendorf, Kellen Krause, Julian Murphy, Grace Mariucci, Sara Mirolli, Kristie Chin, Amanda Miller, Timothy Carroll, Catherine Veasey, Patrick O'Connell, Jordan Del Palacio.

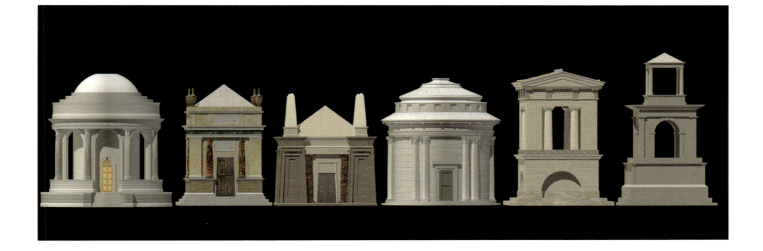

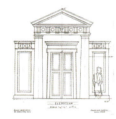 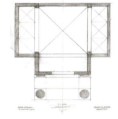

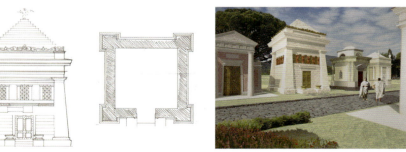

7.15
Student work: *Mausoleums of the Appian Way*: elevations, plans, and rendered perspectives. *From top*: Patrick O'Connell, Amanda Miller, Grace Mariucci, Timothy Carroll, Julian Murphy.

8
Light and Shadow

Anticipating the effects of natural and artificial light can fundamentally affect design choices. We might learn from professional photographers who understand the value of light. When photographing exterior subjects, they sometimes wait days, weeks, or even seasons for the optimal lighting conditions. On the other hand, when photographing interiors, it is surprising how they may completely change the existing lighting conditions with an additional array of artificial lights.

Strategies for Placing Sunlight

When imagining a subject illuminated by natural light, we must first anticipate our position as it relates both to that of the subject and the sun. Basically, the sun is either in front of or behind us and comes from either the left or right. The time of day and season, along with one's position on the Earth, dictates the angle and position of the sun in the sky. While it is prudent to be aware of how sunlight realistically interacts with a subject and its particular site, sometimes a little artistic license reveals a truth by telling a small lie. In other words, consider placing the sun so that it presents the subject in a clear manner that enhances its appearance, even if the sun may never be in that exact position.

Figure 8.1 portrays a figure standing in front of a small cottage. The intersecting lines within the circle beneath the figure's feet correspond to the major axis of the cottage. The yellow arrow indicates the direction of the sun. For consistency, the angle of the sun is set at 45 degrees with respect to the ground plane. For demonstration purposes, the sun revolves around the planet in this pre-Copernican universe.

Sunlight illuminates a surface most intensely when it strikes that surface at a perpendicular angle. As the sun swings around and glances across a surface, the illumination is less intense. If the purpose of an illustration is to clarify our knowledge of a subject, there are usually only a few optimal locations for the sun. For this particular building, A and C are the best options: all the building's surfaces are in sunlight, but the major and minor façades are clearly differentiated by how brightly they are illuminated.

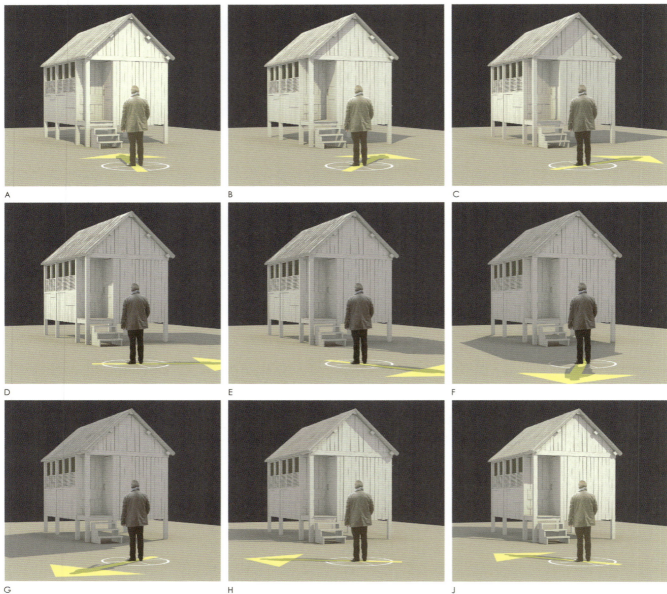

8.1
Positioning sunlight.

Some might think example B is also a good option. However, locating the sun at a 45 degree angle to a subject with principal façades perpendicular to each other is a poor option because it illuminates all the surfaces with equal intensity, confusing rather than clarifying a viewer's understanding of the building.

With the right subject, D and J can also be possibilities for sun placement, although a significant area of the building in each example misses an opportunity for shadows to assist in defining the building's surfaces. Most of the remaining examples illustrate backlighting strategies. It would be a mistake not to consider the full range of options;

indeed, many successful paintings and photographs employ backlighting. These are often enhanced by exaggerating the effects of reflected light, something most digital rendering applications don't offer. Ultimately the creator of an image must not lose sight of the image's purpose: is it to visually describe an object or building as clearly as possible, or is it to evoke an emotional response?

Constructing Shadows

The following examples were created using a computer. When the computer plots shadows so effortlessly, it is difficult to argue for spending time to construct them manually. However, as has been previously suggested, just because the computer knows how to do something does not mean its operator knows how to do it. For those designers who admire buildings created to be seen in sunlight, understanding the laws that govern the effects of light and shadow can inform their design choices.

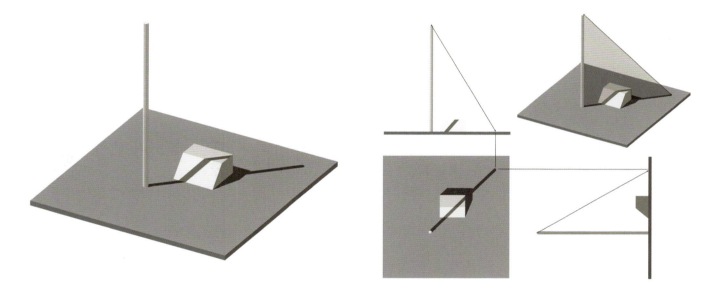

8.2
Shadow study.

One way to understand how to construct shadows is to imagine a point at the top of a pole. The sun's position forms a triangular plane with the top and bottom of the pole and the ground plane. This triangular plane slices through everything in its path, creating a shadow. All shadows can be imagined as a collection of these triangular planes.

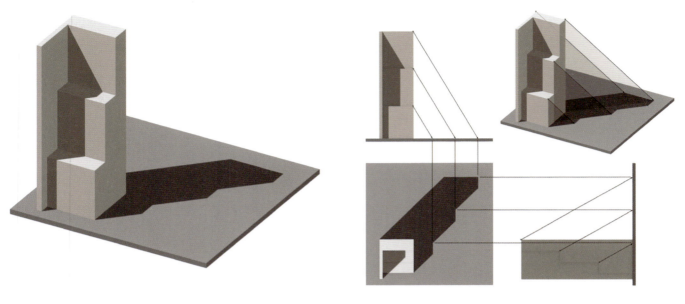

8.3
Shadow study.

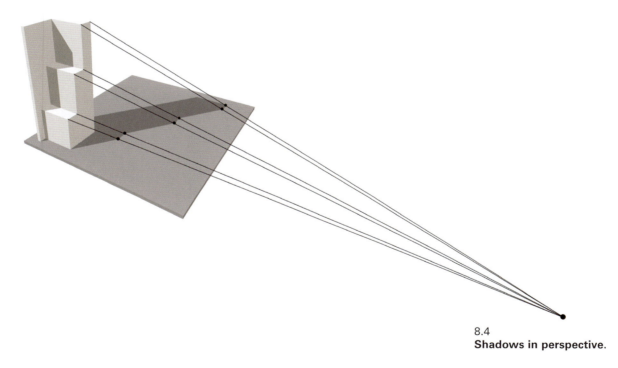

8.4
Shadows in perspective.

When constructing shadows in perspective, remember the important rule: ***all parallel lines share the same vanishing point***. The sun is so far away from the Earth that for all practical purposes its rays are parallel, thus lines coinciding with the sun's rays will converge on a common point.

8.5
Comparing cast shadows in elevation.

Which of the images in Figure 8.5 is correct? A common mistake assumes a profile in either plan or elevation always describes the profile of the shadow.

8.6
Comparing cast shadows in perspective.

Seeing these forms in perspective (Figure 8.6) confirms the shadows in each is correct, but are cast by completely different objects. A few further examples are shown in Figures 8.7 and 8.8.

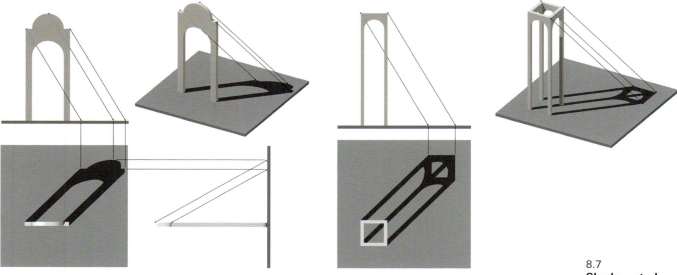

8.7
Shadow study.

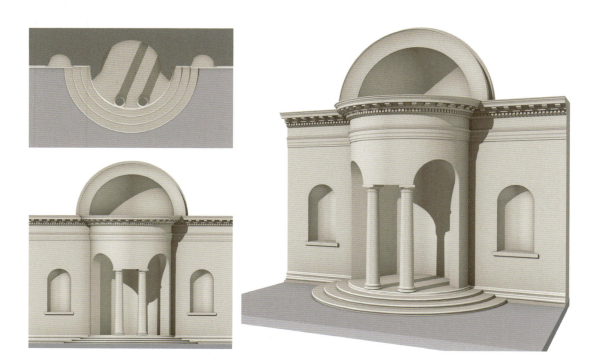

8.8
Shadow study.

Reflected Light

An important but often overlooked consideration when creating images of buildings or environments that don't (yet) exist is the phenomenon of reflected light.

8.9
Reflected light.

On a clear day, sunlight passing through the atmosphere will interact with the gas and water molecules, making the sky appear blue. In addition to the sun, the sky provides a second source of light. The sun's warm light is tempered by light from the rest of the sky's diffused light, explaining why shadows often have a cool cast. In the absence of direct sunlight, elements in shadow may be entirely illuminated by the sky – which is usually a cool color. Photographs taken on the moon record shadows that are black. Since there is no atmosphere to diffuse the light, the sky is not a secondary source of light. Some shadows have a warm cast caused by sunlight bouncing off a nearby surface and reflecting light back on a surface that may be entirely or partially shielded from the sky. The color of the surface reflecting the sunlight will also affect the color of surfaces in shadow. A warm-colored surface enhances the warm color of sunlight; a cool color tends to negate it.

8.10
Reflected light from pavement.

In Figure 8.9, the entire vertical surface of the wall is in shadow. Notice how the wall's color becomes brighter and warmer in the area that is closest to the surface of the pavement that is in direct sunlight. This occurs because the light-colored pavement is an intense source of warm light, even brighter than the ambient light from the sky.

8.11
Reflected light from ledge.

On the vertical surface where the wall steps back, a small horizontal area on the ledge is catching some direct sunlight and reflects that light up, creating a glow on the wall closest to the light source.

8.12
Diffused shadow caused by reflected light.

The area further to the right of the same ledge casts a slight shadow from the light reflecting off the pavement.

8.13
Reflected light and shadow.

Figure 8.13 demonstrates the same phenomenon with a different subject. Recorded late in the afternoon on a cloudless day, the area in shadow is entirely illuminated by the blue sky and thus is blue.

8.14
Reflected light illuminating the shadow.

Some sunlight bouncing off the white surface just under the egg illuminates the underside of the egg and that light bounces once more into the shadow nearest the egg, making that area a little brighter and warmer. Notice how the light on the egg is brightest on the area most perpendicular to the sun.

8.15
The brightest area is perpendicular to the sun's rays.

8.16
Transitional zone from sunlight to shadow.

In the area of the egg that is parallel with the sun's rays, the color of the shell is warmest, and just beyond the point where the sun's rays no longer glance across the surface, the egg's shell is darkest. As more of the egg's surface faces the brightly illuminated ground plane, the area in shadow becomes lighter again. Also notice how the shadow is sharpest closest to that part of the egg casting it, and as that distance increases the shadow becomes blurred.

8.17
Diffused shadow occurs further from the source.

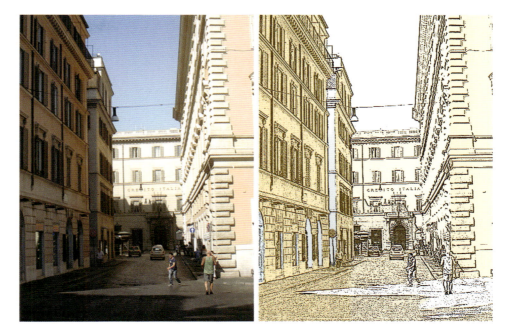

8.18
Cool and warm shadows.

To predict when shadows are warm and when they are cool requires a little further insight. Both warm and cool shadows are present in Figure 8.18. The buildings on the left are principally illuminated by bright, warm light reflecting off the terminus building and the building on the right. The narrow street and cantilevered cornices combine to shield some of the building façades on the left from the cool light of the sky, thus they have a predominantly warm cast, except for the deep window frames and partially exposed façade facing away from the terminus building. Since the only light reaching those areas is diffused light from the blue sky, they have a contrasting cool cast.

8.19
Warm reflected light from clouds.

Light and Shadow

When using color images to predict reality, some exaggeration is allowed – even desirable – to emphasize the effects of reflected light. Remember, not all skies are blue; on some occasions, a setting sun will illuminate a large cloud mass in the east, creating a predominately orange or red sky with quite remarkable reflected light. The photograph shown in Figure 8.19 was taken on Chicago's lake front looking due east at sunset.

8.20
Exaggerated effects of a setting sun caused by an overcast sky.

If weather conditions are just right, sometimes a heavy overcast of clouds will clear at the horizon just as the sun sets, allowing the sun's light – made even warmer by not being affected by any significant diffused cool light from the sky – to illuminate objects with a particularly intense orange light.

Sunlight passing through atmosphere with a high amount of particles in it, such as moisture or smoke or even snow, can also be the source of unusual reflective light.

8.21
Examples of reflected light.

In each of the examples shown in Figure 8.21, sunlight reflecting off a horizontal or vertical surface illuminates an area in shadow with warm reflected light.

8.22
Reflected light from artificial sources.

Artificial light sources can also create dramatic effects, sometimes reversing the normal relationship between cool and warm reflected light.

8.23
The Acqua Paola in afternoon light.

The Acqua Paola in Rome is a bit of Renaissance theater. The façade faces due east and is in shadow throughout the afternoon. Views through three openings in the fountain's façade allow the roofless space behind the fountain to sharply contrast with the front façade. Even though the plane of the rear façade is also in shadow, it receives reflected sunlight bouncing off the back of the front façade, making it look brighter and warmer than the front façade, which, in the absence of any reflected light other than the sky, has a predominately cool color. At night, modern lighting techniques replicate this effect.

8.24
The Jefferson Memorial at sunset.

The photographs of the Jefferson Memorial shown in Figure 8.24 were taken just before sunset. Walls behind the colonnade appear a little darker and more orange than the entablature because these areas do not receive as much of the sky's diffused blue light.

9
Composition Strategies

Basically, composition is the pleasing arrangement of light and dark forms, values, and colors. Most artists create images of things they can see; they pick and choose from visual experiences – places and things they've encountered – and capture those inspirations on paper or canvas. Designers, on the other hand, must express and recreate images from their imagination; things that don't exist. This is a much more difficult task, requiring the designer to understand and predict the effects of visual phenomena – sunlight, reflected light, shade, shadow, and perspective and challenging the designer to use this knowledge to manipulate these elements into a convincing image.

Often, a designer's illustration of a concept must stand on its own without the support of verbal or written explanations. These illustrations, or visual arguments, work on many levels: they must communicate with a viewer who has no prior knowledge of the subject, they must convince a viewer of its merit, and they must be memorable. The best images are theater; they purposely lead a viewer's eye into and around a place they create. Composition can be a powerful means to shape an understanding and appreciation of a design. Over the centuries, a number of compositional strategies have been developed. But art is never contained, by rules; new strategies that extend or challenge existing strategies are constantly evolving. A few effective ones are included here.

Composition Strategies

9.1
Top row, left to right: *Girl Playing a Lute*; *Lady at the Virginal with a Gentleman*, **both by Jan Vermeer**; *Eight Bells* **by Winslow Homer**; *second row*: *Corner of the Church, San Stae, Venice*, **by John Singer Sargent**; *Wheat Field with Cypresses*, **by Vincent van Gogh**; *View of Vétheuil*, **by Claude Monet**; *third row*: *Sunset in the Rockies*, **by Albert Bierstadt**; *La Piazetta, Venice*, **by Jean Baptiste Camille Corot**; *fourth row*: *The Artist in His Studio* **by Rembrandt van Rijn**; *Interior of the Rotunda at Ranelagh*, **by Giovanni Antonio Canaletto.**

In Western art, the majority of paintings read from left to right; the viewer is encouraged to begin looking at the left side of the image first, and then progress to the right. This subtle orchestration can be accomplished by having the light source emanate from the left, or by manipulating compositional elements. Two reasons can be cited for artists using this strategy: first, most artists are right-handed and wisely avoid working in the shadow of their hand. Thus the light illuminating both their canvas and subject is coming from the left. Just as likely, however, Western conventions of reading from left to right are naturally adopted by painters who also lead a viewer through a composition from left to right.

9.2
Top row, left to right: The Scout, Friends or Foe, **by Frederic Remington;** *Morning Sun,* **by Edward Hopper;** *second row:* *Flight into Egypt,* **by David Roberts;** *third row: The Voyage of Life, Childhood,* **by Thomas Cole;** *Etretat,* **by Gustave Courbet.**

Often, left-to-right movement is halted or redirected back toward the interior of the image by a vertical element on the right side, but some artists open up the right side of the image to suggest a desire or freedom to move off toward another place.

9.3
Top row, left to right: *The Night Watch*; *The Anatomy Lesson*, both by Rembrandt van Rijn; *second row*: *Moonrise*, by Frederic Church; *The Battle of Taillebourg*, by Eugene Delacroix; *third row*: *A Lady Writing a Letter*, by Jan Vermeer; *Venice, The Dogana and San Giorgio Maggiore*, by William Turner.

Many of the old masters, Rembrandt most notable among them, favored assigning the most important element in a composition the lightest value. It is human nature to be attracted to light; making the subject the brightest element instantly draws attention to it. However, a dark element contrasting with a light background can also emphasize its importance in a composition.

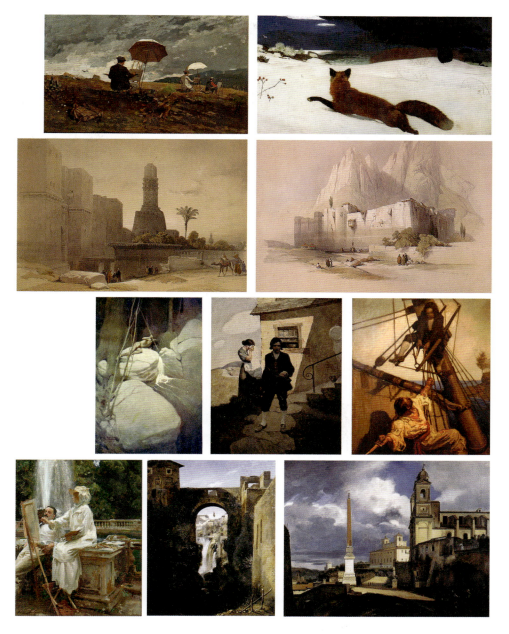

9.4

Top row, left to right: *Artists Sketching in the White Mountains*; *The Fox Hunt*, **both by Winslow Homer**; *second row*: *Gate of Victory and Minerat of Mosque el Harkim*; *Convent of St. Catherine and Mount Horeb*, **both by David Roberts**; *third row*: *The Indian in His Solitude*; *Jim Hawkins*; *One More Step*, **all by N. C. Wyeth**; *fourth row*: *The Villa at Torlonia, Frascati*, **by John Singer Sargent**; *The San Rocco Bridge and the Grand Waterfall at Tivoli*; *San Trinit dei Monti and the Villa Medici*, **both by Francois-Marius Granet**.

Contrast draws attention; locating the most intense light and dark values adjacent to one another emphasizes those elements.

9.5
Top row, left to right: *Ancient School Engineered by Egyptian and Greek*, by Giovanni Battista Piranesi; *Architectural Landscape with a Canal*, by Hubert Robert; *second row*: *Cornard Wood*, by Thomas Gainsborough; *Interior of Saint Peters, Rome*, by Giovanni Paolo Panini; *third row*: *An Oleander*, by Lawrence Alma Tadema; *Hunters in the Snow*, by Pieter Bruegel the Elder; *fourth row*: *Convent of St. Catherine*; *The Entrance to the Temple of Baalbek*; *Bazaar of the Silk Mercers, Cairo*, all by David Roberts.

Creating or suggesting a path leads the viewer's eye.

9.6

Top row, left to right: John Orestes Pursued by the Furies, by John Singer Sargent;
Venus of Urbino, by Titian; *second row*: **Arnofini Portrait,** by Jan van Eyck; **Expulsion
from the Garden of Eden**, by Thomas Cole; *third row*: **The Virgin and Chancellor Rolin,**
by Jan van Eyck; **Philosopher in Meditation**, by Rembrandt van Rijn.

Dividing the image into halves vertically, horizontally, or diagonally can organize a
composition and sets up contrast or tension between elements on either side of the
divide.

9.7
Top row, left to right: *The Gulf Stream*; *Karer See,* both by Winslow Homer; *second row*: *A Dash for the Timber,* by Frederic Remington; *Baalbek,* by David Roberts; *third row*: *The Oath of Horatio,* by Jacques-Louis David; *Virgin and Child with Saints and Donor,* by Jan van Eyck.

Dividing the image into thirds can organize a composition.

9.8
Top row, left to right: **Saint John the Baptist,** by Caravaggio; *On the Island of Earraid,* by N. C. Wyeth; *Cain and Abel,* by Titian; *second row*: *After Leonardo da Vinci, The Battle of Anghiari; Laocoon and His Sons,* both by Peter Paul Rubens; *third row*: *Raft of the Medusa,* by Theodore Gericault; *A Stag at Sharkey's,* by George Bellows.

Diagonals and sharp angles can suggest action or tension.

9.9
Top row, left to right: *View from Central Park*, by William Merritt Chase; *Boys and Kitten*, by Winslow Homer; *second row*: *Chelsea Shops*, by James McNeill Whistler; *Young Woman with a Pearl Necklace*, by Jan Vermeer; *third row*: *In the Luxembourg Gardens*; *Rosina, Capri*, both by John Singer Sargent.

Blank areas can emphasize the focus of interest.

9.10
Top row, left to right: *The Child's Bath*, by Mary Cassatt; *Violation Des Caveaux à Saint Denis*, by Hubert Robert; *second row*: *The Four Great Rivers of Antiquity*; *Venus, Cupid, Bacchus, and Ceres*, both by Peter Paul Rubens.

A spiral based on the golden section or Fibonacci sequence can organize a composition.

9.11
Top row, left to right: Rape of
the Daughters of Leucippus, **by
Peter Paul Rubens;** *second row*:
The Herring Net, **by Winslow
Homer;** *third row*: Petra March,
by David Roberts.

A circle can organize a composition.

9.12
Top row, left to right: **Arrangement in Grey and Black**, by James McNeill Whistler; *The Goldweigher*, **Lady Standing at the Virginals**, both by Jan Vermeer; *second row*: **Falls of the Kaaterskill**; **Architect's Dream**, both by Thomas Cole; *third row*: **View of the Entrance to the Arsenal**, by Giovanni Antonio Canaletto; *The Wedding at Cana*, by Giovanni Paolo Panini; *fourth row*: **Citadel of Jerusalem**, by David Roberts; *Pont d'Argenteuil*, by Claude Monet.

Elements parallel to and recalling the picture plane can strengthen a composition.

9.13
Top row, left to right: *Women of Amphissa*, by Laurence Alma Tadema; *Archers Shooting at a Herm*, by Michelangelo Buonarroti; *second row*: *Forest of Fontainebleau*, by Jean Baptiste Camille Corot; *Landscape*, by Albert Bierstadt; *third row*: *Portrait of Baldassare Castiglione*, by Raffaello Sanzio; *Girl with a Guitar*, by Jan Vermeer; *Blind Pew*, by N. C. Wyeth; *fourth row*: *The Lantern Bearers*, by Maxfield Parrish; *The Great Temple of Aboo-Simble, Nubia*, by David Roberts.

Repeating shapes, profiles, or elements can inform a composition.

9.14
Top row, left to right: *Bacchanal at the Spring Souvenir of Marly le Roi,* by Jean Baptiste Camille Corot; *Grand Portico of the Temple of Philae, Nubia,* by David Roberts; *second row*: *The Last Supper,* by Leonardo da Vinci; *Interior of the Choir in the Capuchin Church on the Piazza Barberini in Rome,* by Marius Granet.

Symmetry is a simple but effective way to organize a composition.

9.15

Top row, left to right: The Allegory of Faith; The Artist's Studio; The Geographer, all by Jan Vermeer; *second row: London, Seen Through an Arch of Westminster Bridge,* by Giovanni Antonio Canaletto; *In the Garden of the Coteau at Sainte Adresse,* by Claude Monet; *third row: Nassau, Water and Sailboat,* by Winslow Homer; *View of the Riva degli Schiavoni, Venice,* by Giovanni Antonio Canaletto; *fourth row: A Hermit Praying in the Ruins of a Roman Temple,* by Hubert Roberts; *Wapping on the Thames,* by James McNeill Whistler.

Framing the view with foreground elements is a common device for emphasizing the subject.

9.16

Top row, left to right: An Actor in the Role of Tegoshi Tsukna; The Actors Ichikawa Kuzo, Sawamura Tanosuke, and Nakamura Shikan; Mitsuji Preparing Tea, all by Toyokuni Utagawa; *Woman Reading a Letter,* by Johannes Vermeer; *second row: Carcere; Prisoners on a Projecting Platform,* both by Giovanni Battista Piranesi; *third row: Church in Unterarch on the Attersee; Water Castle; Fredericke Maria Beer,* all by Gustav Klimt; *fourth row: The Dinner,* by Claude Monet; *Gallery of Views of Ancient Rome,* by Giovanni Paolo Panini.

Composition Strategies

Breaking the rules (see Figure 9.16):

- Giving equal weight to all parts of an image can inform a composition.
- Obscuring or purposely confusing elements in a composition, breaking the laws of perspective, or creating a space that is unfamiliar can encourage a viewer to consider an image further.
- Filling a composition with detail can entice a viewer to spend more time with an image.

10
Color Strategies

The ability to realistically predict color and successfully apply it to images of things that do not exist is infinitely more difficult than replicating observable reality. Most people become frustrated with color because they do not appreciate the difficulty of this endeavor and haphazardly approach it without any strategy for success. The primary objective here is to provide methods for beginners to immediately use color in a competent way. As skills are developed, more ambitious color schemes can be attempted. However, do not be reluctant to begin with or return to the basics; even the best professionals – masters of color – will often use simple color strategies, not because they are easier to control, but because they yield evocative results.

Our color perception is affected by three factors, either separately or in combination:

1 the light source: direct or reflected, cool or warm;
2 the surface receiving the light: cool or warm, smooth, rough, reflective, or matt surface;
3 the color of adjacent surfaces: an area of color surrounded by its opposite contrasting color will have the optical effect of causing that color to appear more vivid, such as red and green, yellow and purple, or orange and blue.

Color can be referred to in three ways:

1 *Hue* is the attribute that classifies a color as yellow, blue, purple, red, green, etc.
2 *Chroma* indicates a color's intensity or brilliance; a color with weak chroma has white and/or black mixed in.
3 *Value* describes the relative lightness or darkness of a color; for instance, pink has a lighter value than red, white has a lighter value than gray, and yellow has a lighter value than blue.

Color Strategies

Strategy 1: Achromatic

One of the easiest ways to assure a successful color scheme is to use an achromatic palette – no color at all. Often overlooked is the elegance of an image rendered only in shades of gray. This strategy allows one to concentrate on the values in an image, carefully controlling lights and darks to reinforce the overall composition. Predicting how light will illuminate an object or building when it cannot be observed from reality requires practice and experience. Taking color out of the equation makes this task much easier.

10.1
Achromatic color scheme.

Strategy 2: Achromatic with Slight Color

The next strategy begins with a black-and-white image, but then adds very limited areas of faint, desaturated color. It is extremely important to resist the impulse to tint the image with too bright a color. If done with restraint, it is often surprising how "colorful" these images appear when before and after versions are compared.

10.2
Achromatic scheme with slight color.

Strategy 3: Desaturated Monochromatic with Contrasting Color

This strategy is similar to Strategy 2, except that rather than begin with achromatic color, a subtle overall hue – either cool or warm – dominates the image. Then, as in Strategy 2, limited areas of faint color, the opposite of the dominant hue on the color wheel, are applied. In other words, if the overall base color is a cool gray, then warm accents are added, or if the overall base color is warm, then cool accents are added. We are often unaware that most grays already tend toward a cool or warm hue. The exceptions to this are some black pigments, such as Lamp Black, Ivory Black, and Mars Black, pigments that are neutral and that, incidentally, many watercolorists avoid using because they can deaden a color scheme. Those interested in variations of this approach might also consider using a warm or cool underlay line drawing and then using an opposing hue for the wash. Canaletto is known for his luminous oil paintings of Venice, but he also made some wonderful studies of the city employing warm sepia ink lines, shaded with cool gray washes.

10.3
Desaturated monochromatic scheme with contrasting color. *Left*: *Moscow High-rise Project*, **Skidmore Owings & Merrill, Chicago, architects, illustration by the author;** *right*: *Venetian Fantasy*, **by Giovanni Antonio Canaletto.**

Color Strategies

Strategy 4: Monochromatic

Another strategy is to use a single hue, referred to as a monochromatic color scheme. While it can actually be difficult to get unsatisfactory results with the first three strategies, a monochromatic color scheme can go wrong if the color is too strong or perceived as suggesting something unpleasant; a murky brown or green comes to mind. Even a "cheerful" color may not work if it is perceived as too bright or unsympathetic with the image.

10.4
Monochromatic color scheme.

Strategy 5: Full Color

As more skill and confidence with color is developed, achromatic hues can be replaced with direct applications of pure color. Still, it is best to use fairly desaturated color at first and gradually build toward using brighter palettes. Remember, when trying to predict color, the brighter the palette the harder it will be to get the entire image and range of colors to harmonize in a convincing way. Once some proficiency with color is achieved, you should trust your intuition. There are formal strategies for using color, such as analogous, complimentary, and contrasting color schemes. While these are useful to consider, successful color schemes sometimes also break the rules.

10.5
Color wheel.

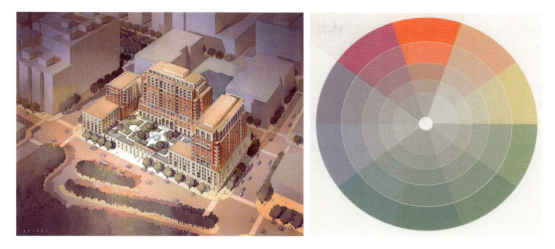

10.6
Analogous color scheme.

Analogous: this limits hues to a narrow range of the color wheel, ensuring the colors selected are harmonious. It is usually best to have one color dominate, and the other used as an accent.

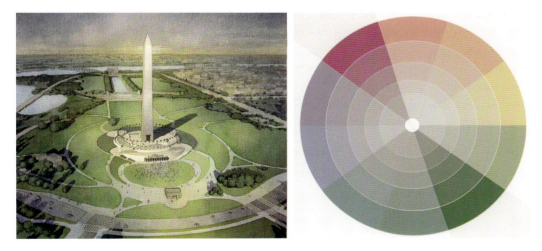

10.7
Complimentary color scheme.

Complimentary: this uses hues opposite one another on the color wheel. Again, it works best if one color dominates.

Color Strategies

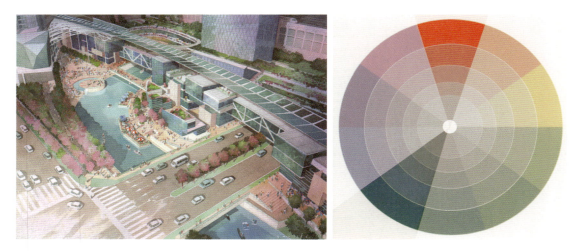

10.8
Contrasting color scheme.

Contrasting: this employs hues that are a few steps apart on the color wheel. Although they are called contrasting, they still share some hue that makes them harmonious.

10.9
Colors with similar values.

Three rules can guide an approach to color:

1 Begin by using desaturated colors.
2 Limit the chroma of all the colors used to a similar range.
3 In any image, 80–95 percent of the color should be chosen from 2–4 adjacent areas of the color wheel. Pick the remaining color from that part of the color wheel opposite the dominant colors. This "accent" color, used sparingly, imparts a little sparkle and draws attention to those areas where it is applied.

10.10
Predominately cool color with warm contrast.

10.11
Predominately warm color with cool contrast.

11
Collection of Illustrations

Professional Work

This exquisitely delicate watercolor by Elizabeth Day (Figure 11.1 top) uses some of the strategies previously described in Chapter 9. The viewer enters the image from the left, through the gate, and winds around back to the house and the front door. Movement to the right is contained by the mass of dark trees. Rather than using the brightest values for the house itself, the artist applies them to the pilasters and fountain in the foreground. The next brightest area is reserved for the minor façade, and even though the main façade is also in sunlight, the sun ever so gently glances across its surface, indicated by the subtle shadows and cool light reflected off the bushes.

There is no question what Thomas Schaller (Figure 11.1 bottom left) wants the viewer to notice in this skillfully conceived image. The small folly building glows with such intensity that the surface of the right foreground building is also illuminated by its light. As in the previous example, the brightest value is reserved for the minor façade of the subject building. Notice how the receding façades of the foreground buildings contain strong diagonal lines that gather and direct the viewer's eye toward the focus of the composition. Movement beyond the subject building is contained by the flat façade of the rear-most building.

This deceptively simple yet evocative watercolor by Douglas Jamieson (Figure 11.1 bottom right) seems to balance on the edge between portraying a tropical cottage on a sunny day and suggesting something else. Does the unusual composition with the large amount of sky – deftly watercolored with subtle hue and detail – suggest a column of humid tropical air that, coupled with the billowing palm trees and illuminated porch light, ominously anticipate a gathering storm?

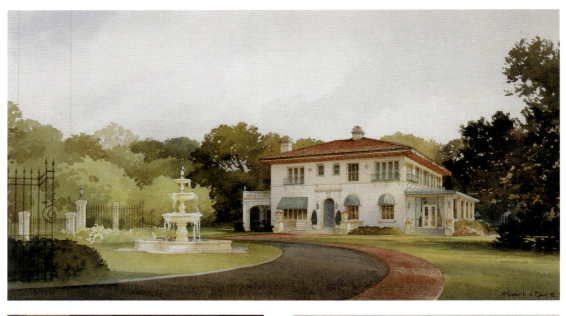

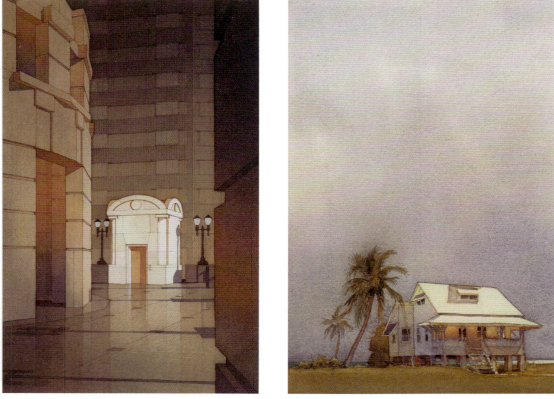

11.1
Top: *Austin Residence*, watercolor, 12" × 21", by Elizabeth Day; *bottom left*: *1000 Wilshire Blvd.*, watercolor, 15.5" × 9.5", by Thomas Schaller; *bottom right*: *Proposed Cottage Renovation*, watercolor, 19" × 14", by Douglas Jamieson.

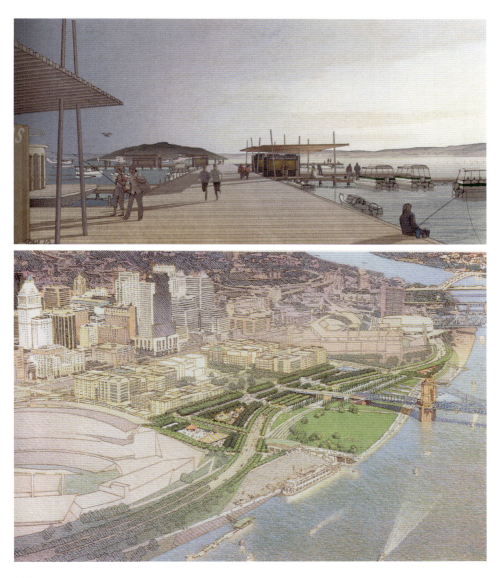

11.2
Top: *Rotorua Lakeside Development*, mixed media, 9.3" × 16.5", by Ian Stantiall;
bottom: *Cincinnati Waterfront Park*, color pencil on photocopy of original pencil
drawing, 9" × 13", by Christopher Grubbs.

A number of the color and compositional strategies covered earlier are effectively
employed in this elegantly restrained illustration by Ian Stantiall (Figure 11.2 top). They
include: a desaturated contrasting color scheme; dividing the image into halves, both
vertically and horizontally; recalling the picture plane with horizontal elements; using
blank areas to emphasize the subject; and subtly suggesting left-to-right movement with
the changing value of the sky and the solitary figure continuing the viewer's progression
through the composition off to the right.

Collection of Illustrations

Christopher Grubbs (Figure 11.2 bottom) has developed an evocative personal style. His relatively small originals emphasizing freehand drawing technique often employ photographs and computer-generated 3D images as underlays to help inform the initial graphite pencil drawings he creates. These drawings are then reproduced onto paper with a copier machine. A light watercolor wash precedes the final application of colored pencil. By coloring a photocopy, the colored pencil does not smear the original pencil lines. Particularly effective in this image is the masterful color scheme and the use of uncolored areas that graphically reference the process and emphasize the subject.

11.3
Top: *Robertson Residence*, pencil and colored pencil on yellow trace paper, 8.5" × 14", by Samuel Ringman; *bottom*: *Hines France Office Tower*, black wax-based pencil on vellum, 13" × 8", by Paul Stevenson Oles.

The two images in Figure 11.3 share the same media – pencil – and both emphasize the process of making a drawing by celebrating technique.

In this virtuoso drawing, Samuel Ringman (Figure 11.3 top) makes no effort to hide the guidelines used to construct the perspective, leaving traces of the drawing's process of creation. An intuitive use of differing line weights defines and clarifies edges and intersections. Created on yellow tracing paper, the restrained color accomplished by quickly placed diagonal pencil strokes leaves one wondering if the color has been applied to the back of the transparent paper, or if Ringman is left-handed.

Paul Stevenson Oles (Figure 11.3 bottom) shares a common bond with the illustrator Hugh Ferriss in that both men often limit their palette to black and white, and by doing so create images that are remarkably sublime. Oles relies on the surface he is working on to provide texture so that the point of the black Prismacolor pencil, either dull or sharp, interacts with the surface, determining the size of the grain and effectively contrasting areas of fine detail in the building with the sky and foreground.

11.4
Left: *Quartet On Stage, Adelphi University*, watercolor, 9.5" × 10.25", by Frank Costantino; *Right*: *Pliny's Villa "Comedy"*, color pencil, 16.5" × 21.25", by the author.

Collection of Illustrations

Images that encourage a viewer to recall experiences involving the other senses, such as sound or touch, are more memorable than those that only rely on the sense of sight.

This insightful composition by Frank Costantino (Figure 11.4 left) simultaneously involves the audience, the performers, and us, the viewers. If a strategy for emphasizing the most important element in an image is to make that element the brightest value – in this case, the sheets of music – then this artist wants us to think about another dimension: that of sound.

This capriccio by the author (Figure 11.4 right), inspired by the work of Leon Krier, alludes to another time when life in general, and architecture in particular, was perhaps a more sensual experience. As in the previous example, the other senses are invited to participate: the breeze animating the billowing clouds, curtains, flags, and sails; the fragrance of the flowers and fruit trees; the heat of the sun and ceremonial fire contrasted against the cool areas of shade and water.

Al Rusch (Figure 11.5 top) combines traditional drawing, transparent watercolor, and digital techniques in this masterfully conceived hybrid image. The brightly colored boats, as well as the repetition of cylinders and circles, introduce an unexpected playfulness into what otherwise might have been a rather gritty subject. Here, the artist reminds us that a strategy of using symmetry to organize a composition also includes reflecting the composition around a horizontal centerline.

This complex illustration by Wesley Page (Figure 11.5 bottom) incorporates so many effective compositional strategies that one might suspect they were not all conscious choices and that this level of expertise can only be achieved through practice and intuition. The composition is based on a strategy of dividing the image into thirds, with the large blank foreground acting to give emphasis to the profusion of small-scale detail in the middle third of the image. The muted warm-colored buildings draw our attention by contrasting against the rest of the image's cool color palette. We assume this image accurately depicts the site's topography which portrays the individual buildings situated on a descending grade. The potentially awkward composition is brilliantly rectified by the gesturing trees that catch the viewer's attention and direct it up, around, and back into the composition. (Try imagining the illustration without the trees.) Notice how the distant mountains and hills repeat the geometry of the buildings' roofs.

11.5
Top: *River Driver's Retreat*, watercolor and digital, 18" × 13", by Al Rusch; *bottom*: *Sage Point Housing, University of Utah*, ink- and wax-based pencil, 16.5" × 27.5", by Wesley Page.

11.6
Top: *Tuscan Cityscape*,
watercolor, 7" × 10", by Henry
Sorenson; *bottom, Pino's Town*,
mixed media, 17" × 28", by
Lucien Steil.

Digital tools favor using perspective images, which now more than ever dominate how design intent is communicated. Yet the emotions art inspires can sometimes be better evoked by images that abandon perspective, encouraging the viewer to enter a world of subconscious memories and dreams. The work of artists such as Gustav Klimt and Giorgio De Chirico come to mind.

In this cleverly conceived image by Henry Sorenson (Figure 11.6 top), a constrained use of line and color effectively express the archetypal grammar that is the essence of Italian hill towns. The work of twentieth-century artists interested in abstraction has allowed us to see with new eyes the patterns informing our environment.

Architect Lucien Steil's whimsical drawings of urban environments (Figure 11.6 bottom) are "fictions," to be imagined rather than experienced in a physical sense. By challenging our normal expectations for thinking about architecture with his highly personal drawing style, he allows us to engage his conception of the essential elements that define traditional towns and cities.

11.7
Top: *Proposed Renovation of Crown Hall*, digital, 2,600 × 4,000 pixels, by the author; *middle*: *The Temples of Saturn, Vespasian and Concordia*, digital, 3,800 × 5,000 pixels, by the author; *bottom*: *Oslo Opera House Exterior View*, digital, 2,200 × 4,000 pixels, courtesy Studio AMD.

There are certain subjects that defy expression through traditional means, or require a detached objectivity to effectively convey an idea.

The impact of this capriccio (Figure 11.7 top) suggesting a renovation of Mies van der Rohe's Crown Hall would have been diminished by a more subjective technique employing watercolor or pencil.

Beaux-Arts architects seldom attempted perspectives, as the skill and effort required to capture ornament or the delicate fluting on a column is a daunting challenge when using traditional techniques. Today this endeavor is made much easier with computers.

This ethereal image by Studio AMD (Figure 11.7 bottom) is a perfect example of an architecture that simply cannot be expressed by any other means except to employ computer modeling.

11.8
Top and middle: *Flair Tower, Chicago*, Antunovich Associates, Architects, aerial view, 4,500 × 3,100 pixels, digital; pool view, 2,600 × 4,500 pixels, by the author; *bottom*: photograph, courtesy Antunovich Associates.

Digital copies of working drawings provide backgrounds over which the 3D model is constructed (Figure 11.8). The ability to generate realistic perspectives from any position, simulating any time of day, is a convincing reason for using computers. The architect shared with the author a photograph of the finished pool deck taken a year after these illustrations were completed.

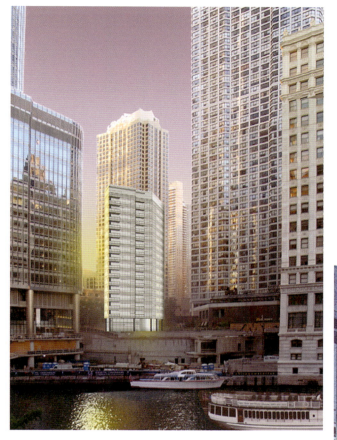

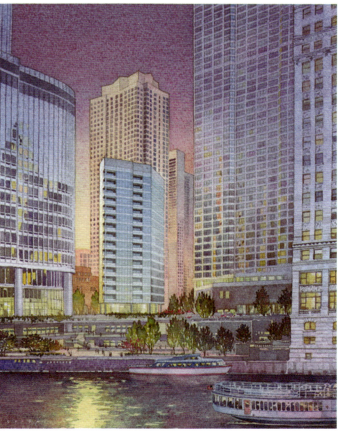

11.9
Top: *Proposed Hotel, Chicago,*
composite image, photograph
with digital model inserted;
bottom: watercolor, 10" × 8", by
the author.

Visitors to Chicago may recognize the view from the Michigan Avenue Bridge (Figure 11.9). In this example, elevations supplied to the author are pasted onto the façades of a digital massing model. A few 3D modeling software applications now offer tools that can exactly match a perspective view of the digital model to that of a photograph.

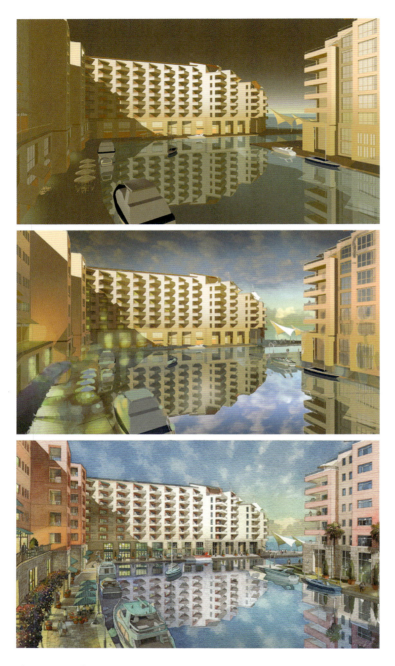

11.10
Top: *Proposed Waterfront Development, Dubai,* Lucien LaGrange Architects, screen shot of digital model; *middle*: composite image, digital model enhanced with Photoshop; *bottom*: watercolor, 12" × 18", illustrations by the author.

Watercolor is an unforgiving medium and it is sometimes useful to create one or more color studies. In Figure 11.10, a digital massing model is used to evaluate the best point of view and position for locating the sun. The image is then imported into Photoshop, where a sky is added and hand work employing a stylus and tablet is used to further investigate color and lighting possibilities. This process is very quick – less than 30 minutes. After the color study is shared with the client – and in this case some of the building colors were reconsidered – the final watercolor is completed.

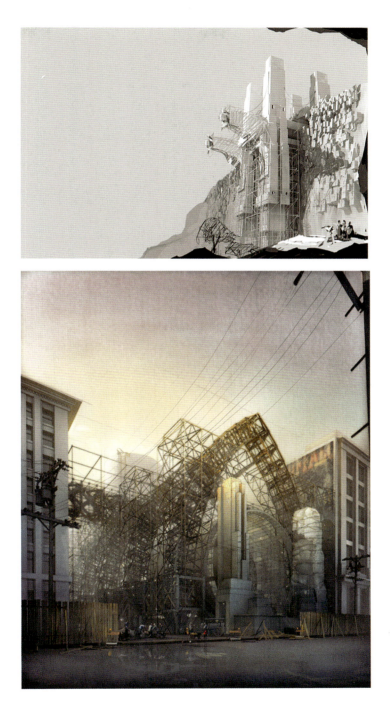

11.11
Top: *Theoretical Study*; *bottom*:
Exostra V, by Dennis Allain.

Dennis Allain (Figure 11.11) has emerged as a pioneer in developing a personal style using digital applications. While he still sketches on paper, the top image reveals his synthesis of freehand digital drawing and 3D modeling in the conceptual process. With the bottom image, subtle effects, such as using edge lines to define form and applying paper textures in the sky, recall associations with traditional techniques.

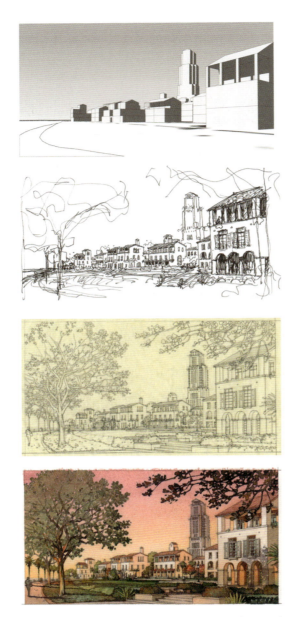

11.12
From top: *Heart of Lake in Xiamen, China*, **computer model and freehand sketch, courtesy Robert A. M. Stern Architects; hard line drawing and watercolor, 5″ × 12″, by the author.**

Simple massing models can serve as underlay images for tracing over with hand technique. This approach utilizes the strengths of both the traditional and digital environments: the perspectives are accurate, while the hand sketching remains intuitive and spontaneous. In the example shown in Figure 11.12, the design architect made loose sketches over prints of the digital model. The sketch was interpreted and refined by the author on yellow sketch paper. Once the final line drawing was approved, the image was scanned and printed onto 300 lb watercolor paper using waterproof and fadeproof ink, duplicating the appearance of a pencil drawing and providing the base to which watercolor was then applied. Keeping the original line drawing and watercolor small allowed the entire process to be completed in one day.

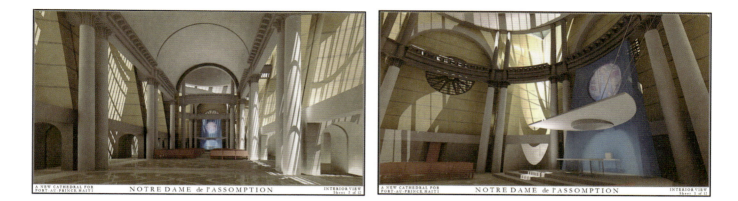

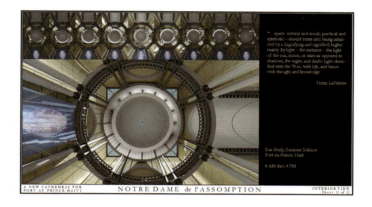

11.13
Notre Dame de l'Assomption Competition, Haiti, digital model images retouched with Photoshop, 3,500 × 1,850 pixels, design and illustrations by the author.

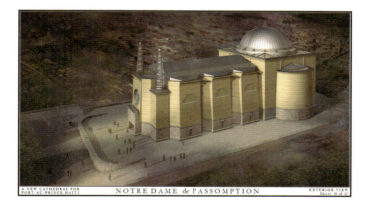

Another advantage 3D modeling offers is the ability of some software applications to simulate reflected light. This competition project envisioned the interior of the proposed cathedral to be almost entirely illuminated by reflected sunlight. Those architects interested in the phenomenology of architecture now have a powerful tool to investigate the fourth, fifth, and sixth dimensions: movement, wind, and even gravity.

223

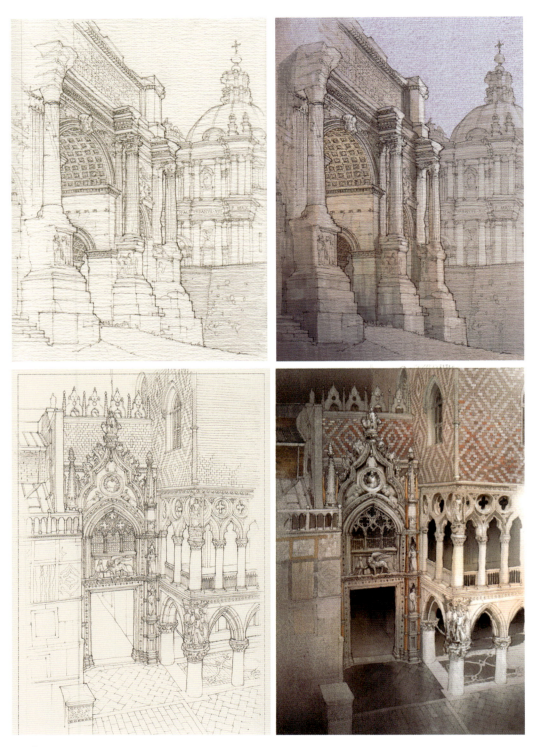

11.14
Top: *Arch of Severus, Rome*, graphite pencil drawing on watercolor paper, 10" × 14", digitally applied color; *bottom*: *Doges Palace, Venice*, graphite pencil drawing on watercolor paper, 10" × 14", digitally applied color, both by the author.

Originally created on site with pencil on watercolor paper, the images shown in Figure 11.14 were intended to be painted back in the studio. As time went by, they were eventually scanned and brought into Photoshop for coloring. The difference between the two color versions is how much time was employed in the coloring process. The image of the Arch of Severus in Rome was colored in less than 30 minutes using a few masks and the *Radial Gradient* tool. The entrance to the Doges Palace required more time – about a day's work – and used many more tools and techniques. While the second image may have been created with traditional techniques in about the same amount of time, there are a few advantages with using Photoshop. Employing the *History* and *Layers* features allow mistakes to be taken back and changes to be made more easily. There also emerged a unique quality about the image that could not have been achieved using traditional techniques. I often think about the fact that digital art produces no physical artifact. For this reason, I believe it is important to create at least one print of a finished work using archival paper and ink.

Student Work

11.15

Top: *Theater Proposal, Columbus, IN*, traditional line drawing with digital color, by Daniel Ostendorf; *bottom*: *National Poetry Center Proposal, Washington, D.C.*, traditional line drawing with digital color, by Timothy O'Hara.

11.16
Thesis Project, Fitger's Center for the Arts, CAD drawing with digital color, by Lon Stousland.

11.17
National Poetry Center Proposal, Washington, D.C., traditional line drawing with digital color, by Mark Santrach.

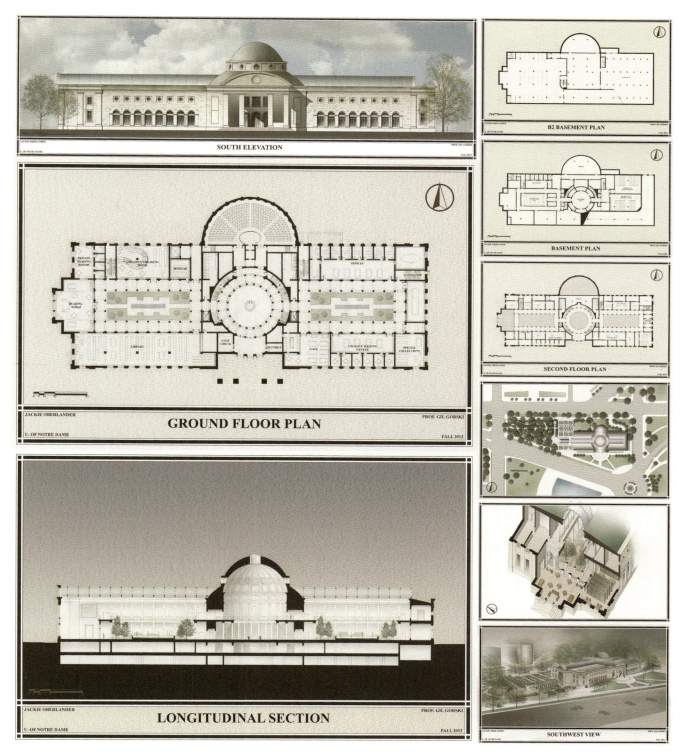

11.18
National Poetry Center Proposal, Washington, D.C., traditional line drawing with digital color, by Jacqueline Oberlander.

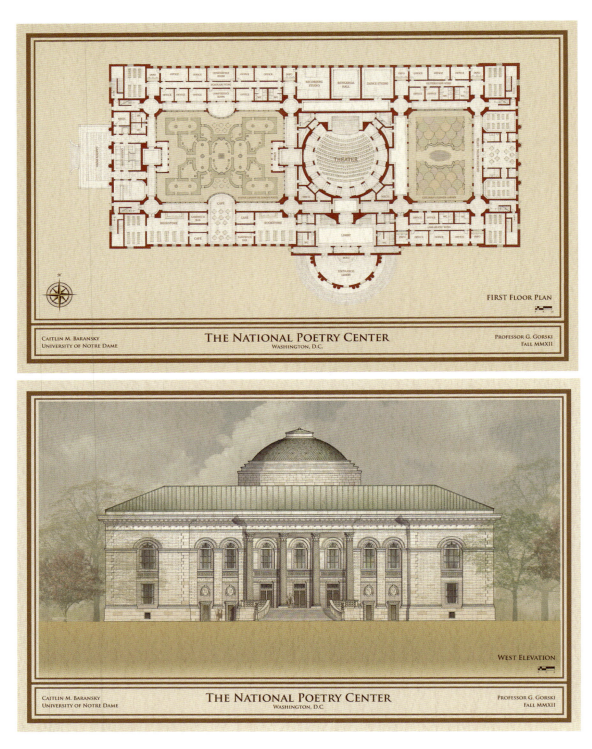

11.19
National Poetry Center Proposal, Washington, D.C., traditional line drawing with digital color, by Caitlin Baransky.

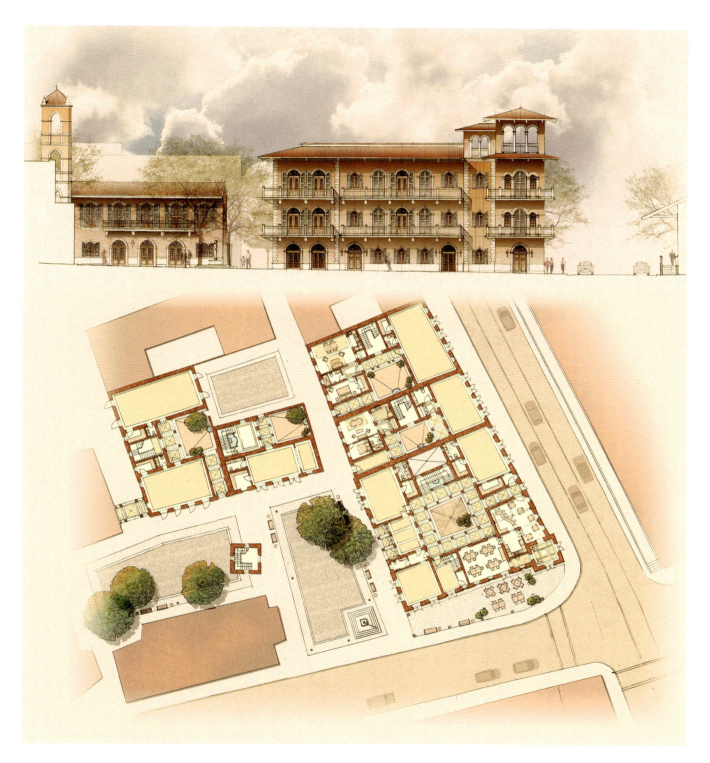

11.20

Multiple Unit Residential Project, by Timothy O'Hara.

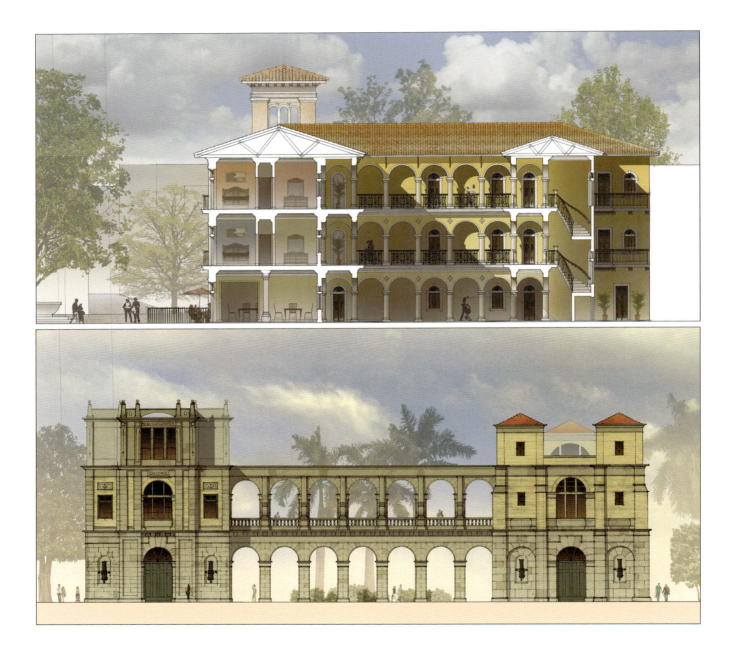

11.21
Top: *Avenida Project,* by Daniel Sacco; *bottom*; *Havana Maritime Museum*, by Marc DeSantis.

11.22
Top: *Thesis Project, An Urban Hotel in a North Dakota Boom Town*, CAD drawing with digital color, by Ryan Nelson; *bottom*: *Thesis Project, A Counter Proposal for the Oxbow School of Art, Saugatuck, Michigan*, digital, by Alexander Paolucci.

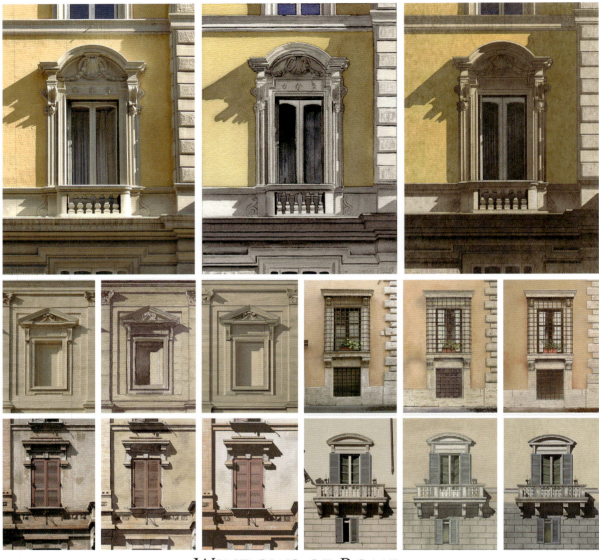

WINDOWS OF ROME
PHOTOGRAPH WATERCOLOR DIGITAL COLOR

11.23
Windows of Rome. Top row by Daniel Sacco; *second row left to right*: by David Hayes, Taylor Stein; *third row left to right*: by Mathew Cook, Maria Harmon.

To master the ability to portray ideas that do not yet exist, it is useful to practice drawing and painting from life or photographs. This exercise asked students to copy a photograph, first with a watercolor technique and then with a digital technique. The students, already proficient with watercolor, were just learning how to use Photoshop. Many were surprised by how they were able to achieve similar results with digital techniques – often in less time.

Appendix: Entourage Reference Files

Included on this book's eResource site (www.routledge.com/9780415702263) are images of people, trees, skies, and texture fields that those purchasing the book are free to use without copyright restrictions.

Incorporating entourage in an illustration is often neglected, and yet many professional illustrators will acknowledge that entourage can be an illustration's most important element. The only thing worse than an illustration devoid of elements that impart a sense of life is one that includes poorly drawn people, cars, and trees that impart a sense that the life is malformed. The best way to ensure accuracy is to use photographs, either by tracing over them or incorporating them directly. Digital tools make the task of collecting and resizing entourage elements much easier. Don't be reluctant to add lots of people in a view; an illustration with a few lonely souls has a melancholy feeling about it. Don't forget to pay attention to the correct scale of the trees, and to include shrubs and flowers, streetlights, and benches if appropriate.

Although a bit time-consuming, you can generate your own image files. It is useful to isolate entourage images on a separate layer or against a white or black background, so that once imported into a view, the background color can be selected and quickly deleted. Trees are easier to isolate if you can photograph ones already silhouetted against a sky. Then use Photoshop's *Eyedropper*, *Select*, and *Delete* options to isolate it against a blank background. Images of people require a little more work: use the *Lasso* tools to trace around the figure in order to delete its surroundings.

Images of cars have not been included. My experience has been that no matter how many photographs of cars you may have, they are never quite in the right position as the illustration requires. For this reason, I either include them as elements in the original digital model or I generate images of them from digital models that approximate the desired view. If that is not possible, I will go out with a copy of the view in hand and photograph cars in a parking lot from the desired angle.

If you are using subjects photographed in strong light, remember to coordinate the direction of the light source in both the base image and entourage. If they conflict, simply flip the horizontal orientation of the entourage photograph. The images of skies that are included on the eResource site avoid shots of a rising or setting sun, which, while often

dramatic, would then dictate that the subject of the illustration is backlighted – seldom a good strategy.

The images that are included on the eResource site of textures – line patterns and watercolor fields – are necessarily large to ensure compatibility with larger illustrations. Don't forget to consider using Photoshop's tools, such as *Curves*, *Saturation*, or *Adjust Color*, to fine-tune these images further for specific applications.

Doorway Study, digital model.

Image Credits

We are thankful to those who gave permission to reproduce the material in this book. While every effort was made to acknowledge and obtain the permission of copyright holders, we would be grateful to be made aware of any errors or omissions. All images not listed here are by the author.

2.1	Courtesy Duncan McRoberts.
2.2	William Bouguereau, courtesy Wikimedia Commons.
2.3	The Office of Frank Lloyd Wright, courtesy The Frank Lloyd Wright Foundation Archives (The Museum of Modern Art/Avery Architectural & Fine Arts Library, Columbia University, New York).
2.4	Robert Atkinson, reprinted, by permission, British Architectural Library, Royal Institute of British Architects.
2.5	*Top*: Raffaello Sanzio da Urbino; *bottom*: Michelangelo Buonarroti, both images courtesy Wikimedia Commons.
2.9	*Clockwise from top left*: courtesy: Lisa Schumaker, Stephanie Escobar, Patrick Alles, Yukiko Inoue, Taylor Stein, Kathleen Joyce.
3.9	Helmut Jacoby, courtesy Bofinger & Partners, Architects, Professor Helge Bofinger.
3.12	Courtesy Leon Krier.
3.13	*From top row, left to right*: courtesy: Geoffrey Barnes, Paul Hayes, Paige Mariucci, Brendan Hart, David Hayes, Bill Hull, Danny Sacco, Taylor Stein, Christopher Snyder, Danny Sacco, Maria Harmon, Chris Fagan, Maria Harmon, Olga Bryazka, Daniel Ostendorf.
4.2–4.4	Courtesy Adobe Photoshop.
5.1	Toyokuni Utagawa, courtesy Library of Congress.
5.2	Kunichika Toyohara, courtesy Library of Congress.
5.3	Hiroshige Ando, courtesy Library of Congress.
5.4–5.7	Otto Wagner, reprinted, by permission, Wien Museum, Vienna.
5.8	Helmut Jacoby, courtesy Entelechy II Collection, The Portman Archives Collection.
5.9–5.41	Courtesy Adobe Photoshop.

11.4	*Top*: courtesy: Frank Costantino.
11.5	*Top*: courtesy: Al Rusch; *bottom*: courtesy: Wesley Page.
11.6	*Top*: courtesy: Henry Sorenson; *bottom*: courtesy: Lucien Steil.
11.7	*Bottom*: courtesy Studio AMD.
11.8	*Bottom*: photograph courtesy Antunovich Associates, Architects.
11.11	Courtesy Dennis Allain.
11.12	*Top two images*: Computer model, freehand sketch, courtesy Robert A. M. Stern Architects, LLP. Project: *Heart of Lake in Xiamen, China.*
11.15	*Top*: courtesy: Daniel Ostendorf; *bottom*; courtesy: Timothy O'Hara.
11.16	Courtesy Lon Stousland.
11.17	Courtesy Mark Santrach.
11.18	Courtesy Jacqueline Oberlander.
11.19	Courtesy Caitlin Baransky.
11.20	Courtesy Timothy O'Hara.
11.21	*Top*: courtesy Daniel Sacco; *bottom*: courtesy Marc DeSantis.
11.22	*Top*: courtesy: Ryan Nelson; *bottom*: courtesy: Alexander Paolucci.
11.23	*Top row*: courtesy: Daniel Sacco; *second row left to right*: courtesy: David Hayes, Taylor Stein; *third row left to right*: courtesy: Mathew Cook, Maria Harmon, photographs by the author.

Bibliography

Albus, Anita, *The Art of Arts*, Alfred A. Knopf (New York), 1997/2000.

Bachelard, Gaston, *The Poetics of Space*, Beacon Press (Boston), 1958/1969.

Beckmann, John, editor, *The Virtual Dimension: Architecture, Representation, and Crash Culture,* Princeton Architectural Press (New York), 1998.

Benjamin, Walter, *Illuminations, Essays, and Reflections*, Schoken Books (New York), 1955/1969.

Berger, John, *Ways of Seeing*, British Broadcasting Corporation and Penguin Books (London), 1972.

Berger, John, *About Looking*, Vintage International (New York), 1980/1991.

Blau, Eva and Kaufman, Edward, editors, *Architecture and Its Image*, MIT Press (Cambridge, MA and London), 1989.

Borgmann, Albert, *Crossing the Postmodern Divide*, University of Chicago Press (Chicago, IL and London), 1992.

Cole, Bruce, *The Renaissance Artist at Work: From Pisano to Titian*, Harper & Row (New York), 1983.

Cook, Peter, *Drawing: The Motive Force of Architecture*, John Wiley & Sons Ltd. (Chichester), 2011.

Derne, David, *Architectural Drawing*, Laurence King Publishing (London), 2010.

Ellul, Jacques, *The Technological Society*, translated by John Wilkinson, Alfred A. Knopf, Inc. (Toronto), 1954/1964.

Evans, Robin, *Translations from Drawing to Building*, MIT Press (Cambridge, MA), 1997.

Edwards, Betty, *Drawing on the Right Side of the Brain*, J. P. Tarcher, Inc. (Los Angeles, CA), 1979.

Eisenstein, Elizabeth, *The Printing Press as an Agent of Change: Communications and Cultural Transformations in Early-Modern Europe*, Cambridge University Press (New York), 1979.

Frascari, Marco, Hale, Jonathon, and Starkey, Bradley, editors, *From Models to Drawings: Imagination and Representation in Architecture*, Routledge (London and New York), 2007.

Gill, Brendan, *Many Masks: A Life of Frank Lloyd Wright*, Putnam (New York), 1987.

Glasser, Milton, *Drawing is Thinking*, Overlook Duckworth, Peter Mayer Publishers (New York, Woodstock and London), 2008.

Goldschmidt, Gabriela, and Porter, William editors, *Design Representation*, Springer-Verlag, (London), 2004.

Hale, Jonathon, *The Old Way of Seeing*, Houghton Mifflin Company (Boston, MA and New York), 1994.

Henri, Robert, *The Art Spirit*, Westview Press (Boulder, CO and Oxford), 1923/1984.

Johnson, Mark, *The Meaning of the Body: Aesthetics of Human Understanding*, University of Chicago Press (Chicago, IL and London), 2007.

Kellert, Stephen, Heerwagan, Judith, and Mador, Martin, *Biophilic Design: The Theory, Science and Practice of Bringing Buildings to Life*, John Wiley & Sons Ltd (Chichester), 2008.

Lawson, Bryan, *Design in Mind,* Butterworth Architecture (Oxford), 1994.

LeFebvre, Henri, *The Production of Space*, translated by Donald Nicholson, Smith Basil Blackwell Ltd. (Oxford), 1974/1991.

Lotz, Wolfgang, *Studies in Italian Renaissance Architecture*, MIT Press (Cambridge, MA), 1977.

McElhinney, James Lancel, Faculty of the Art Students League, *The Visual Language of Drawing: Lessons on the Art of Seeing*, Sterling (New York), 2012.

McLuhan, Marshall, *Essential McLuhan*, edited by Eric McLuhan and Frank Zingrone, Basic Books (New York), 1995.

Magonigle, Harold Van Buren, *Architectural Rendering in Wash*, Charles Scribner's Sons (New York), 1921.

Mallgrave, Harry Francis, *The Architect's Brain: Neuroscience, Creativity and Architecture*, John Wiley & Sons Ltd. (Chichester), 2008.

Merleau-Ponty, Maurice, *Phenomenology of Perception*, Routlege (London and New York), 1962.

Merleau-Ponty, Maurice, *The Visible and the Invisible*, Northwestern University Press (Evanston, IL), 1968.

Neidich, Warren, *Blow Up: Photography, Cinema, and the Brain*, Art Publishing, Inc. (New York), 2003.

Pallasmaa, Juhani, *The Eyes of the Skin: Architecture and the Senses*, John Wiley & Sons Ltd, (Chichester), 2005.

Pallasmaa, Juhani, *The Thinking Hand: Existential and Embodied Wisdom in Architecture*, John Wiley & Sons Ltd. (Chichester), 2009.

Pallasmaa, Juhani, *The Embodied Image: Imagination and Imagery in Architecture,* John Wiley & Sons Ltd. (Chichester), 2011.

Perez-Gomez, Alberto, and Pelletier, Louise, *Architectural Representation and the Perspective Hinge*, MIT Press (Cambridge, MA), 1997.

Pinker, Steven, *How the Mind Works*, Norton (New York), 1954.

Pinker, Steven, *The Blank Slate*, Penguin Group (New York and London), 2003.

Pollock, Sydney, director, *Sketches of Frank Gehry*, 2006.

Bibliography

Postman, Neil, *Technopoly: The Surrender of Culture to Technology*, Vintage Books (New York), 1992/1993.

Rasmussen, Steen Eiler, *Experiencing Architecture*, MIT Press (Cambridge, MA), 1959/2000.

Robbins, Edward, *Why Architects Draw*, MIT Press (Cambridge, MA), 1994.

Sennett, Richard, *The Craftsman*, Yale University Press (New Haven, CT and London), 2008.

Steele, James, *Architecture and Computers: Action and Reaction in the Digital Design Revolution*, Laurence King (London), 2001.

Stephens, Suzanne, "Perspective News", *Architectural Record*, 9, 2013.

Tafel, Edgar, *Apprentice to Genius: Years with Frank Lloyd Wright*, McGraw-Hill (New York), 1979.

Trachtenberg, Marvin, *Building in Time: From Giotto to Alberti and Modern Oblivion*, Yale University Press (New Haven, CT), 2010.

Treib, Marc, editor, *Drawing/Thinking: Confronting an Electronic Age*, Routledge (London and New York), 2008.

Wilson, Frank, *The Hand*, Vintage Books (New York), 1999.

Index

Index